W9-AVA-722

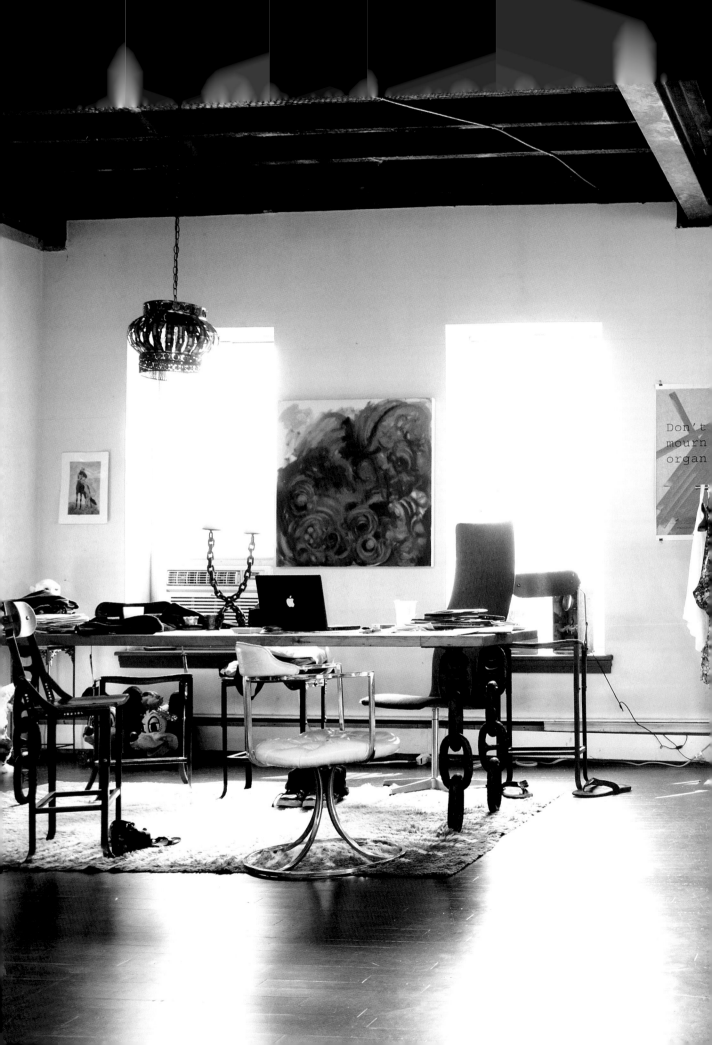

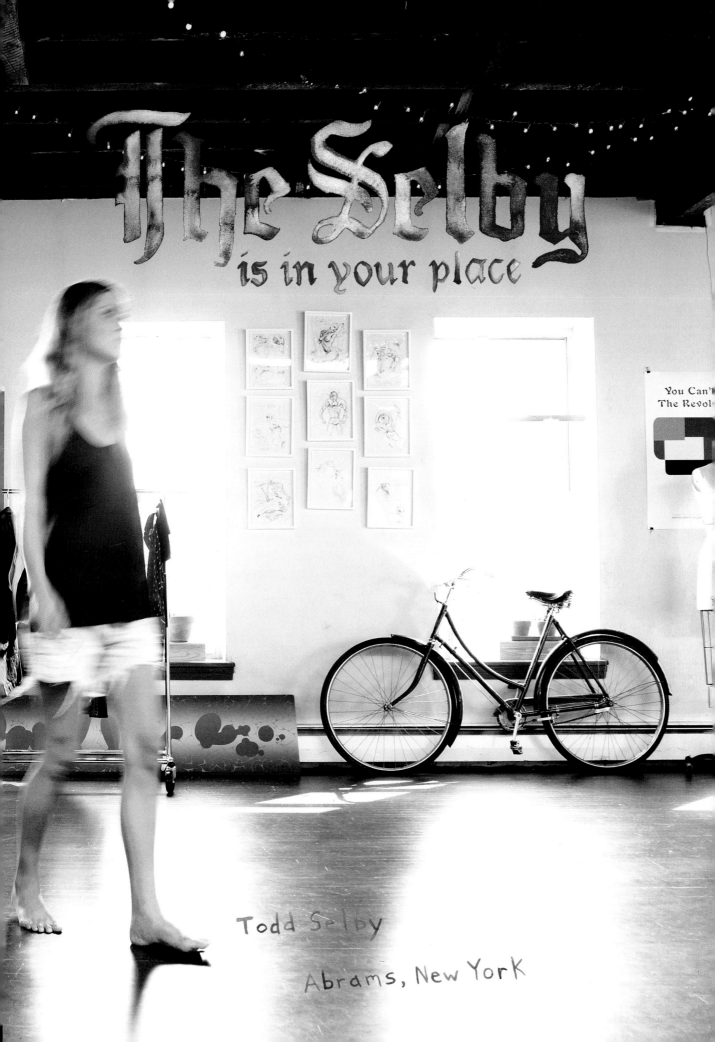

Contents

CHRISTIAN LOUBOUTIN (130)

JEFF JOHNSEN (138)

LOU DOILLON (146)

HIRAKAWA TAKÉHARU (154)

MERYL SMITH (162)

BILL GENTLE (170)

FANNY BOSTROM

HELENA CHRISTENSEN (178)

RETTS WOOD (184)

ELISA NALIN (192)

GRACE KELSEY

KENYAN (198)

THIBAULT DE MONTAIGU

SOFÍA ACHÁVAL (208)

NAKAO (214)

FARIS BADWAN (222)

MELIA MARDEN

FRANK SISTI JR. (228)

DJ VERBAL

YOON (234)

AARON ROSE (240)

MAXIMILLA LUKACS

GUY BLAKESLEE (248)

Introduction

IF THERE'S ONE THING that unites us in New York City, it's not love.

It's not loyalty or intelligence or pride. It's not even money. The particular type of thread I'm thinking of falls closer to envy. It runs through us like thread through a needle. Everything we do is stitched in its color.

There's this thing we New Yorkers do when we walk down the street. We look in the windows of other people's apartments. We don't do it in a creepy, stalker way. It's nothing like that at all. We do it more in a curious, maybe even competitive way, although that's not to say it's in a negative way either. In this city we're always looking over each others' shoulders. There's always a hotter person we could be going out with. There's a cooler job just around the corner. Of course, someone else's apartment is always better than our own. The grass is always greener on the other side of the fence, but we don't have green grass here, and we don't have fences. What we have are fishbowl-type windows that we look into so we can judge your life. Is it better? Is it worse? Our competitive streak is closely linked to our drive to do better. It's what gets us out of bed in the morning. It's what gets us to wait in line at sample sales in the pouring rain or to the gallery opening we have to attend. We're a greedy bunch when it comes to our time and our goals. A materialistic bunch, too, but also a determined one. Basically, we all just want cool stuff. And we want it now.

Gore Vidal once said, "Whenever a friend succeeds, a little something in me dies." We judge that success by where we live and what we own. Sometimes we're lucky enough to get to peek inside someone's apartment or house. We get to compare, and then we get to despair. Todd Selby has taken that luck and multiplied it thirty-two times.

I've known Todd for almost ten years. In fact, the second article I ever published was about him. It was something I wrote for *Vice* magazine. I had heard about a secret clothing company whose owners wouldn't give interviews and wouldn't reveal themselves. They were called "Imitation of Imitation of Christ," which everyone at the time thought was pure genius and really funny. Turns out it was just kind of a prank that William Eadon and his best friend, Todd Selby, set up. When I got to meet this "genius" in person, I found out we were the same age, twenty-three. He had a mess of curly hair, and wore a fanny pack and some sort of ironic Gucci sweatshirt. The year was 2001. None of us really knew what the hell was going on, and, meanwhile, Todd had figured out some way to make that work for him. I liked that, and we've been friends ever since.

Have you ever seen his apartment? I think he's had a few, but the one he currently lives in isn't that big a deal. It's great, don't get me wrong. It's a simple East Village studio. The perks include a clawfoot tub and a decorative fireplace. Big whoop.

One thing I can say about Todd that completely refutes my "envy" theory is that he never seems jealous or envious at all. In fact, Todd has always just been a hard worker. If he is competitive, we would only know it by his drive and ambition. Todd will always make time for a lunch meeting or just a fun casual hangout, although beneath the surface he is busy plotting his way to the top like the rest of us. Todd does it with a smile and a warm hug. I think that's a good thing. So while envy and competition keep someone like me tuned in to The Selby, fascinated with how the rest of the world enjoys their totally awesome lives (because everyone's place is totally better than mine, duh), Todd seems to have approached the project from a different place. A place of curiosity and celebration, and (sigh) fine, I guess, even love, too.

All of the subjects in The Selby want to be friends with you. They want you to see their cats, the weird ceramic sculptures they bought on the side of the road in West Virginia, their collection of Chanel shoes. And you *want* to see those things! The Selby has encouraged not only our inner voyeur, but also our inner exhibitionist. I think I can speak for everyone when I say that it feels fucking great.

When Todd asked to shoot me in my apartment, of course I agreed, but at the time I didn't realize how huge the project would turn out to be. I made a few mistakes. For starters,

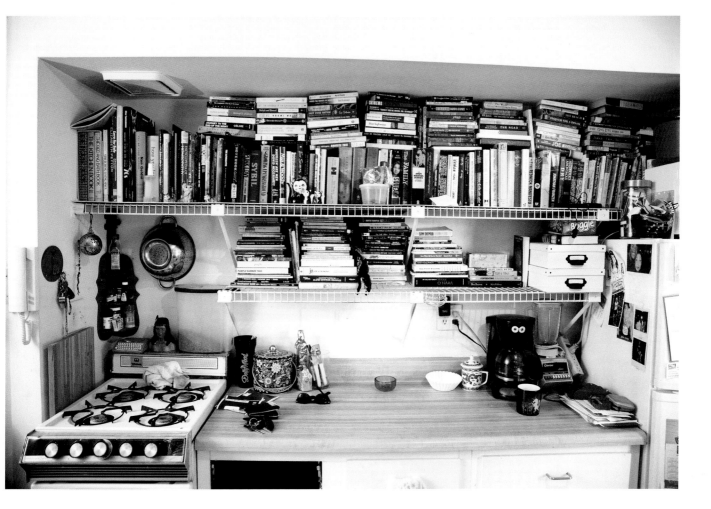

↑ Lesley's kitchen doubles as a storage facility.

lesley artin

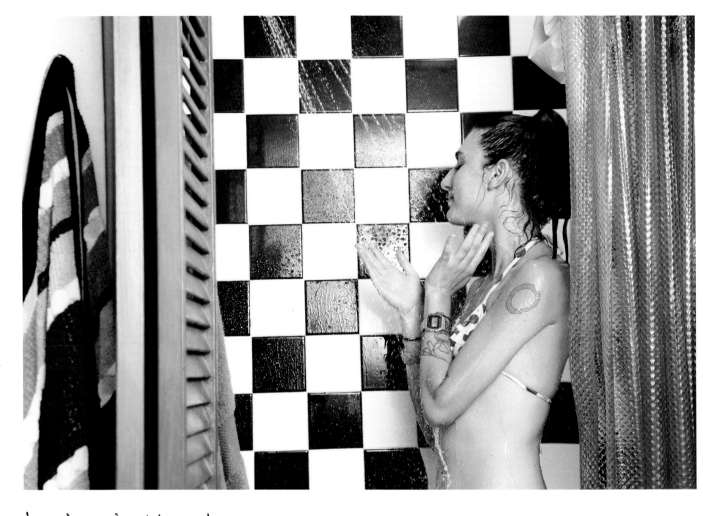

Lesley in the shower,
which happens to be in
the kitchen. NY living!

I didn't vacuum. (Why didn't I vacuum?!) I didn't realize my big red dress would be so big on me, my makeup was sparse, and I made a weird choice to get into the shower (???). I loved the pictures, but every time I see Todd I bug him to shoot me again. "I have new cool things!" I tell him. "New outfits! New furniture! I'll even vacuum!" I fight for a revisit, and he kind of just laughs. My whole thing is, because I crave everyone else's nest, I'm thinking that people absolutely need to crave mine. And the answers on my questionnaire—those can be better, too!

Like I said before, envy is the thread. And Todd has sewed us an entire wardrobe out of the stuff. But if envy is a sin, Todd has changed that, too. Looking through these images, you might find yourself feeling just a little more intimate with a person you've never met, and might never meet. But you know their stuff, you know their bedding,

and with each tiny object they've collected, you know them better, maybe better than some of your closest friends. So, yeah, I hate everyone in this book because I'm jealous, but I also kind of love them because they collect weird and sometimes even ugly things, just like me. There's hope in these pages. And that means there's hope in envy. And if there's hope in envy, I think it's safe to say there's hope in everything. And that everything starts in a very special place: home. It's where the heart is, after all.

Lesley Arfin

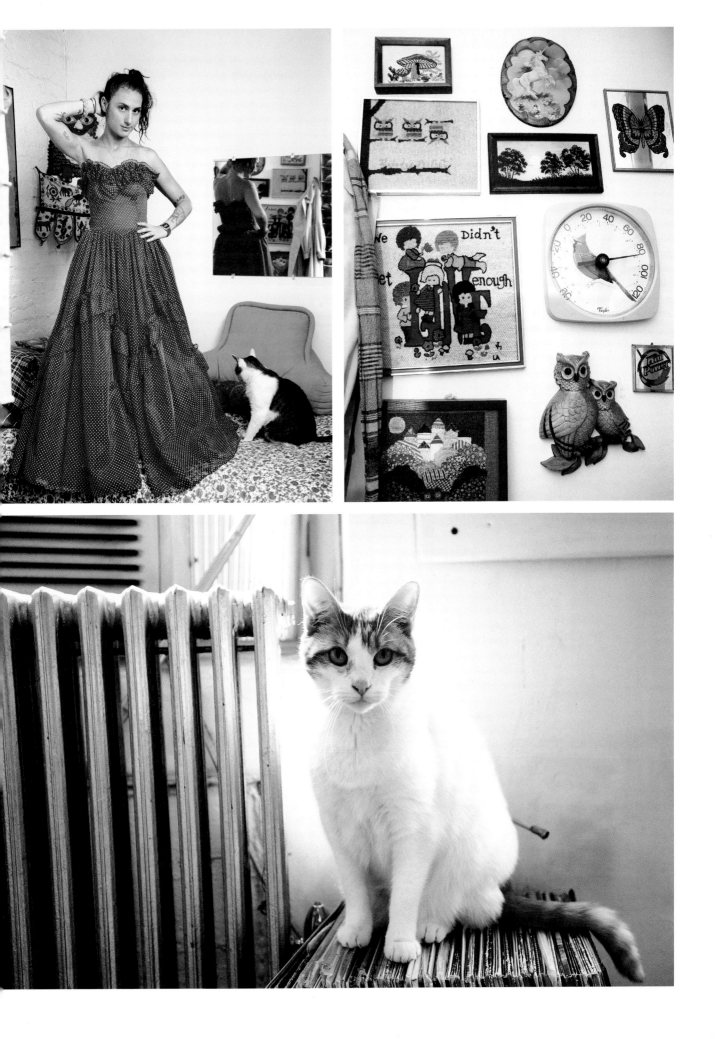

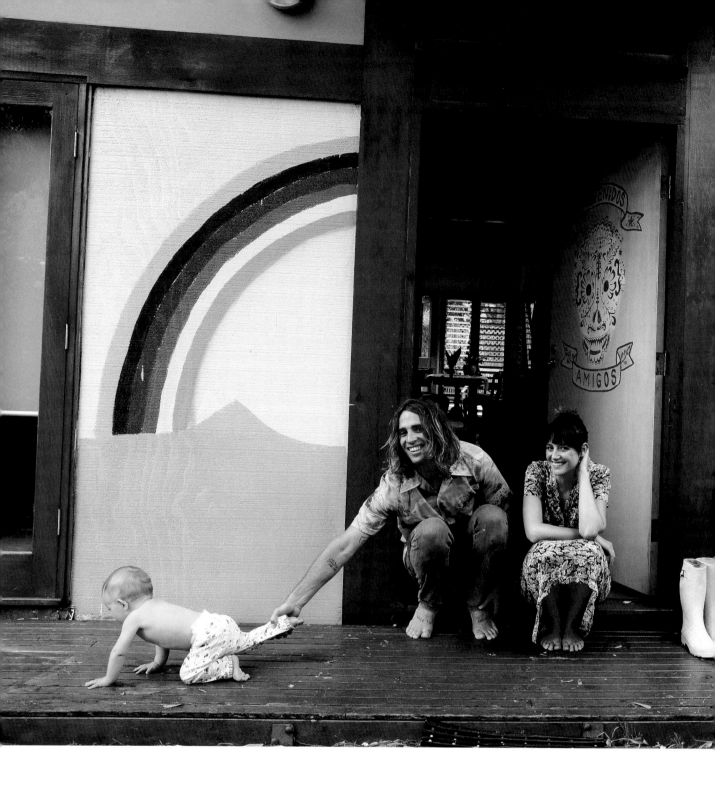

OZZIE IS A PRO SURFER who lives in Sydney with his family. He is also a super-talented artist. His wife, Mylee, serves as his muse and the inspiration for many of his drawings. Everywhere you look in their home you see Ozzie's artwork: a giant rainbow on the front door, painted surfboards, the pastel skate ramp in the backyard, and drawings on every wall. Their son, Rocky River, loves silk pajamas, fresh peaches, and skateboarding.

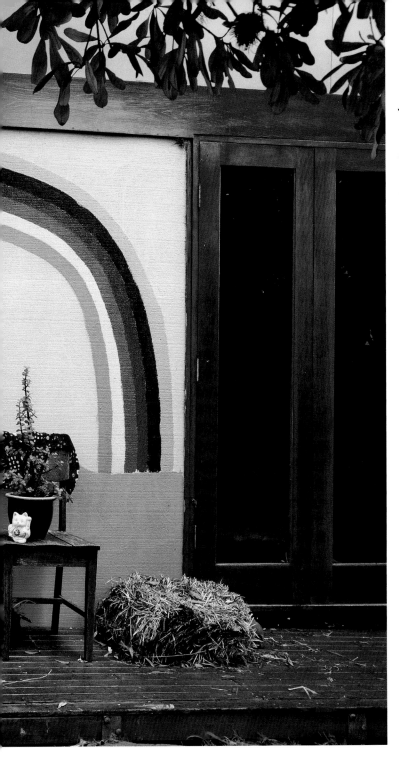

Ozzie and Mylee painted the rainbow to attract a colorful type of parrot known as the Rainbow Lorikeet.

ozzie wright

mylee fitzgerald

rocky river

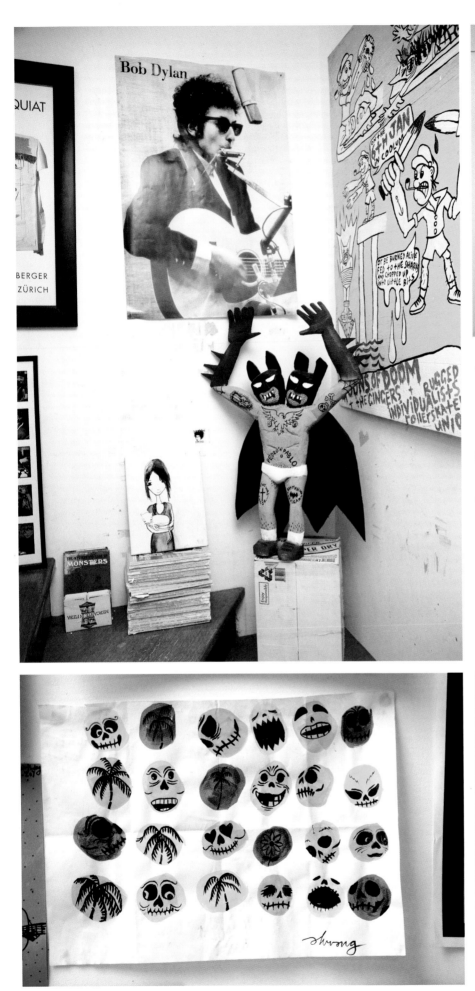

The office desk doubles as the phone book, which can make it a hassle to find a number.

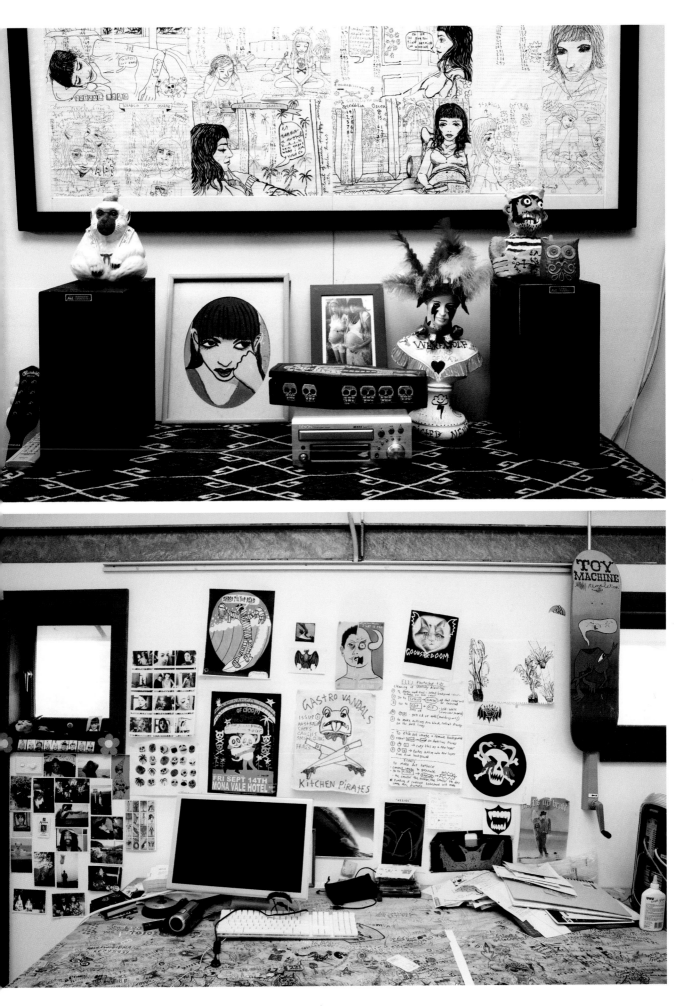

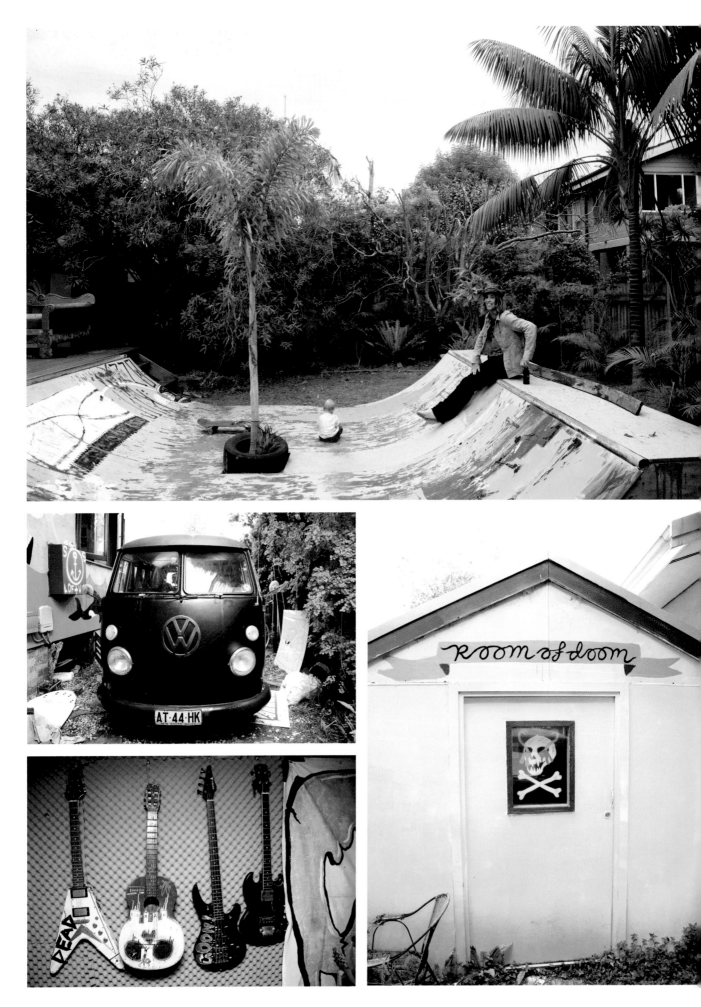

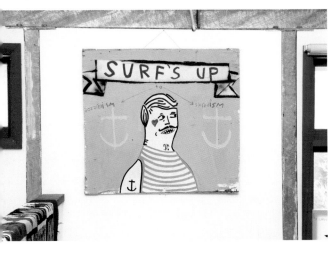

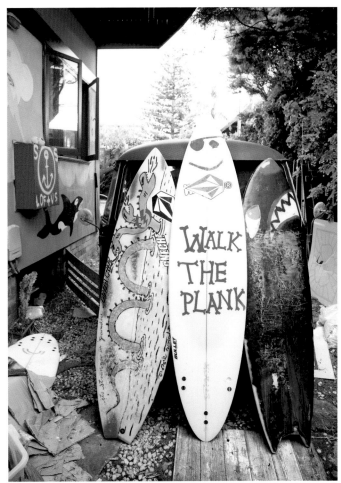

The backyard ramp finally got a hole, which was fixed with the strategic planting of a foxtail palm.
←

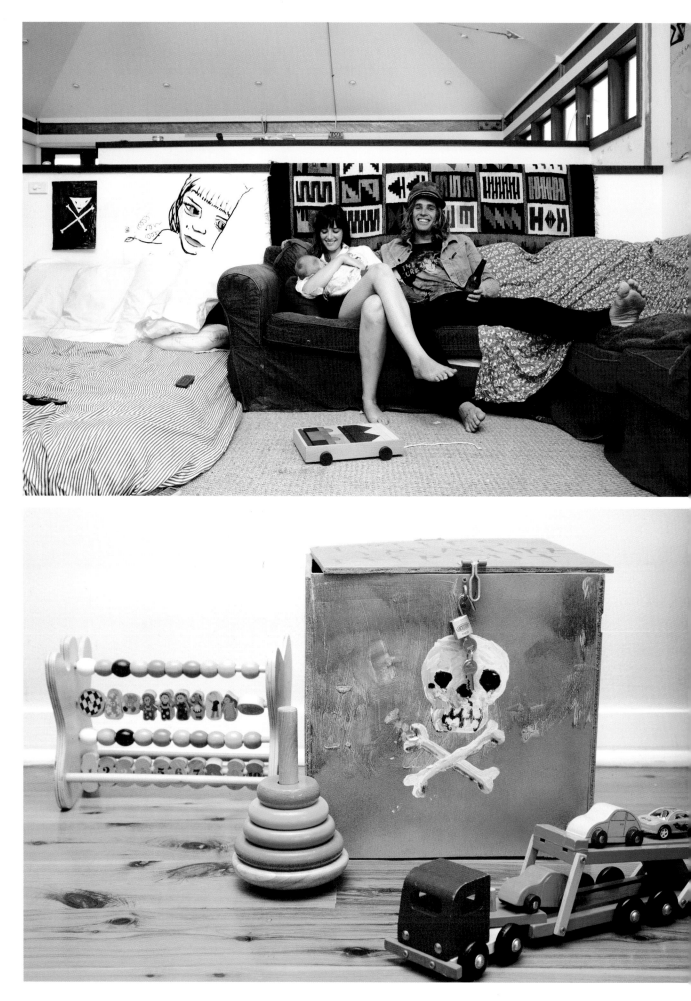

Hi Amalia, Oscar + Rocky, Oscar could you draw what Rocky looked like the day he was born)

Amalia can you draw what Oscar looked like the day you met him ↙

Oscar could you write some lyrics about your house ↓

in love land you can get a sore tongue by sayen love land all day long if you try really hard you can fly to the moon but its almost just as fun to lie in the SUN

Amalia tell me 4 funny things Rocky does

1 slap cuddles

2 yodeling

3 sings into the microphone
4 laughs at me

Oscar describe your best surfing moment →
Relaxing deep inside the perfect tubes that break on the coral reefs of indonesia come in and eat a nasi gereng special

Amalia what 6 things do you look forward to

1 life in the moment

2 having a bath

3 family cuddle

4 writing a hit song
5 Having a laugh

6 having a dance

Oscar draw a great white shark ↘

111

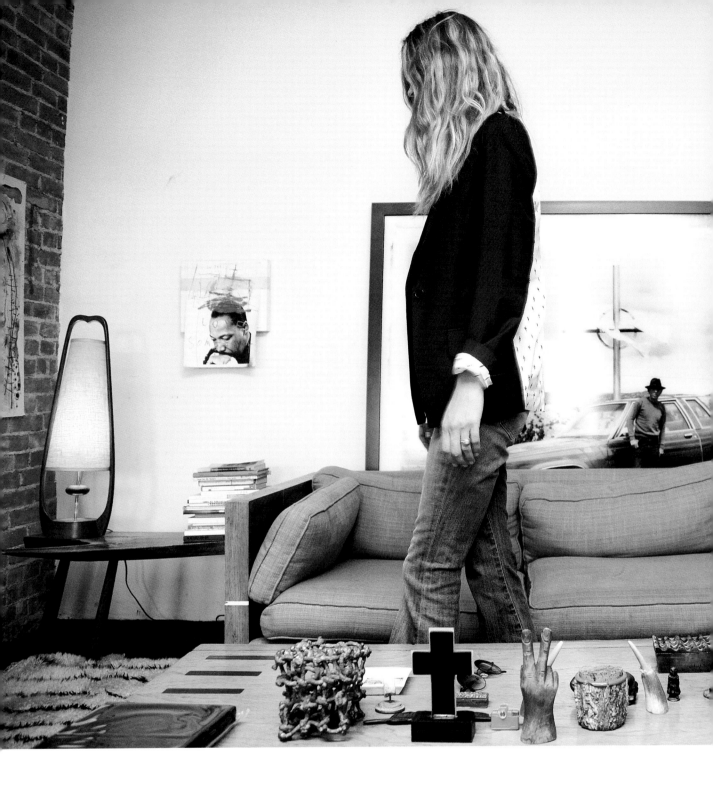

ERIN HAS BEEN A MUSE for the downtown hip set for both her fashion sense and bohemian lifestyle. She combines a sexy, assertive femininity with a rough urban vibe. She found almost all the furniture in her home on the street or in thrift stores. As a result, her space has an eclectic, lived-in, 1970s feel.

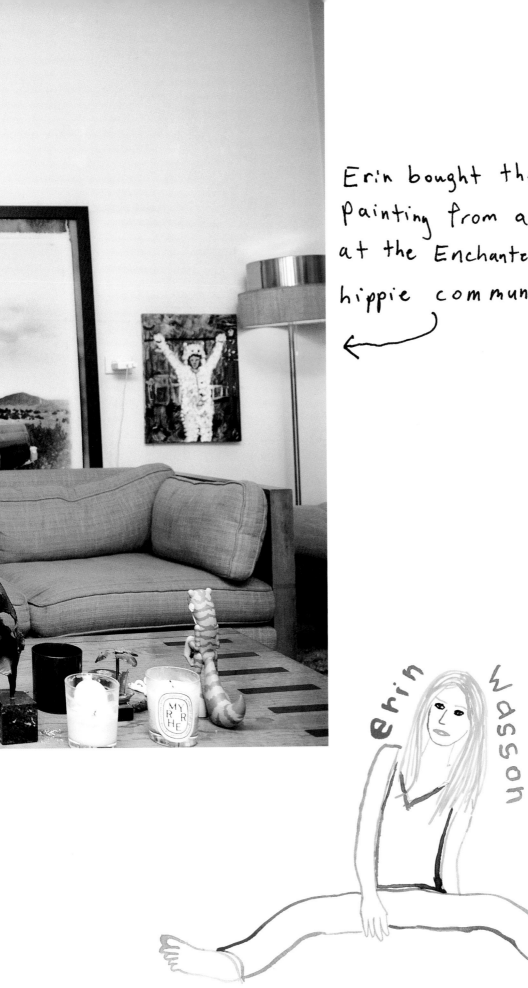

Erin bought the bunny suit painting from a guy in a tent at the Enchanted Forest hippie commune.

erin wasson

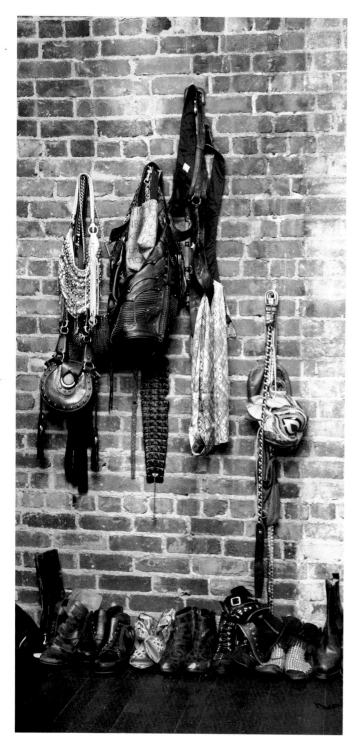

Erin sleeps with a spear above her head, a bat under the bed, and a whip hanging from the wall.

The bird is from a vintage store in Texas. ↘

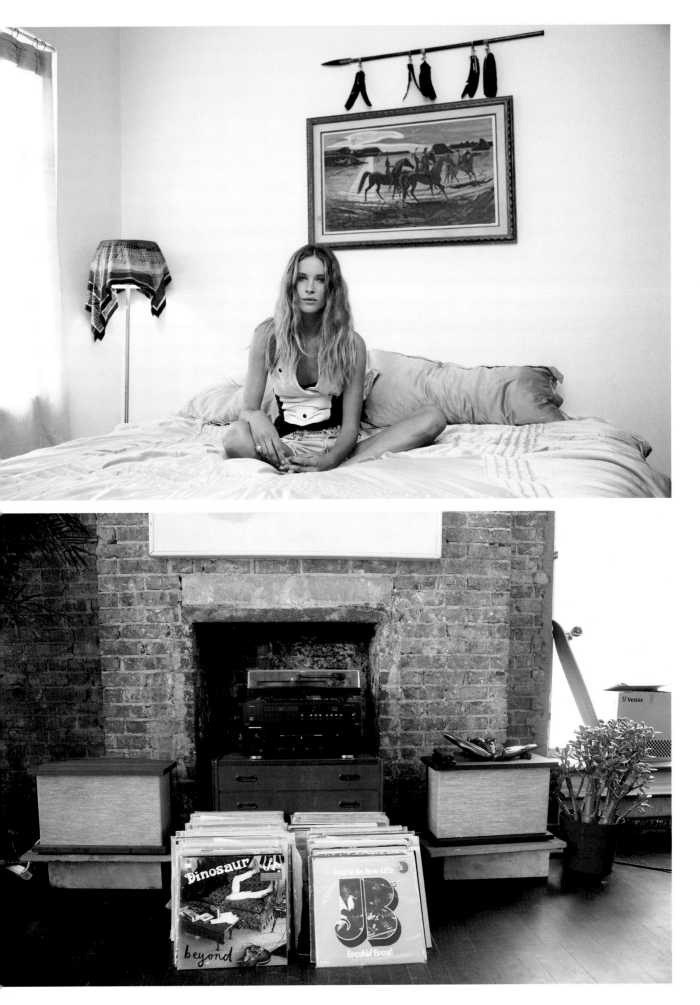

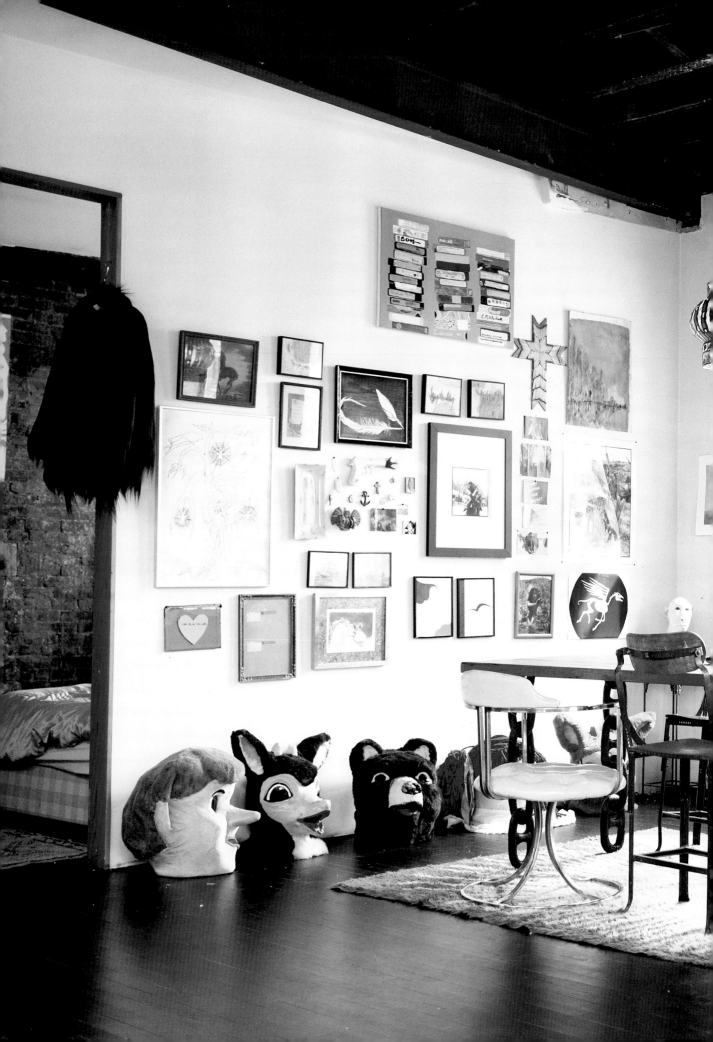

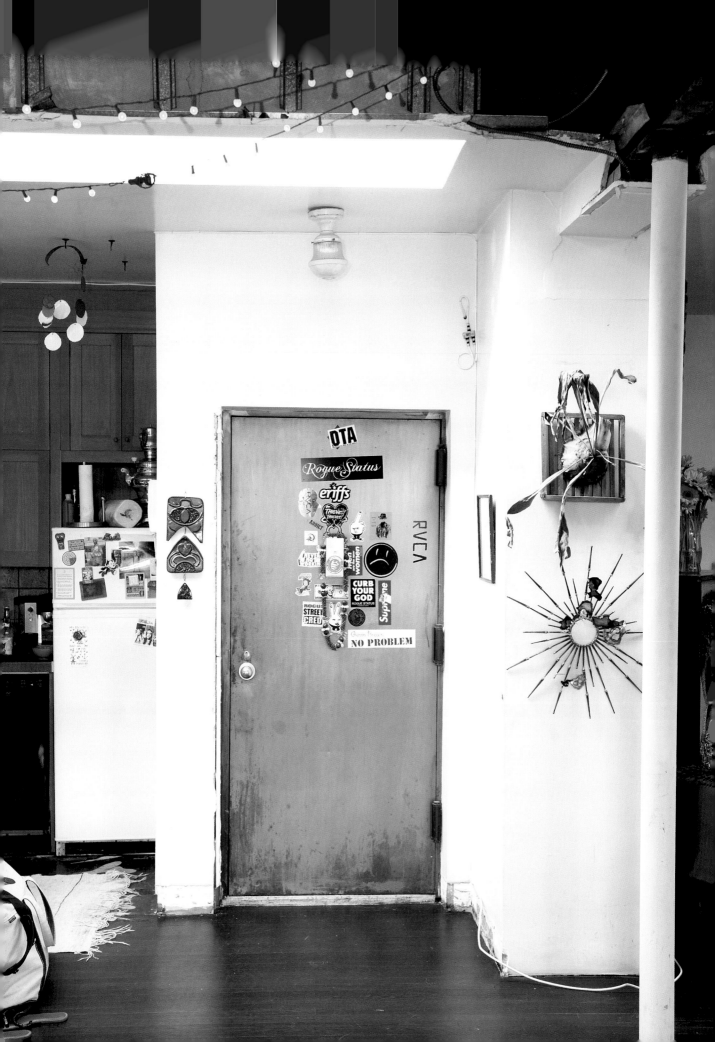

What are your five year goals?
 Barrel racing in Makewaoh, Maui
whats your favorite thing in your house?
 Amber lights
Erin whats your pet peeve?
 drunk people not realizing they're drunk
what was the last song you danced to?

 Augustus Pablo Jungle City
Draw Sara Glick here please

Who inspires you?
Go Getters
are there aliens?
All around
Thanks!
 —Todd

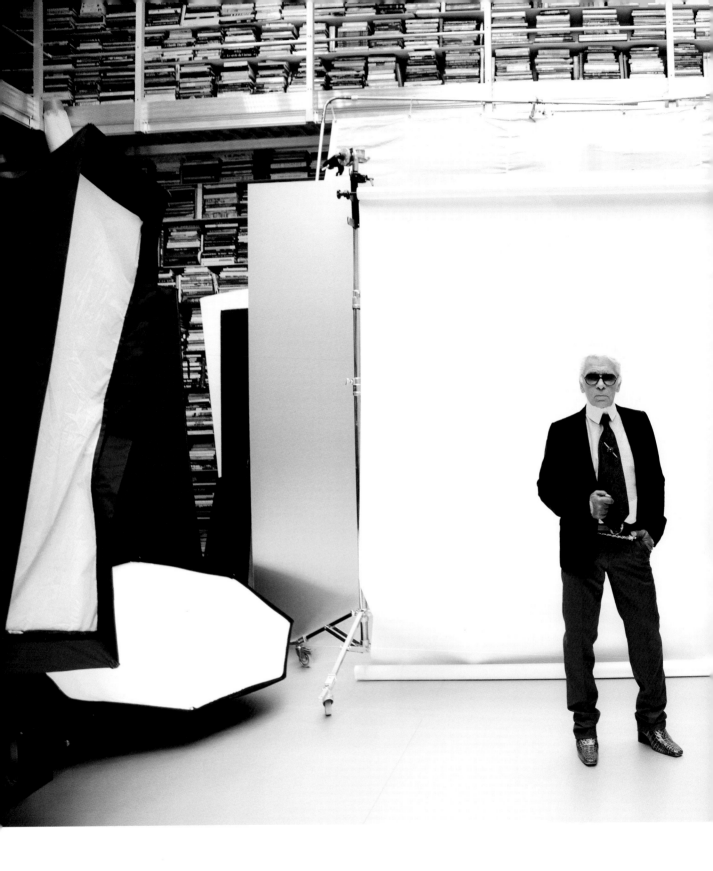

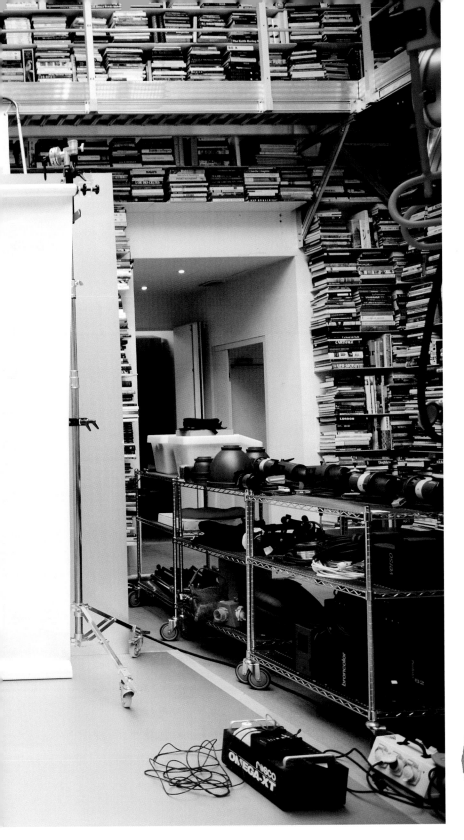

Karl lagerfeld

EVERYONE KNOWS THAT KARL is one of the top fashion designers in the world, but not many people know how much Karl loves books. His books cover every wall of his studio from the ground, up two stories, to the skylights. Plus he owns the bookstore that is right next door. And for someone who appears so untouchable, he is surprisingly funny and quick with wisecracks. Karl is the man.

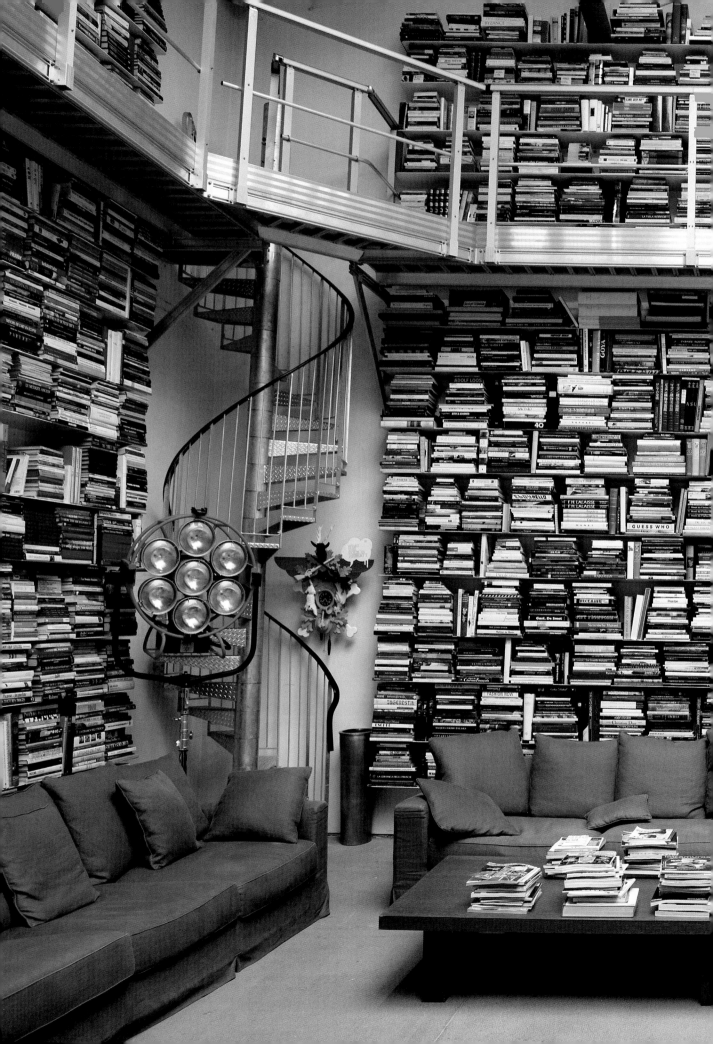

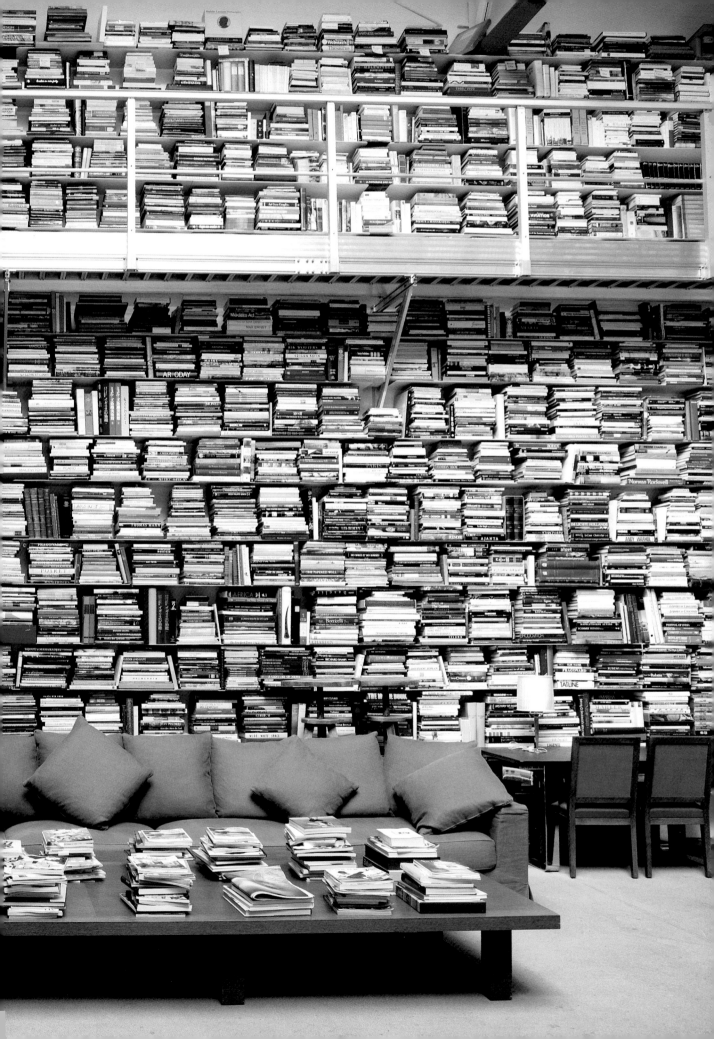

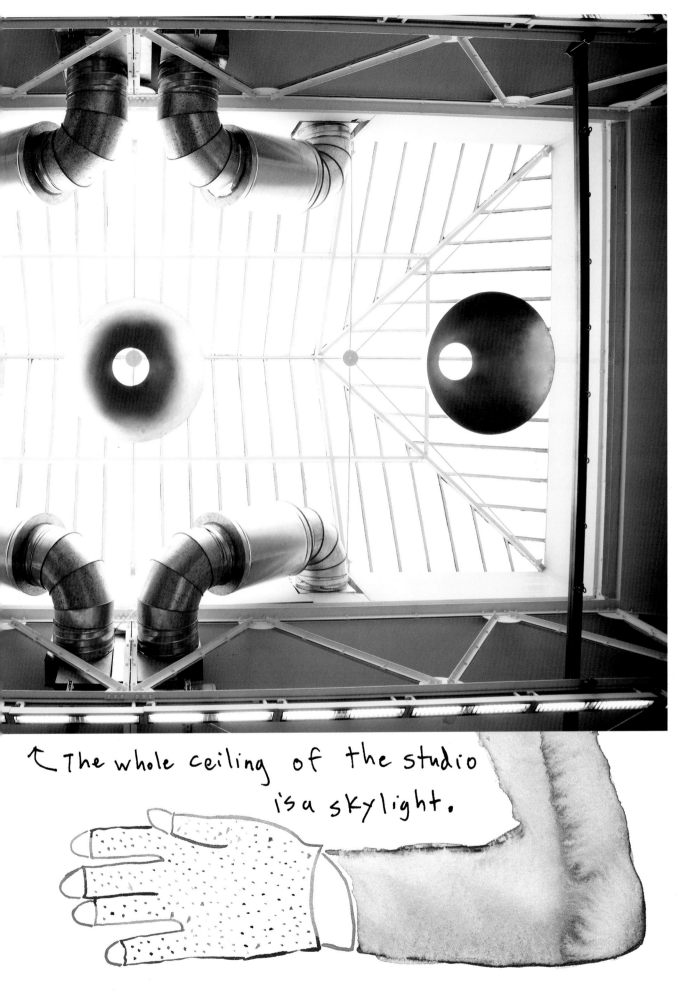

↖ The whole ceiling of the studio is a skylight.

Karl uses these makeup applicators to paint his illustrations.

Hi Karl! Karl what comes next?
Collections, collections, collection...
photo, photos, photos...
books, books, books

Could you draw me a design for a new jet?

the Concord as a private jet

Karl what does the future
smell like? I Hope it
will be a great
still unknown scent

What does it mean to be a fashion designer today?
The same thing as it meant to be all my life

what is your favorite Biography you have ever read?
Rilke's life by Raddatz (il just came out)

what 6 things define beauty in a woman?
① not only looks ④ not only expensive clothes
② not only youth ⑤ not only a brilliant conversation
③ not only style ⑥ not only sexyness

(could you draw a self portrait)

What drives you?
curiosity
the love of my jobs and
doing them in the great
conditions I can do them
in

Thanks!

van neistat

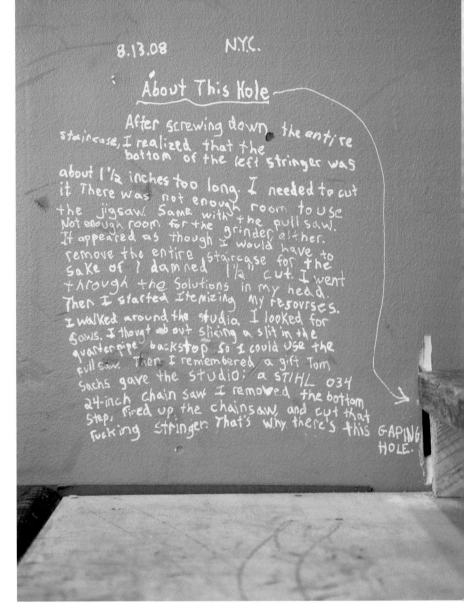

8.13.08 N.Y.C.

About This Hole

After screwing down the entire staircase, I realized that the bottom of the left stringer was about 1½ inches too long. I needed to cut it There was not enough room to use the jigsaw. Same with the pull saw. Not enough room for the grinder either. It appeared as though I would have to remove the entire staircase for the sake of 1 damned 1½" cut. I went through the solutions in my head. Then I started itemizing my resourses. I walked around the studio. I looked for saws. I thought about slicing a slit in the quarterpipe backstop so I could use the pull saw. Then I remembered a gift Tom Sachs gave the studio: a STIHL 034 24-inch chain saw. I removed the bottom step, fired up the chainsaw, and cut that fucking stringer. That's why there's this GAPING HOLE.

casey neistat

I FIRST SAW THE Neistat brothers' videos while shopping at colette in Paris. They did all sorts of crazy stunts, like locking their bikes around New York City and then using an axe to "steal" them in broad daylight. Their studio reflects their organized yet bizarre way of doing everything. All of the tools and supplies in their studio are stapled or taped together, perfectly labeled, and then neatly tucked away in their own little cubbyholes or designated stations. My favorite thing in their studio is the "Money Green" leather sofa with the lyrics of the Notorious B.I.G.'s song "Juicy" written on it.

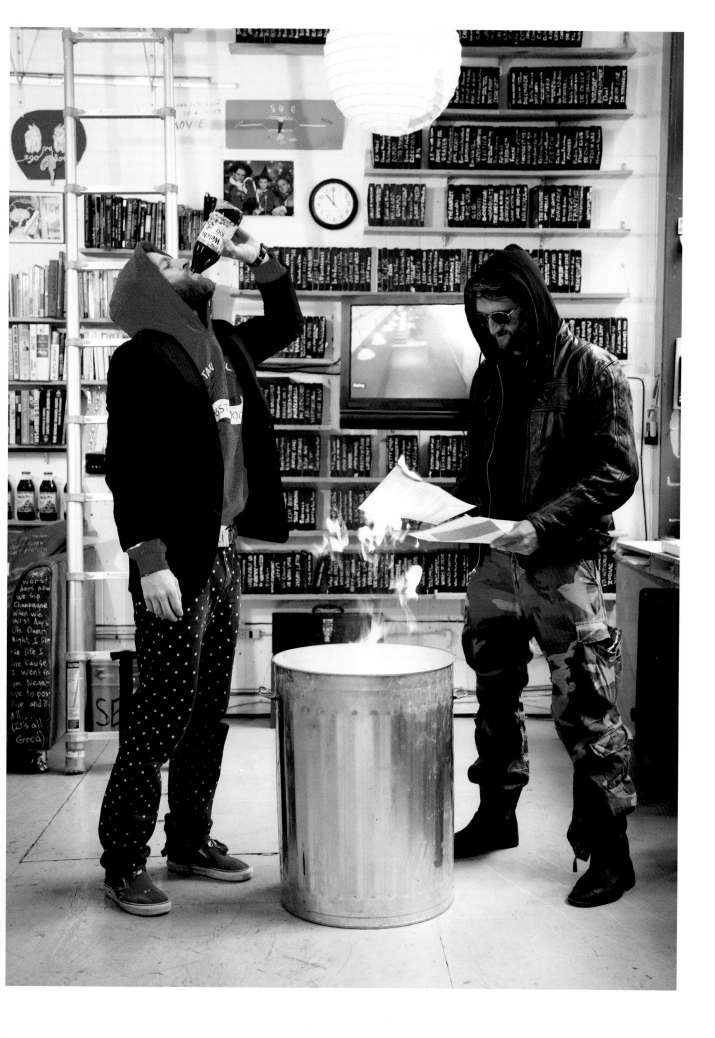

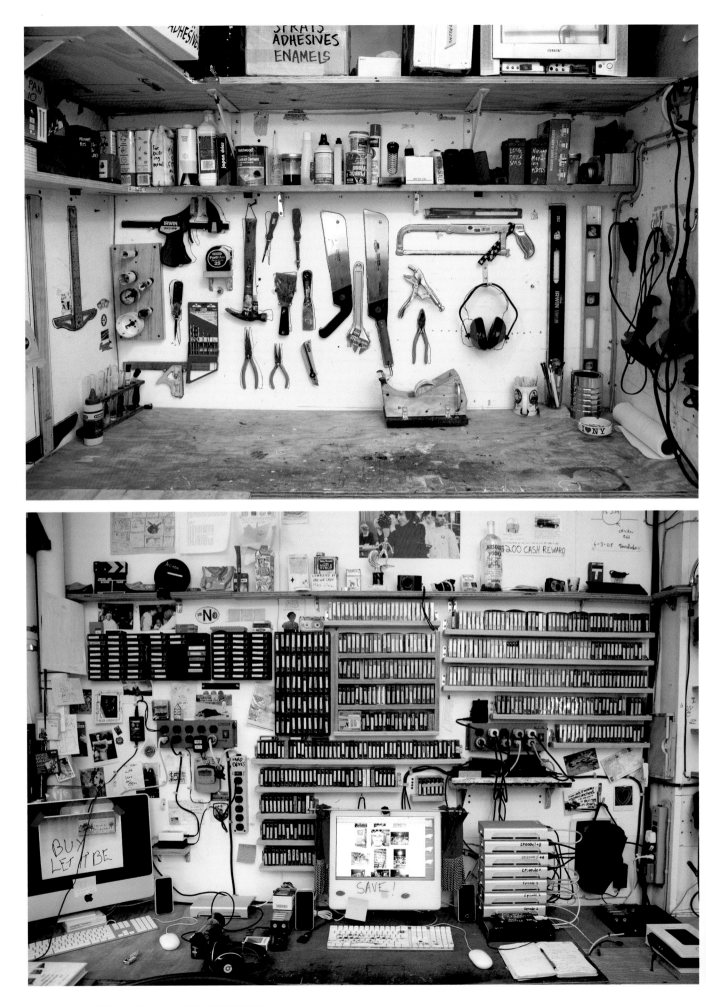

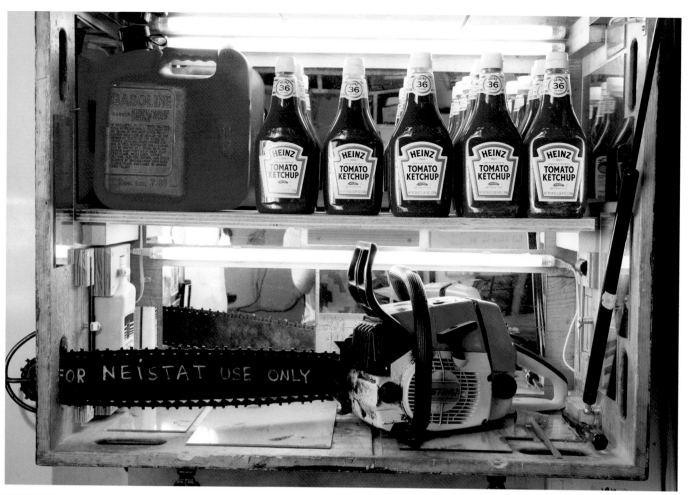

FOR NEISTAT USE ONLY

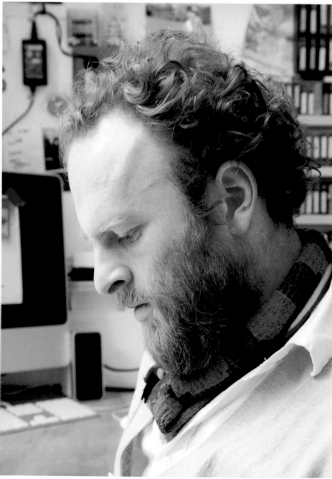

↖ A house warming gift from Tom Sachs. The chain saw does work and is considered part of the active Neistat tool collection.

Toast from the Mississippi Down to the East Coast Condos In Queens, Indo for weeks sold out seats to hear Biggie Smalls Speak Livin' Life Witout fear Puttin 5 Karats in My Baby Girl's Ears Lunches,

...ches, interviews By the pool Considered Stereotypes of a Black male misunderstood and Now you know nigga Super Nintendo Sega Genesis this 50-inch Screen, **MONEY GREEN**

Got 2 rides, a limousine and a Chauffeur My accountant handles that AND My whol...

Public housin' Thinkin' back on my one-room s... back And she loves to show me off of course Sn... used to fuss when the landlord dissed us No...

18K GOLD

Welch's 100%

LIFETIME

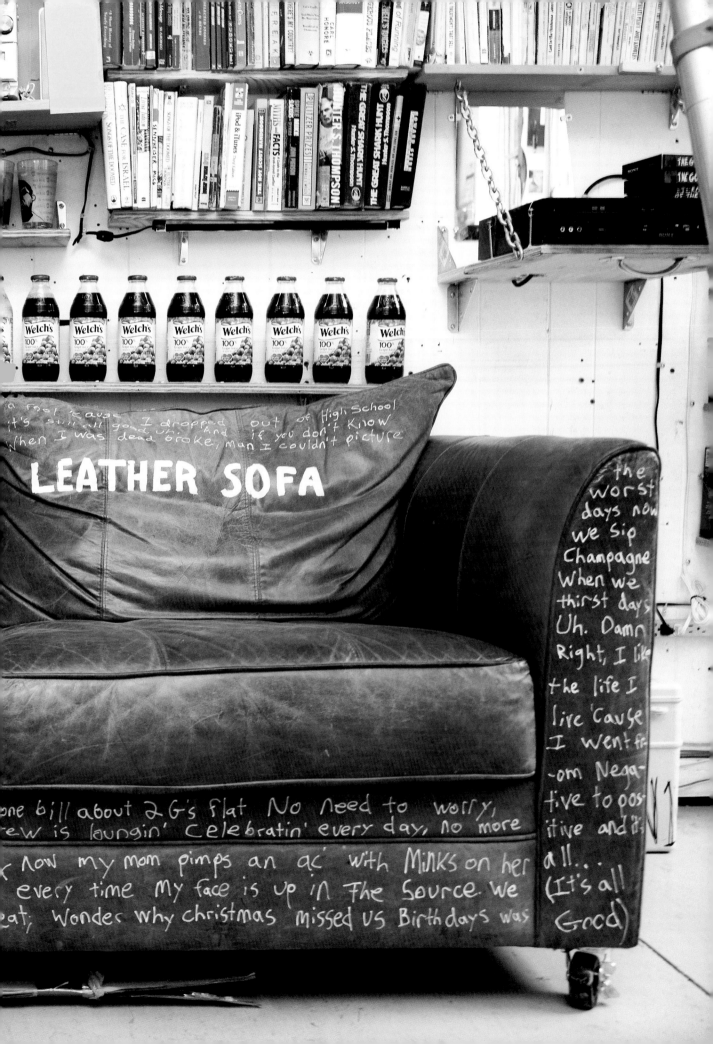

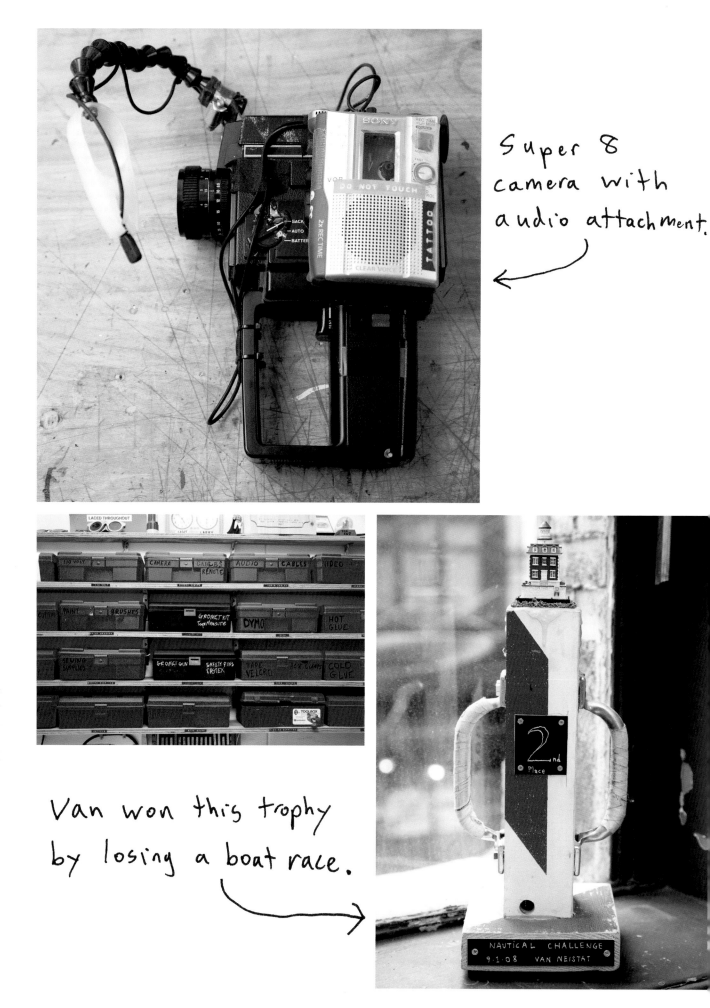

Super 8 camera with audio attachment.

Van won this trophy by losing a boat race.

Hi Casey + Van!

Van what ~~physical~~ challenges are you better at than Casey? Tool Maintenance

What ~~measures~~ do your challenges attempt to measure?
NOT so sure i understand the questions. i guess competition breads Motivation.

Casey draw van's beard

Van draw casey's beard →

Van what is your ideal day? Labor Day, the last day of summer. I rode my schwinn to work. In times square I ran into Yaniv and Katie on Yaniv's motorcycle. Then Brett, Josh, casey, Sam and I hit some golf balls at chelsea piers. Sam figured out how to rig the machine to get unlimited balls and he lost his club on the driving range. Josh stripped down to his boxers and ran through a fountain on the west side Highway. We went to tompkins squared park and Had a fence- walking contest. Met Mickey and Rel for dinner. Then we rode to casey's. mickey pedaled and casey steered. We had dessert on the way. my cheese cake was the best. We played guitar hero and sam beat 3 songs on expert. Ride home. sex with a beautiful girl.

Casey what is it that you try to do with your work? NO TRY. ONLY DO

Van what are some rules of your studio? 1. No Flat Head screws 2. If you borrow a tool and I don't have it back when I need it, you lose your Borrowing privileges. 3. No one uses my private stash tools. 4. Clean up your mess. 4. Garbage taken out every day. 5. 1 person picks up lunch, the other picks out the movie to watch. 6. Replace if you use the last one. 7. Avoid purple. 8. Pencil Jar fully stocked at all times 8. Half pipe can only be ridden after 9. Be Nice to the photographers.

philip smiley

abigail smiley-smith

willy hops

I MET ABI AND Phil in 2001 at an electronic music festival in New York. Abi was wearing a white tutu, and Phil was rocking out on the bass. In addition to their music, Abi is a fashion designer and Phil is an illustrator and sculptor. In 2002 they left New York, moved to East London, and bought a three-story house with a big backyard so their rabbit, Willy Hops, could get some exercise. The house is filled with thrift store finds, Phil's art, and random bric-a-brac. I always stay in their basement when I visit London, and at night Willy Hops comes downstairs and humps a soccer ball while I am trying to sleep.

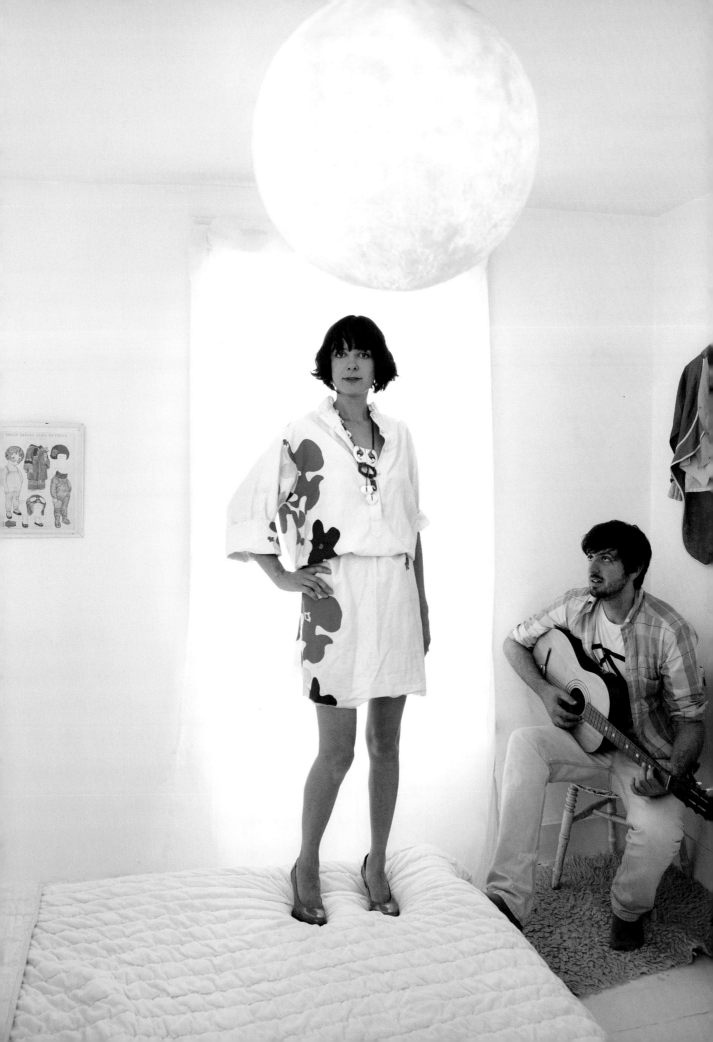

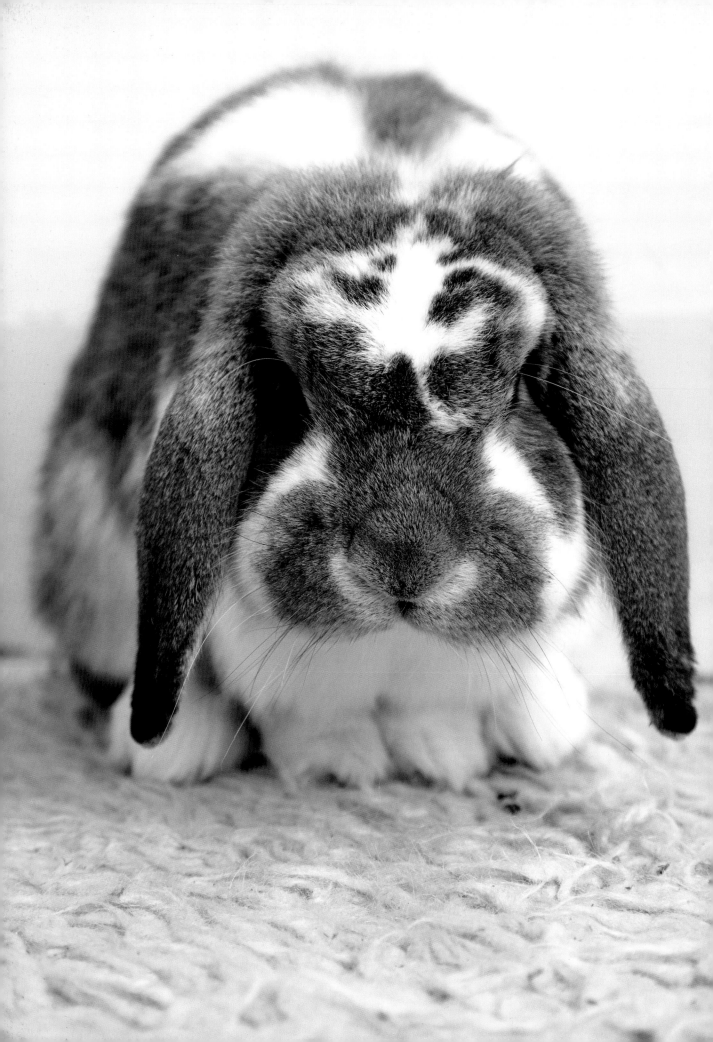

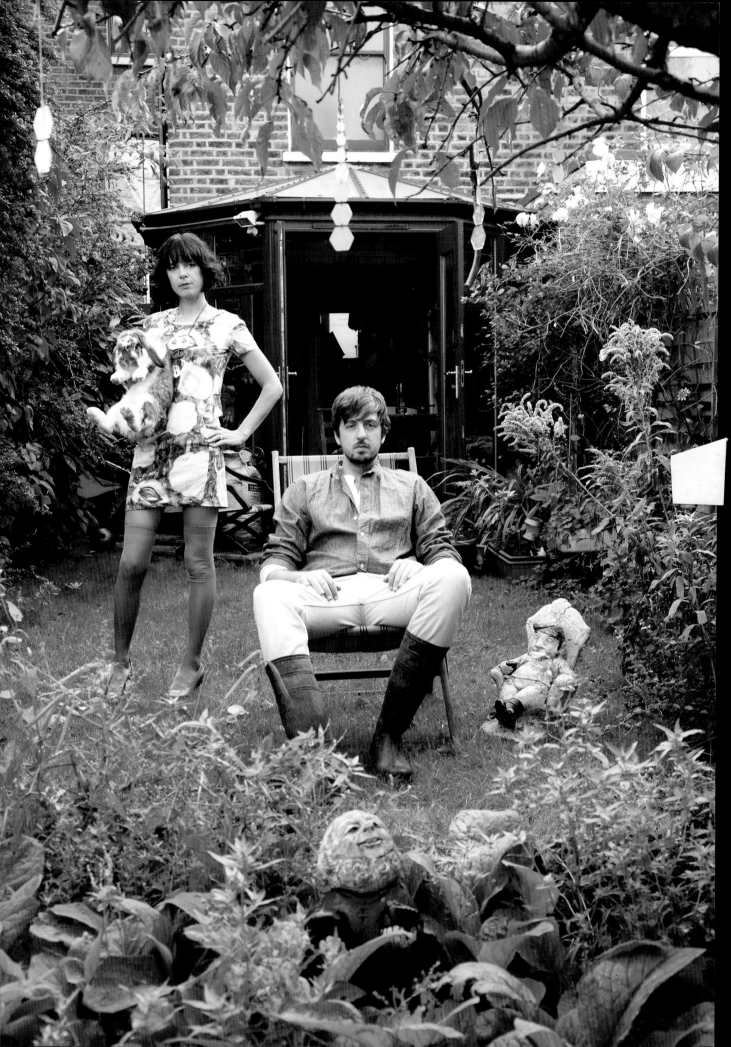

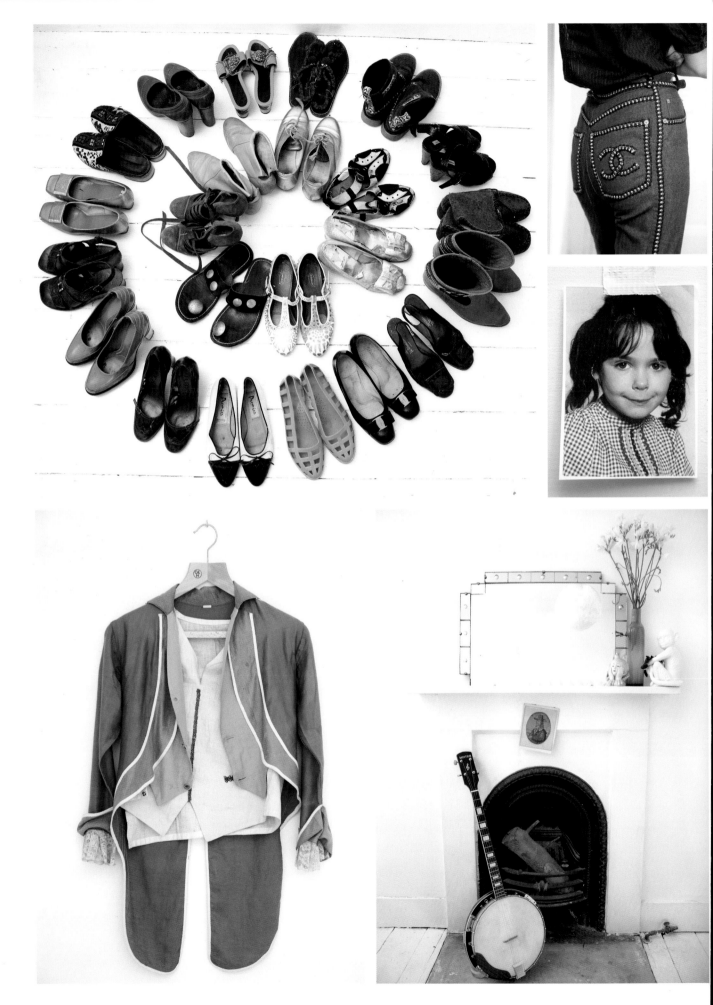

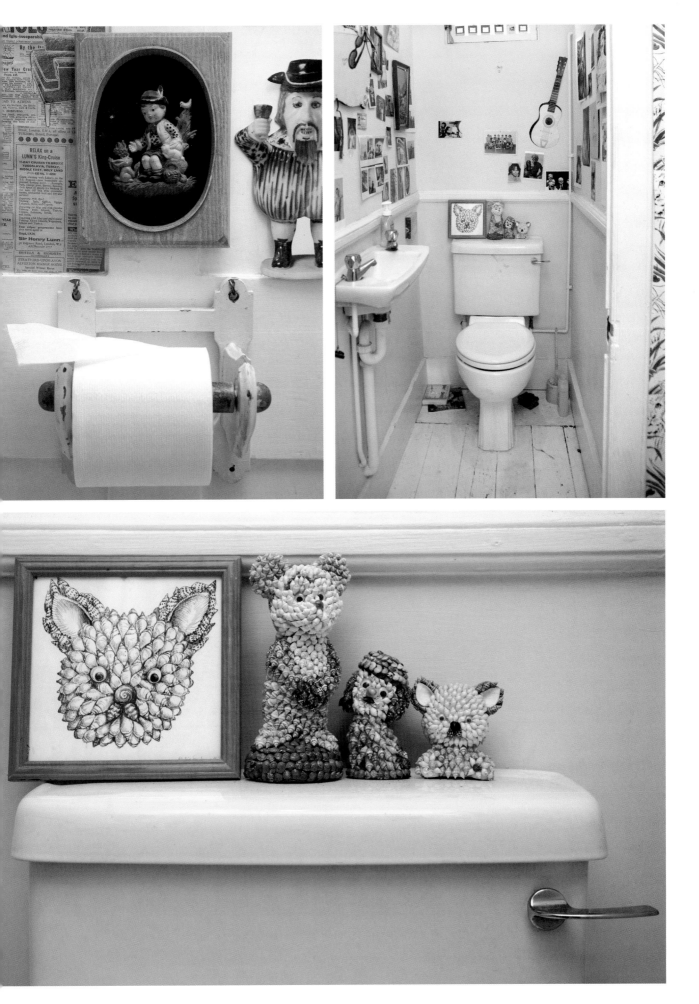

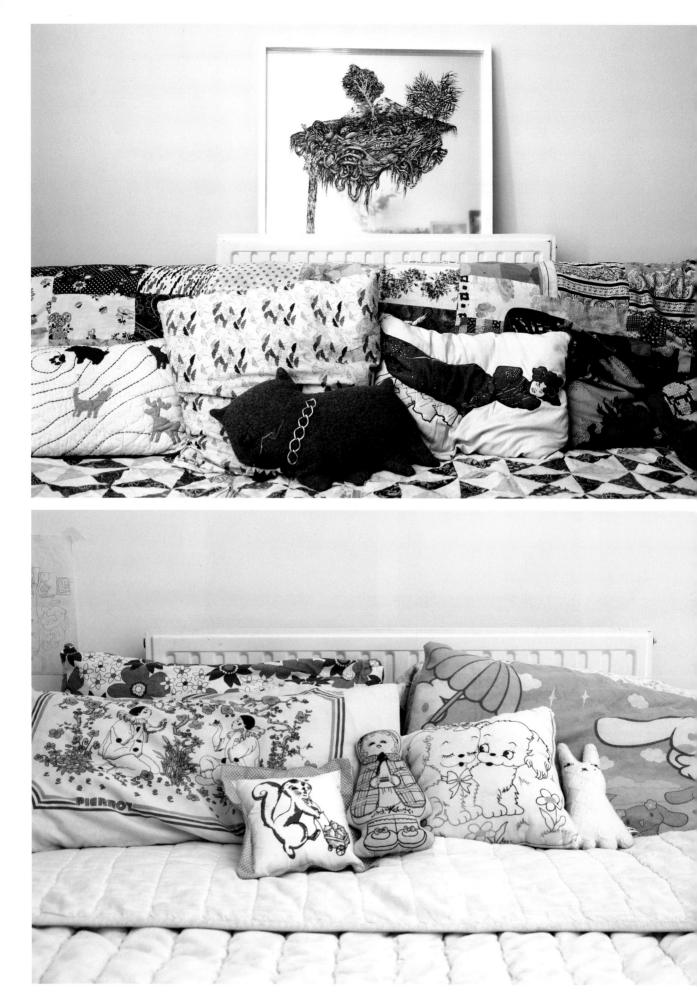

Hey abi and Phil!
Abi what do you miss about NY? 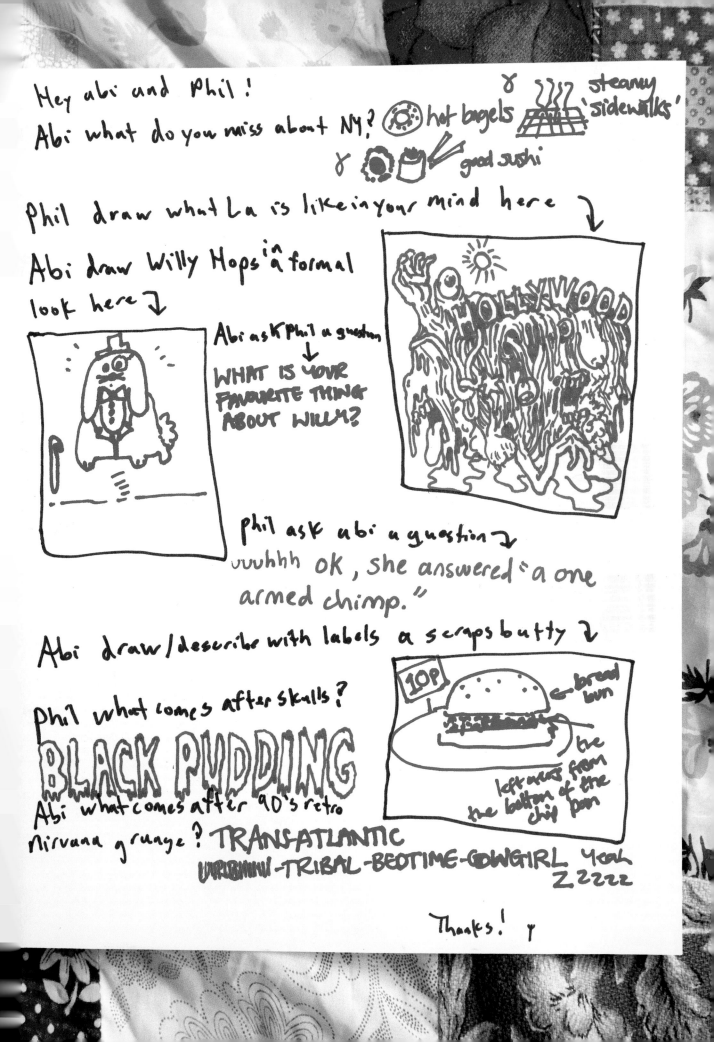 hot bagels — steamy 'sidewalks'
good sushi

Phil draw what La is like in your mind here ↓

Abi draw Willy Hops in a formal
look here ↓

Abi ask Phil a question
↓
WHAT IS YOUR
FAVOURITE THING
ABOUT WILLY?

Phil ask abi a question ↗
uuuhhh OK, she answered "a one
armed chimp."

Abi draw/describe with labels a scraps butty ↗
10P
← bread bun
the leftovers from the bottom of the chip pan

Phil what comes after skulls?
BLACK PUDDING
Abi what comes after 90's retro
nirvana grunge? TRANSATLANTIC
UURBMMM -TRIBAL -BEDTIME -COWGIRL yeah
zzzzz

Thanks! ૪

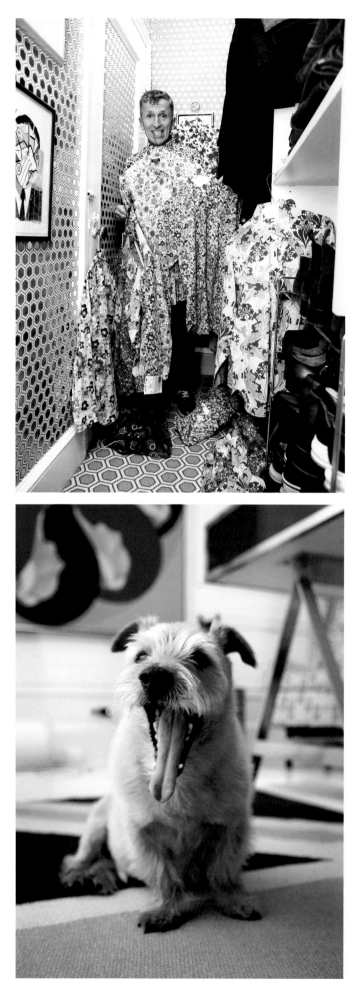

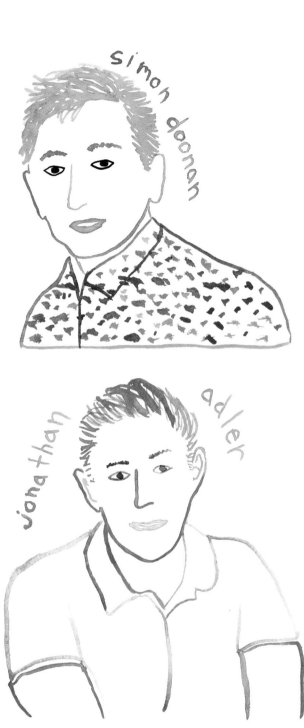

SIMON IS CREATIVE DIRECTOR at Barneys New York and the funniest fashion commentator out there. Jonathan is the most successful potter/interior decorator in the world. Together they make the cutest and kitschiest power couple ever. Their home is two apartments combined into one hyper-art-directed 70s shag pad taken to the next level.

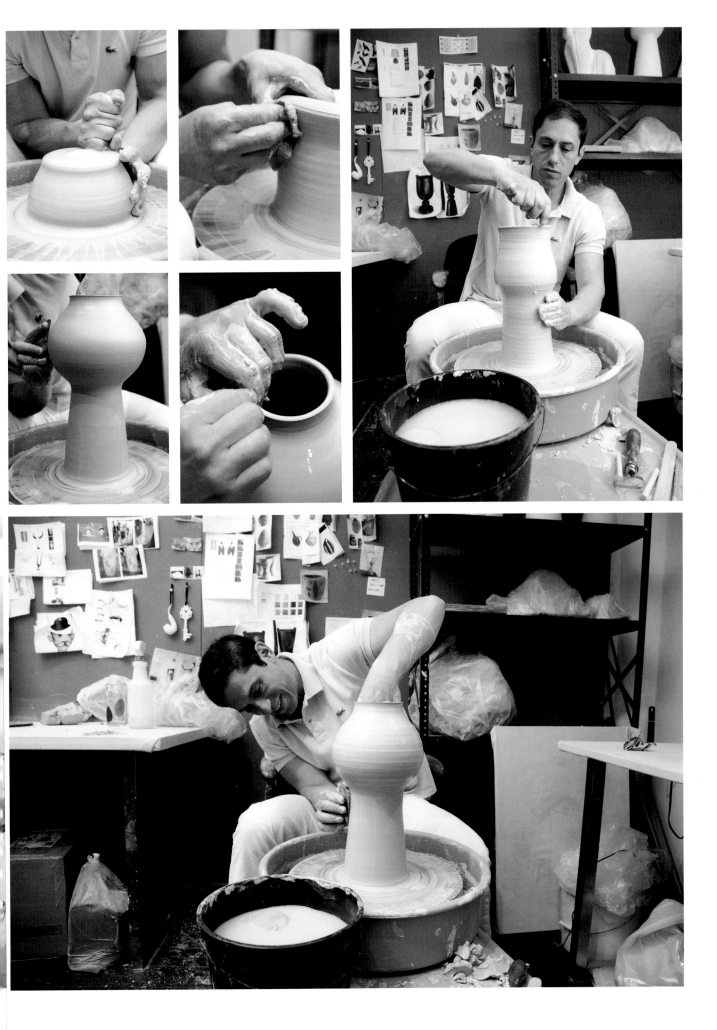

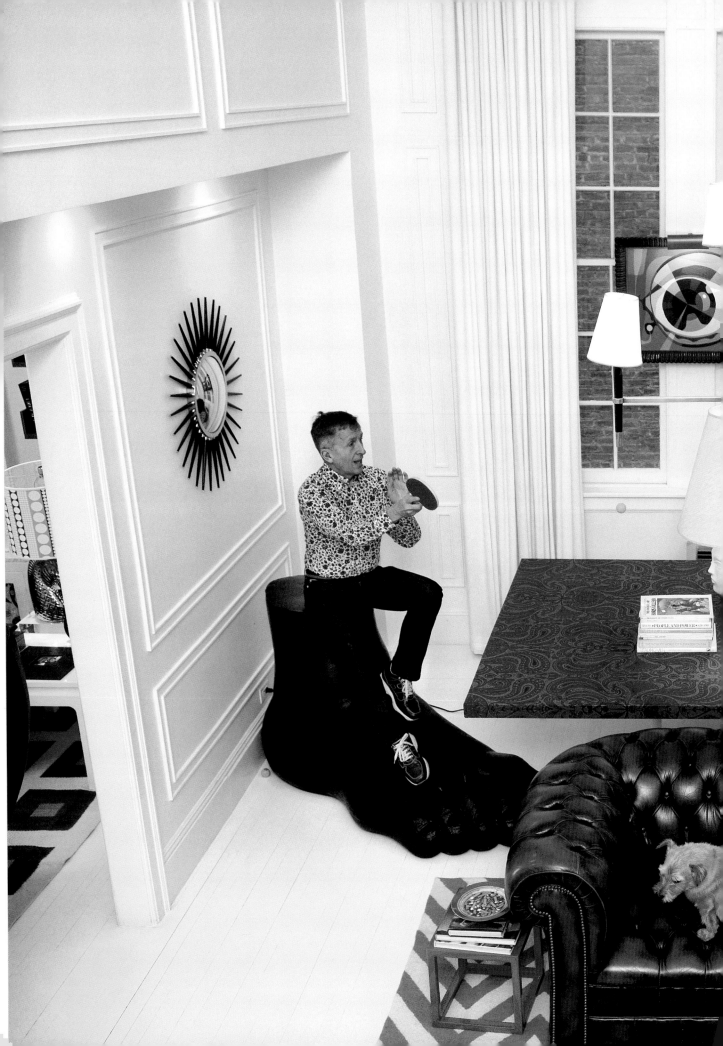

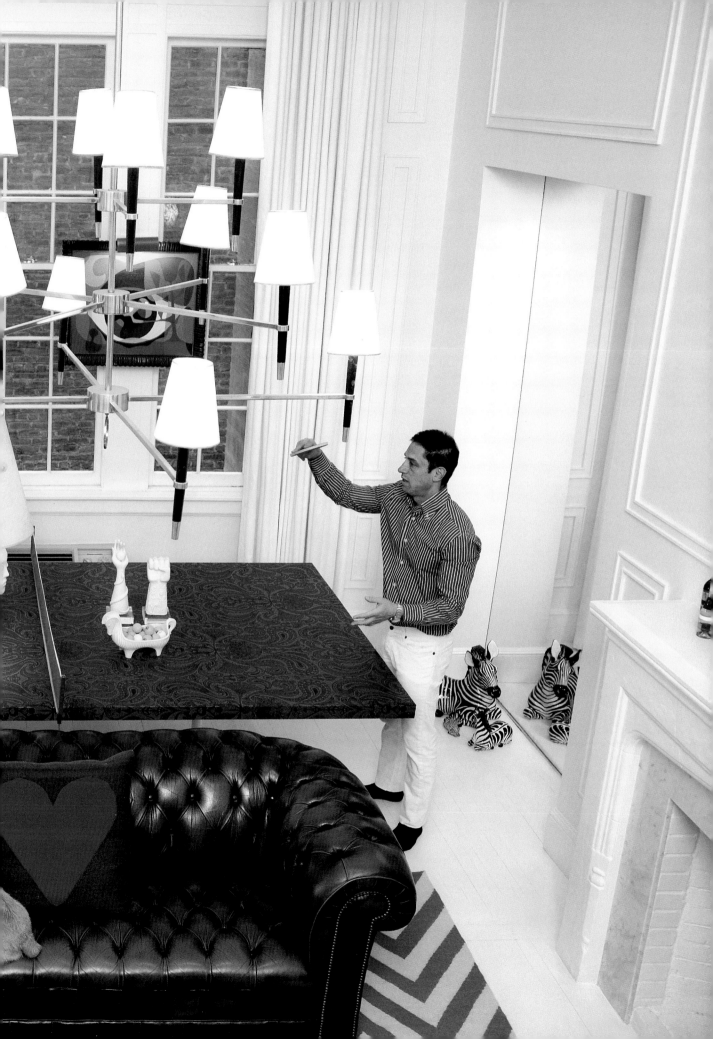

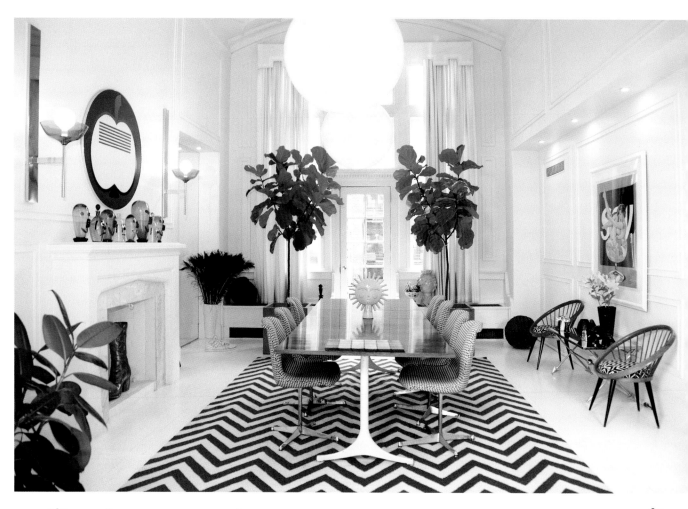

The far side of the dining room has a balcony just↱ large enough for one person to stand on.

The photo on the previous spread is extra chic as they are playing ping-pong on a fully accessorized table.

One of Simon's custom shirts. ↵

Hi Simon + Jonathan! Jonathan could you design a Simon vase?

Simon could you design a window display inspired by "advertising"

Jonathan what are your top 6 concepts that you apply to your interior design work?

I like putting shoes on

girl's heads.....

① YOUR HOME SHOULD MAKE YOU HAPPY!
② CLASSICAL FOUNDATION PLAYFUL PUNCTUATION
③ WIVES HAVE BETTER TASTE THAN HUSBANDS
④ ECCENTRICITY ALWAYS
⑤ BE MEMORABLE!
⑥ COLOR!

Simon what is authenticity?

Authenticity is never having to say you're SORRY.

Jonathan what is good taste? GOOD TASTE IS THE STUFF YOU LOVE ♡ + NOT CARING WHAT ANYBODY ELSE THINKS....

Simon could you describe your first date with Jonathan?

Jonny has cute eyes + nice eyebrows. I kept staring at his eyebrows. Maybe he thought I was creepy.

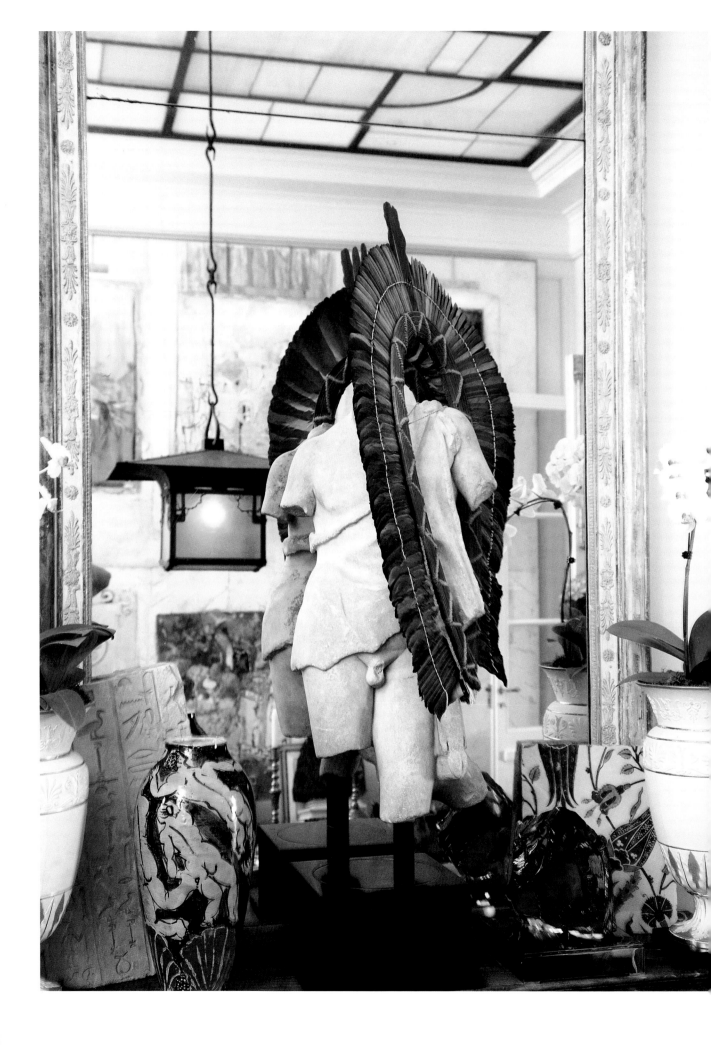

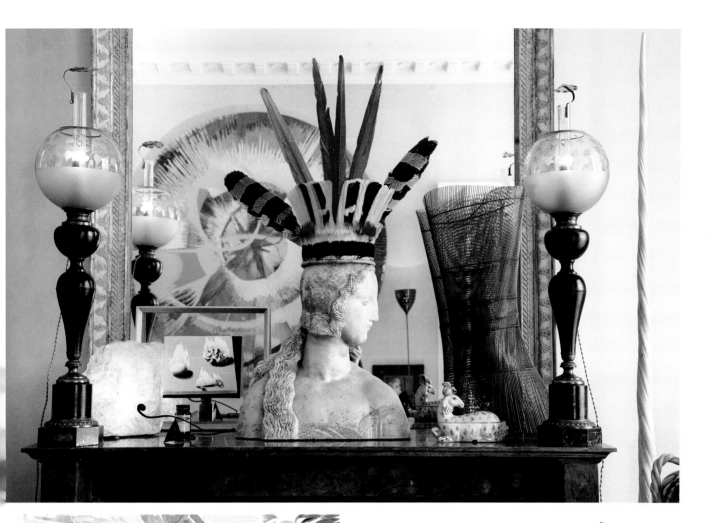

Narwhal tusk. →

jacques grange

JACQUES IS AN INTERIOR architect who doesn't just decorate
spaces, he art directs them. His playful style includes a love of
antiquities, modern art, bright colors, wild textures, and a mixture
of the high and low. He lives in the famous author Colette's old
apartment in Paris near the Louvre. Jacques's home contains ancient
Greek sculptures, porcelain cabbages, a giant narwhal tusk, Andy
Warhol Polaroids, and feather headdresses all juxtaposed in such
a way that somehow it all works perfectly together.

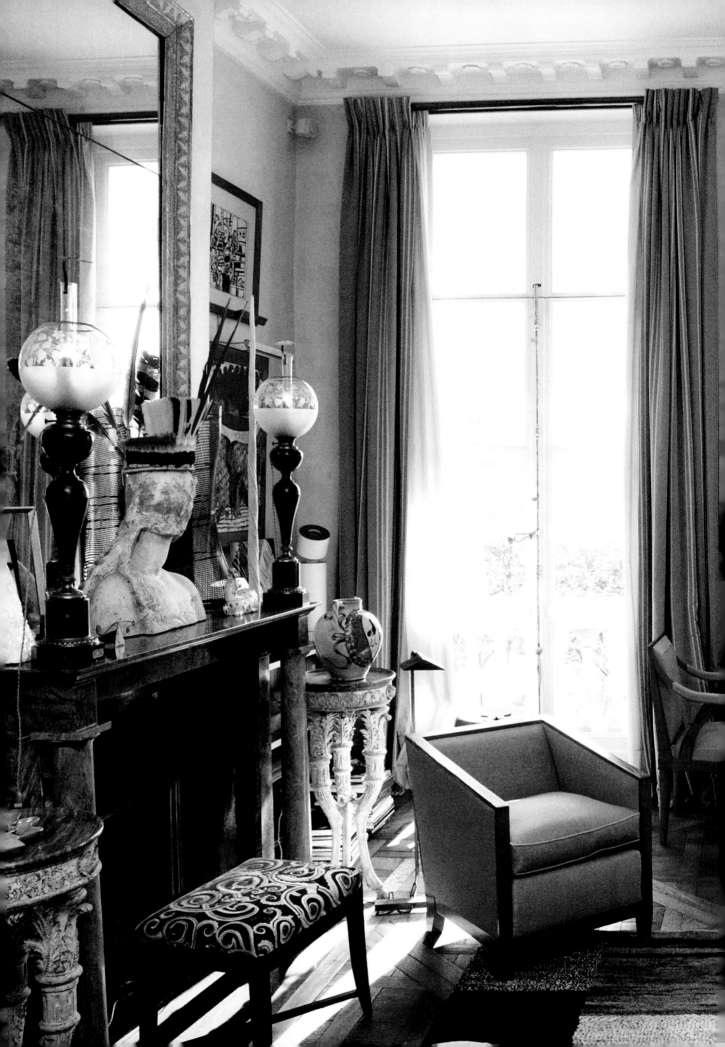

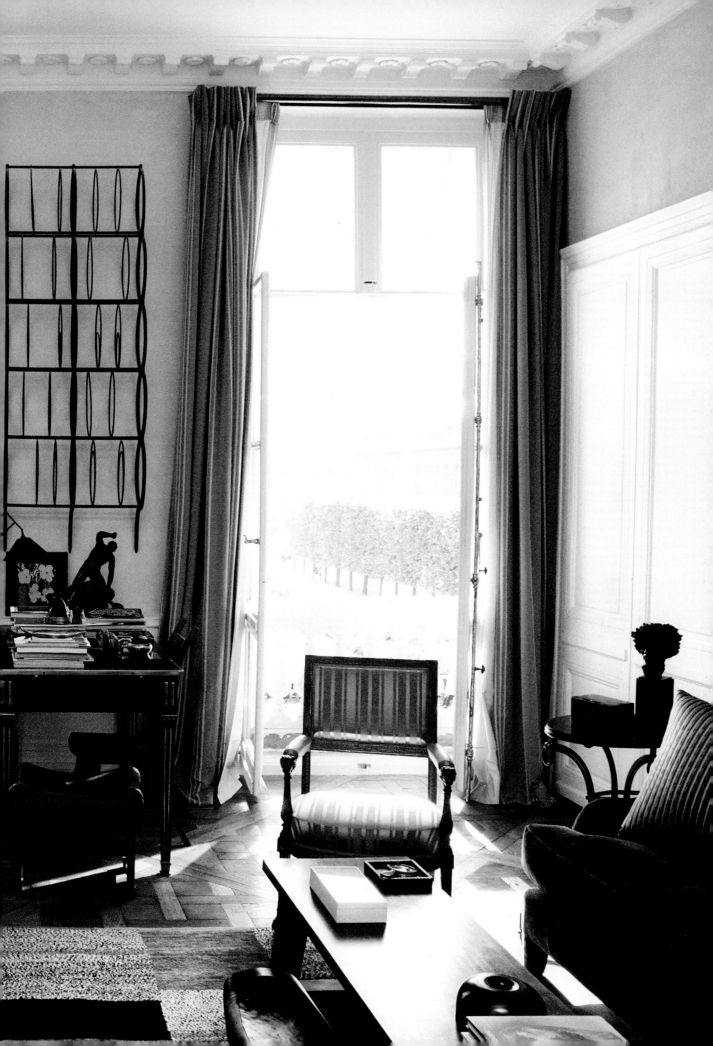

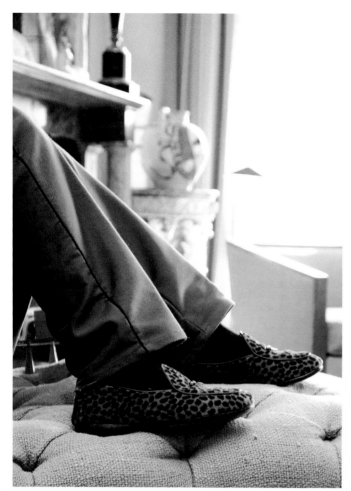

Jacques's leopard-print house slippers.

Marilyn Monroe's bottle of sleeping pills is on the right page. →

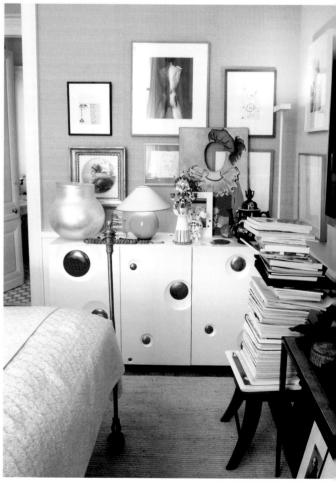

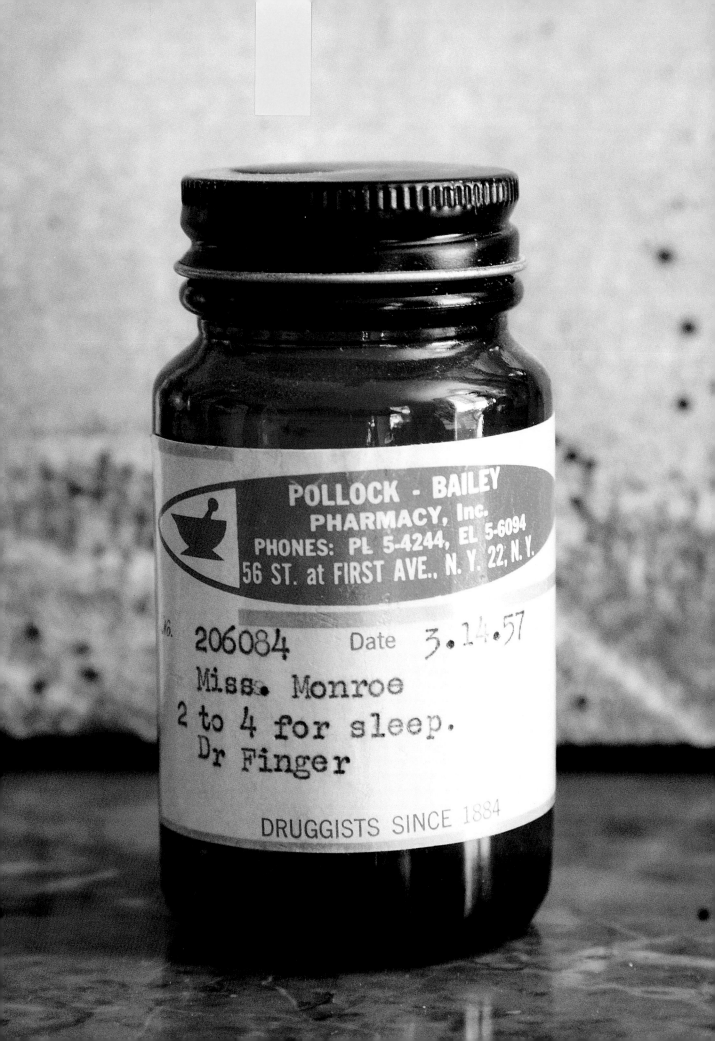

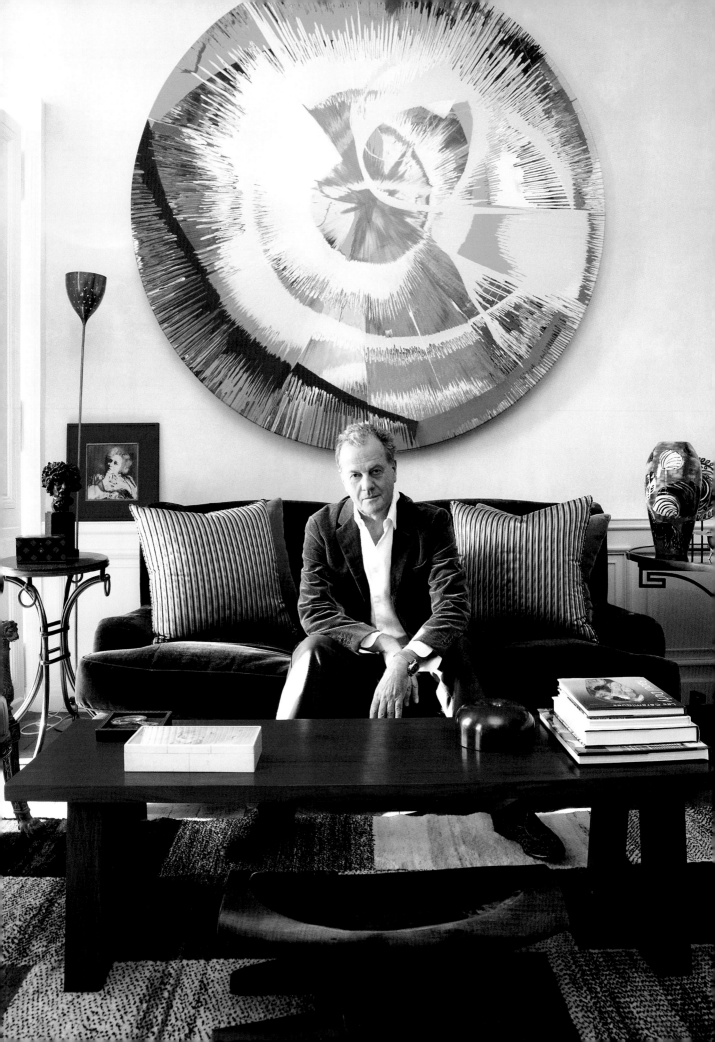

monsieur Grange what was the last artwork you
have seen that has really inspired you?
Picasso and the master. Because that is timeless
What are your favorite colors? Some gold yellow honey
. Blue sky. For the moment

what is the key to good interior design?
elegance comfort simplicity. location location
who was your biggest influence when you were
just starting out? Marie Laure de Noailles house
in Paris . Italie All.

could you sketch a design for Obama's
private apartment in the white house ↘

what are you scared of?
Solitude.
what is the favorite
part of your day?
Sunset
Time

good Luck. Jacques

ot 2008. grange

Could you design a chair for Dennis Hopper ↘
What is most important to you now?

l'amour
Love.
relationship.
— Jacques G

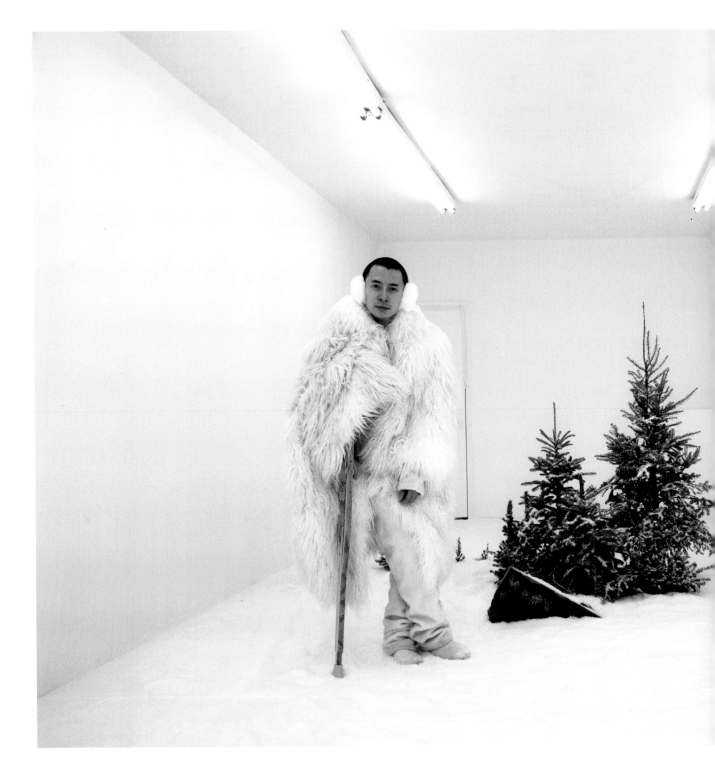

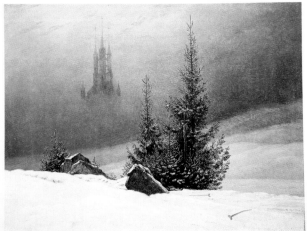

This is the ground floor of the Asia Sony Society gallery. It is filled with fake snow in reference to this Caspar David Friedrich painting.

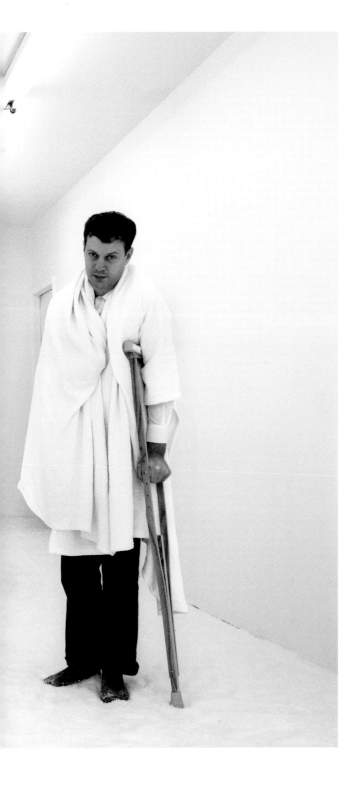

TERENCE AND GARRICK WORK in a three-story building in Chinatown. They live on the third floor with a giant, stuffed albino peacock. On the second floor Terence and his staff fabricate his artwork, and Garrick works in his design studio. Terence runs an art gallery out of their first floor called the Asia Song Society (A.S.S.). I was really shocked when I saw their bedroom because I assumed it would be super-minimalist, with just a white bed and nothing else. But instead it is the one colorful room in the house, filled with stuffed animals, punk rock posters, religious candles, melted chocolates, and designer clothes.

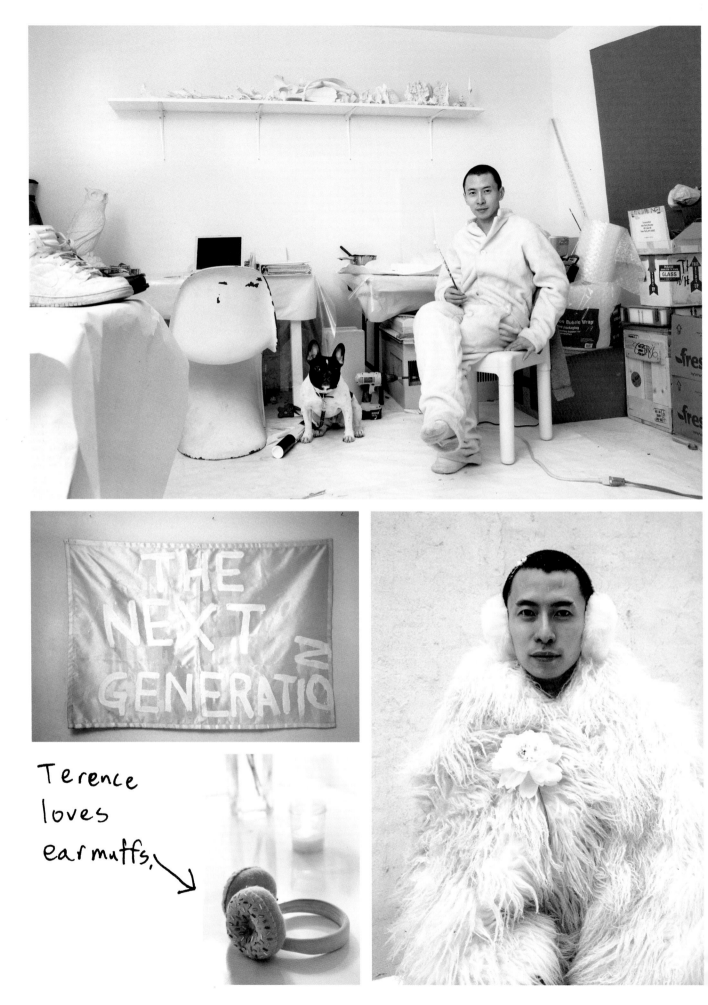

Terence
loves
earmuffs,

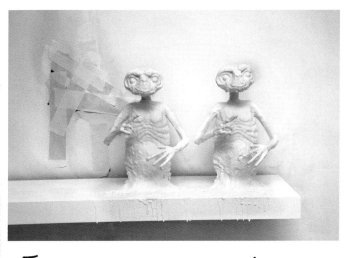

Terence wearing a bunny
Suit and Marcel the
dog in the studio on the
Second floor.
←

On the roof in the Snow. ↘

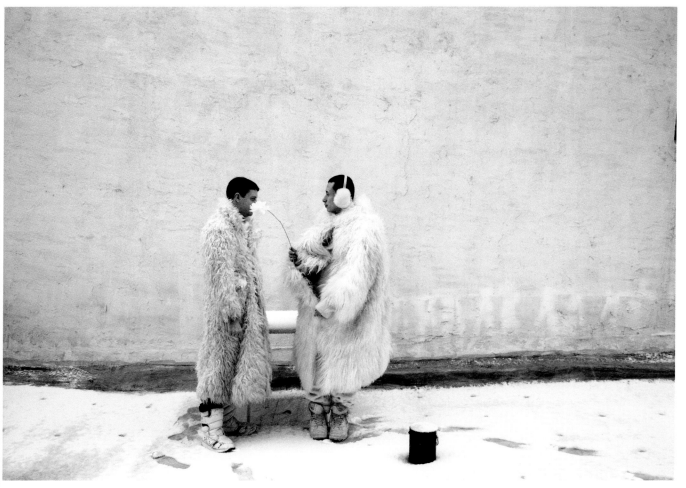

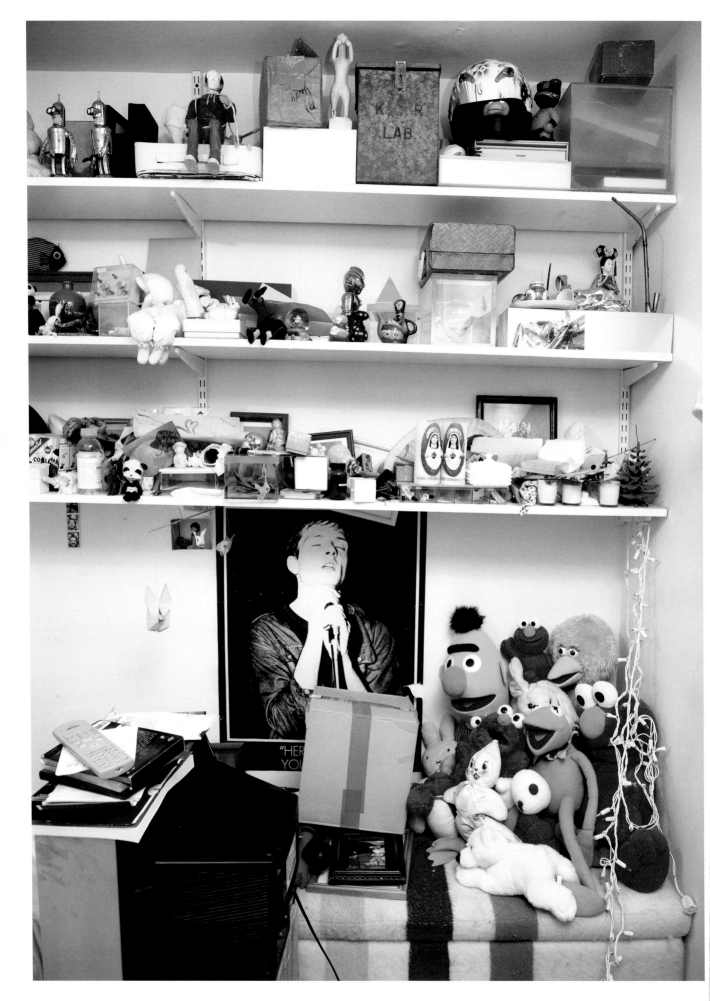

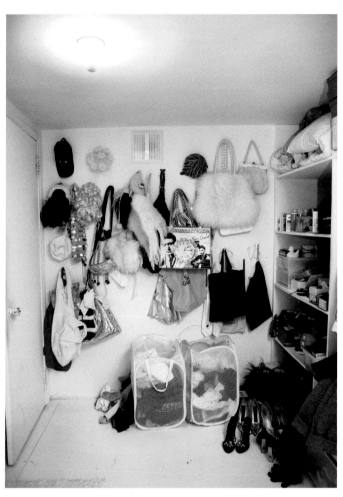

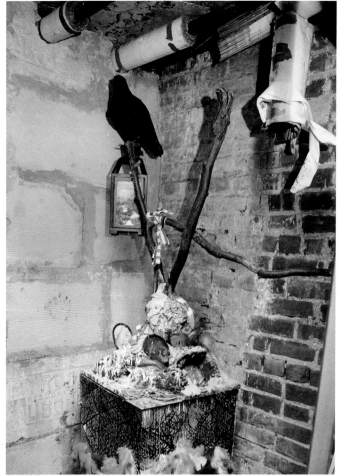

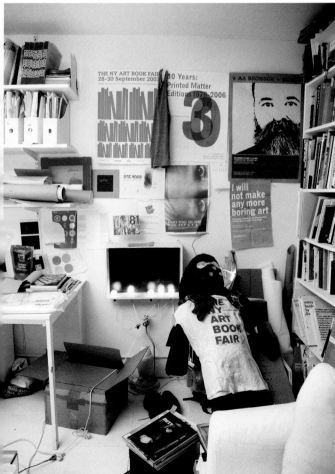

↖ This artwork is left over from a group show that the Asia Song Society had in the basement and is permanently cemented to the floor.

← Garrick's office on the second floor.

The opposite page is their bedroom on the third floor.

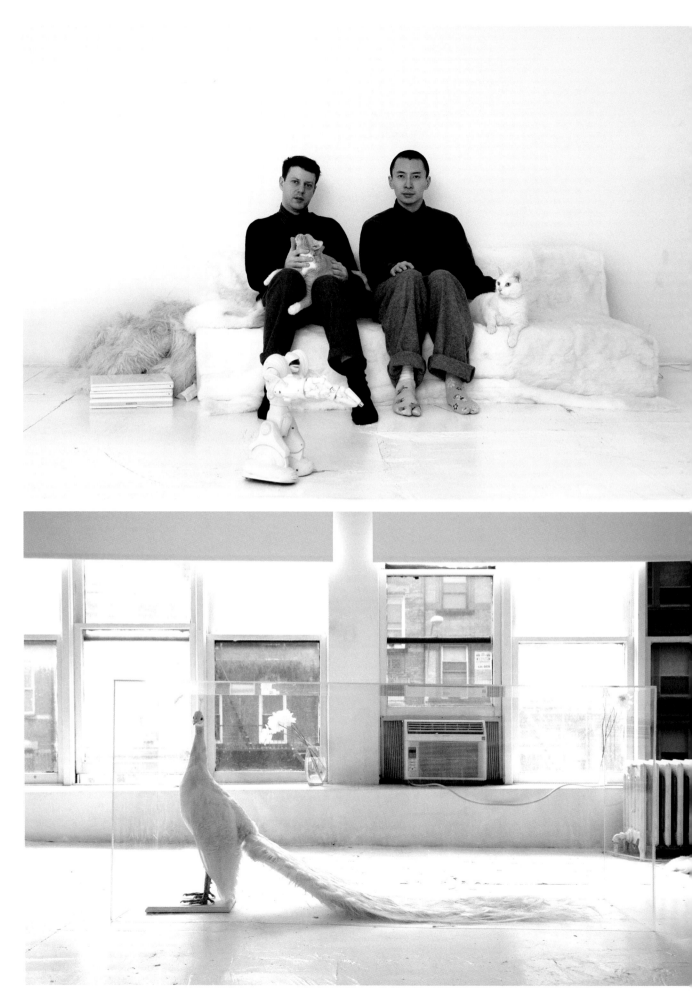

Hi Garrick + Terence! Terence could you please draw your great great
grandfather?

Garrick could you tell me your 6 favorite books?

① Flowers of Evil
 Baudelaire (cover)

② Printed Matter by Karel Martens

③ Typography: Encyclopedic survey throughout history

④ Tales of the Unexpected, Roald Dahl

⑤ Rose Bakery Cookbook

⑥ Graphics Handbook by Ken Garland (1970s)

Terence what do you love about your house?

like a **white horse dream**

Garrick what do you love about your house?
My bedroom (i love sleeping)

Terence describe what you do → ○○

Garrick could you draw/design a new canadian flag ↘

Terence what is the best compliment you were ever given?

"nice manners"

Garrick what is your favorite part of your job? Working in my underwear
↑ HA HA HA, LAZY BONES

NEW CANADA

Terence could you draw yourself as a toy? ↘
Garrick could you draw yourself as a toy?

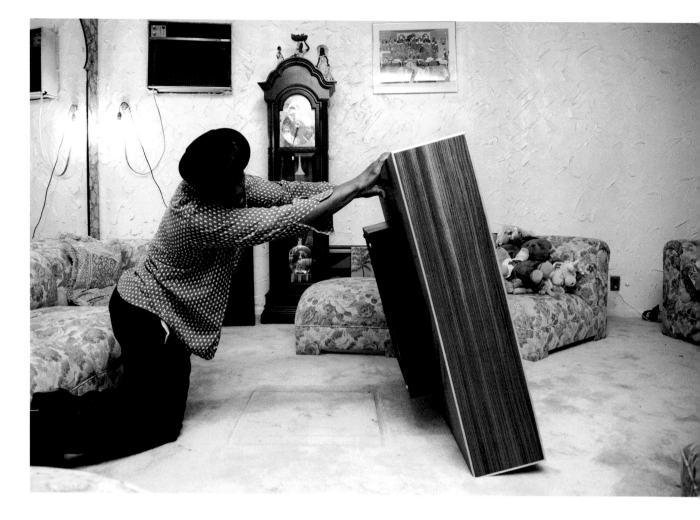

The hard drive hanging on the wall is a reminder of the photos André lost when the drive crashed.

andré walker

EVERY TIME I HANG out with André I feel the creativity pouring out of him. And when he talks about fashion, I sense the truth in what he is saying, though I usually have no clue what he is talking about. He often says, "Todd, you are so horrible, I love it." He had one of his first runway shows at the Roxy in the 80s, showed in Paris in the 90s, and now runs his own magazine, *Tiwimuta*. *Tiwimuta* stands for "This Is What It Made Us Think About." He works as a design consultant to the top fashion houses, which hire him to come in and inspire them. André lives with his parents in a huge Victorian mansion in Brooklyn with a wraparound porch. Both of his parents are ordained ministers. His mom is also a retired hairdresser and moved her entire salon into the basement to work on her congregation.

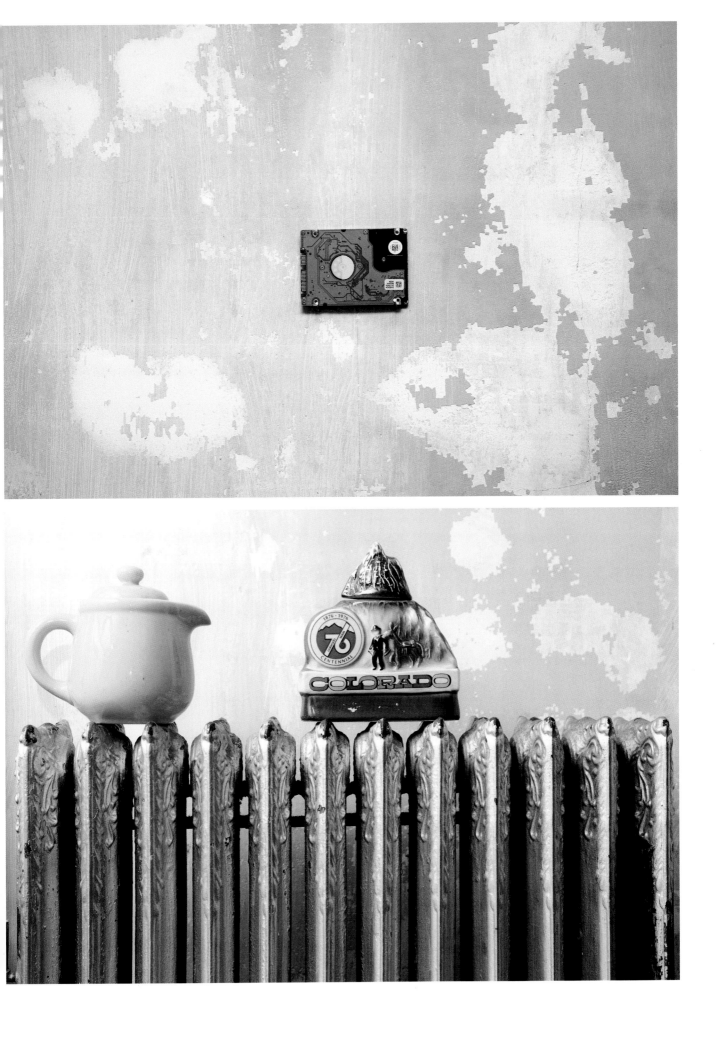

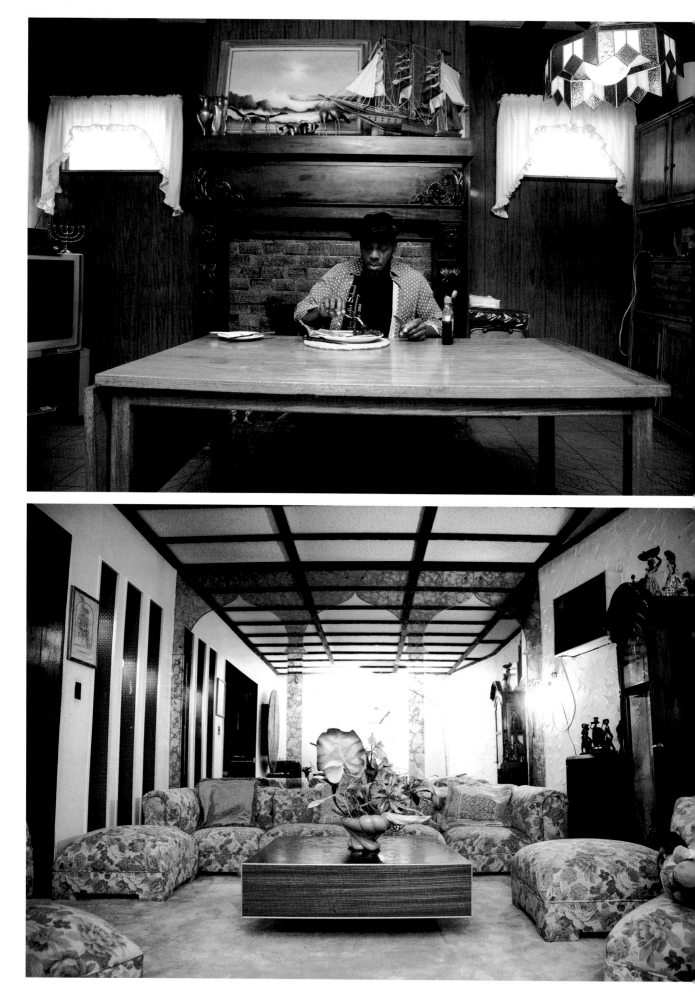

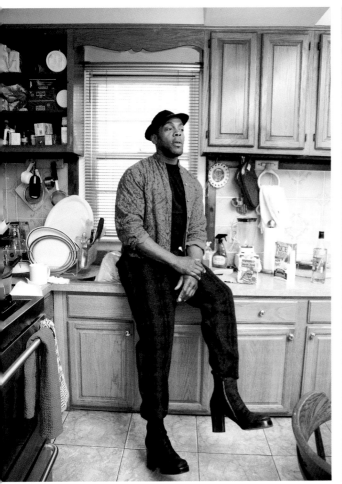

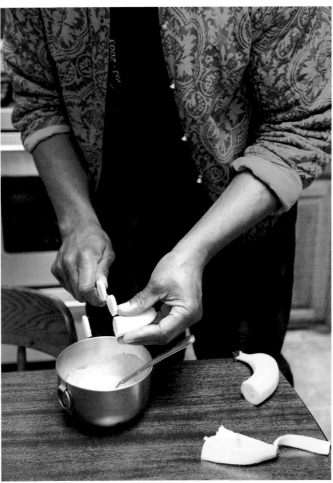

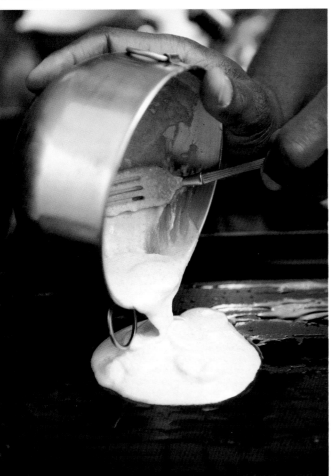

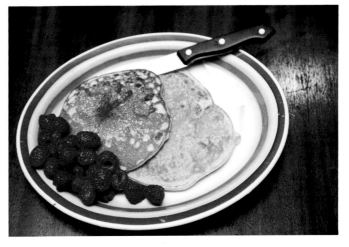

André was nice enough to make healthy banana and raspberry pancakes for me during our shoot.

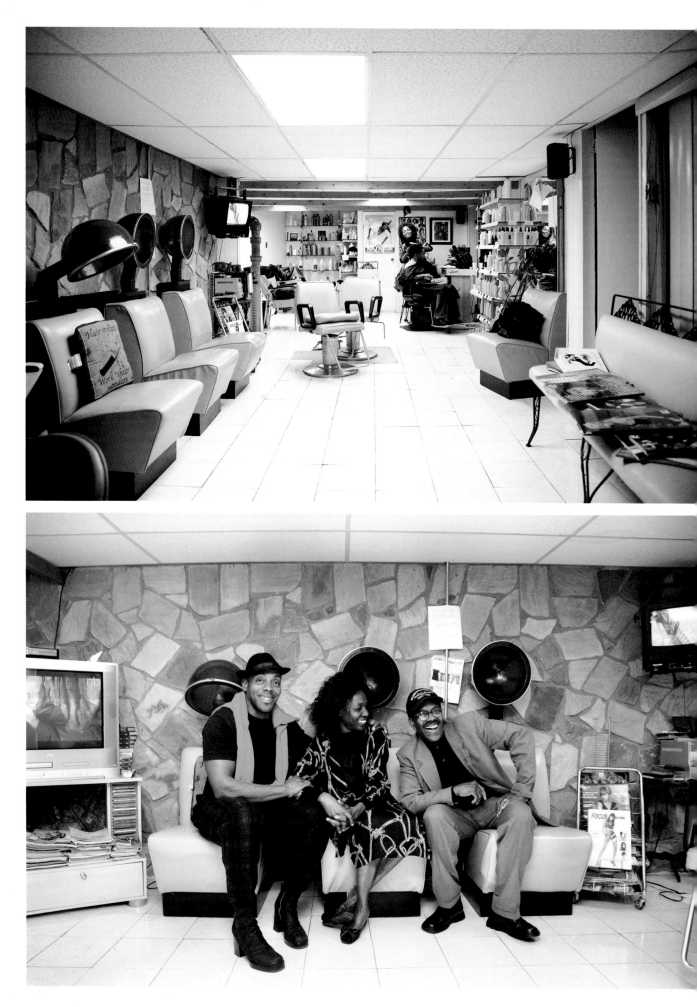

Hi Andre! Who is Andre? Thanks Todd

What is nothingness? The space in between all molecular value - void - interstice, etc

Could you draw a look from your first collection you showed in NYC at the Roxy
Could you draw a look from your 2002 collection you showed in Paris?
What is style?

Scarf Jumpsuit

PaperBag Tunic and Hobble Skirt

What were your 6 favorite things about living in Paris
① The ability to think ④ Learning French
② Meeting People Slowly ⑤ Sidewalk Cafe Beaux Arts
③ Louvre Jardin des Tuileries ⑥ Museum Decorative Arts and Mode

What makes something worth making? Its *inevitability and/or sense of urgency/necessity.

why did you make your own magazine "This Is what It Made us Think About"? I have not signed any work officially (other than my sketch book) The mag was an imagined necessity in the publishing realm so...

What 6 things have inspired you lately
① Destruction of Hesitation ③ Steve McQueen (Hunger) Kalup Linzy ⑤ race track sets
②Open Toes ④ Making Your Own Interpretation ⑥ Bulletin Boards

* Martha Graham

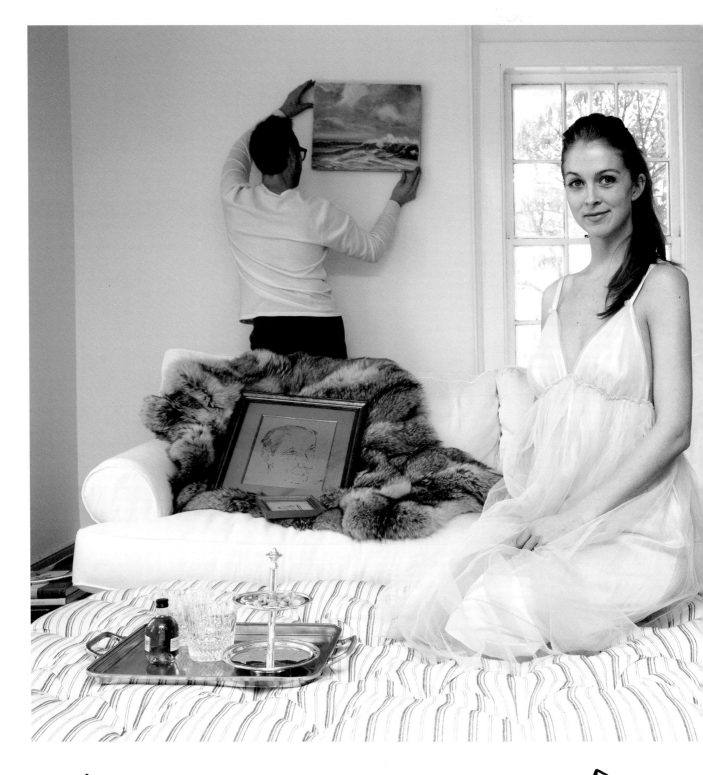

↰ The silver serving piece was bought on their honeymoon after they were inspired by the breakfast service at the Hotel du Cap.

↑ From Texas.

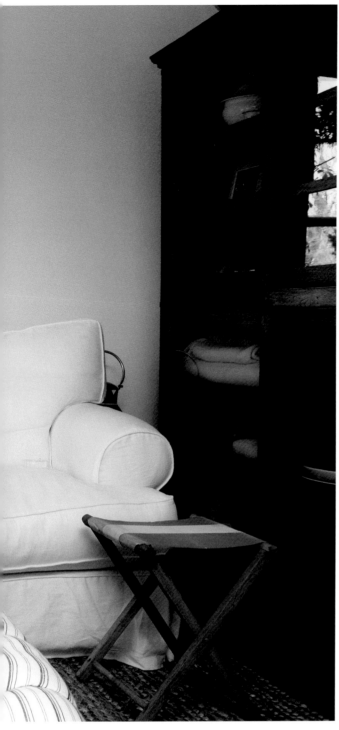

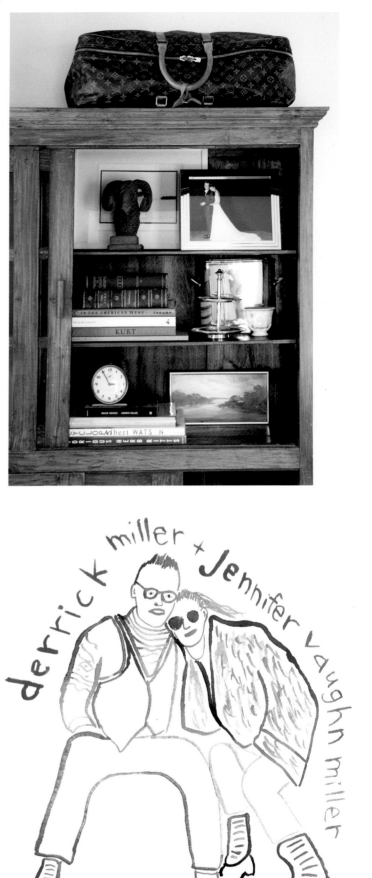

I HAVE KNOWN DERRICK since 2000, when he lived next door to me and slept in a bunk bed he shared with his brother. Nowadays Derrick lives with Jennifer in a cute, 18th-century saltbox-style house on the North Fork of Long Island. In the 1700s, the town miller built this house and had the words "The Miller" chiseled over the front entrance. Derrick applies his old-school, English gentleman with an edge style to his fashion design work. Jennifer is an architect and interior designer who loves classics mixed with unusual vintage objects. Together they have spent endless days fixing up their house and tracking down the perfect accoutrements: egg-shaped doorknobs, bearskin rugs, crystal glasses, and outdoor urns.

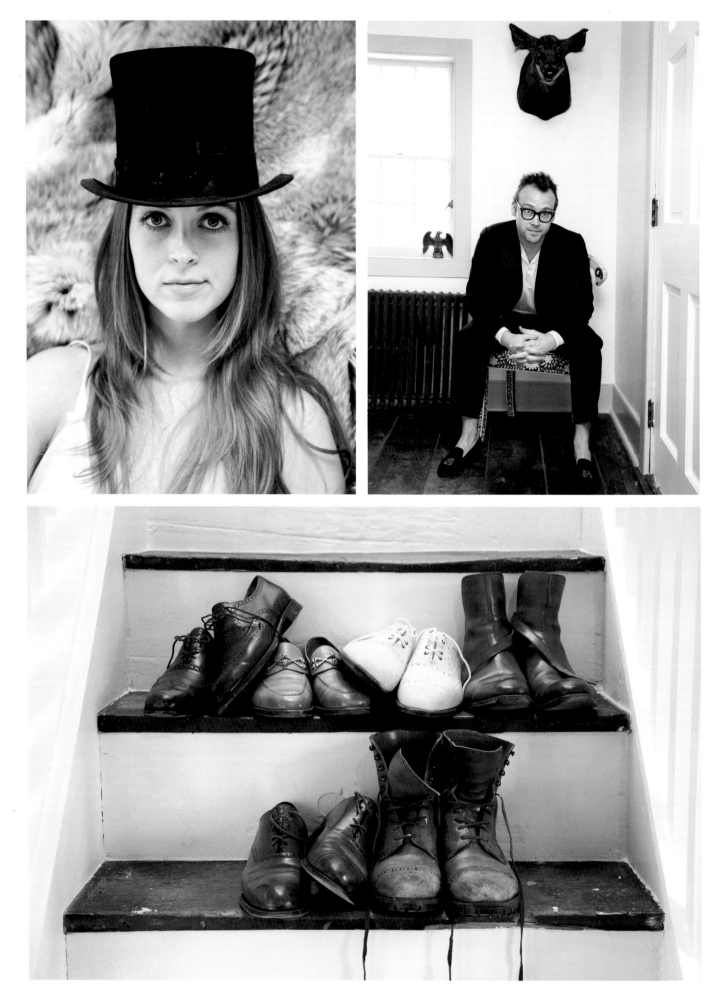

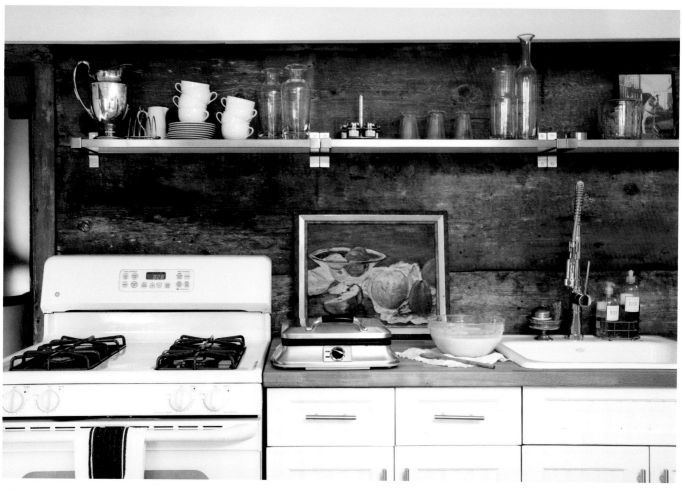

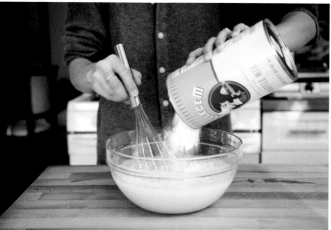

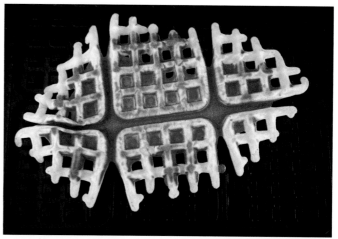

Jennifer making
Sunday-morning
waffles in her gray
waffled onesie.

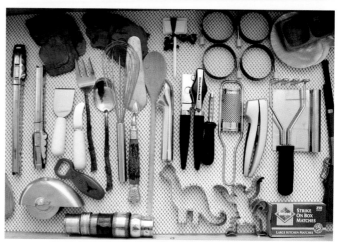

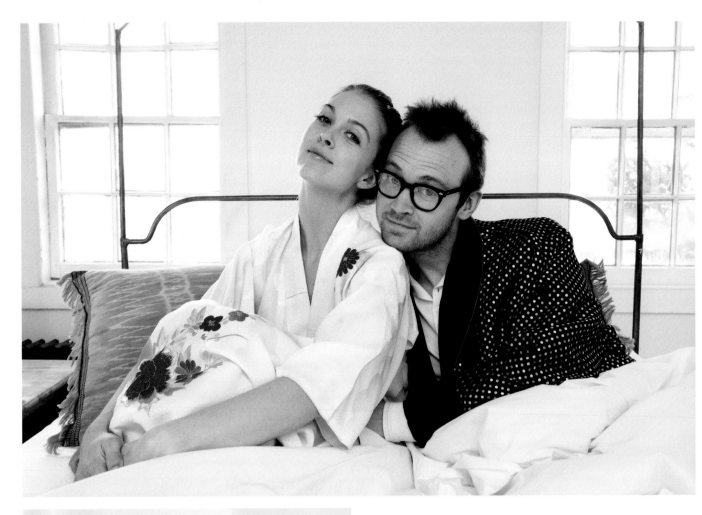

Elsie the Boar Head.

Bearskin rug.

Hey Derrick + Jennifer what is the overall inspiration for how
you have renovated + decorated your beach house?
WE'RE BRINGING CITY TO THE COUNTRY... BEING THAT 300 YEARS OLD, IT NEEDED FRESH,
CLEAN, COMFORTABLE AND OPEN

Derrick tell me 8 things that have inspired your designs
for Barker Black

1 ARROGANCE
2 REBELLION
3 CRAFTSMANSHIP
4 HIDDEN/SUBTLE DETAILS

5 17TH LANCERS
6 JAILHOUSE TATTOOS FROM THE 1920'S
7 60'S CAR DETAILING
8 "SEXY" SHAPES

Jennifer draw your ultimate door knob ↓

NO SCREWS OR SUPERFLUOUS DETAILS

Jennifer what could NYC learn from Texas?

1 MANNERS
2 BBQ (KETCHUP IS NOT AN INGREDIENT)
3 GRACE (ESPECIALLY AMONGST WOMEN)
4 MEN WHO CAN DANCE ARE SEXY
5 Q.U.E.S.O!
6 HOSPITALITY

Derrick what are the ways/method on how to tell if a suit
is well made? FIT. CHEAP GARMENTS USE CHEAP CANVAS TH
AT IS GLUED TOGETHER SO IT DOESN'T MOLD TO YOUR BODY... A QUICK
WAY WITH VINTAGE COATS IS WORKING BUTTON HOLES... HAND
STITCHED IMPERFECT STITCHS ARE A TELL TALE SIGN TOO...

Jennifer what are your 8 favorite Things to collect

1 CHINA (TRANSFERWARE)
2 CUFFS
3 TAXIDERMY
4 ART (USUALLY FROM FLEA MARKETS, NOT GALLERIES)
5 ANTIQUE LINENS & FABRICS
6 CAFTANS
7 LIGHTING
8 OLD TROPHIES

Jennifer what is chic?
A HEAP OF BLUSH PINK ROSES IN AN
ANTIQUE CHAMPAGNE BOWL

Derrick draw a crest inspired by your beach house ↓

Y.M. 1706

Derrick define good style?
FLAIR. MAN. ADDING THAT ONE
SUBTLE DETAIL TO BE DIFFERENT. AND
WELL DRESSED. IT DOESN'T MATTER
WHAT YOU WEAR RATHER HOW
YOU WEAR IT.

Lorie Karnath

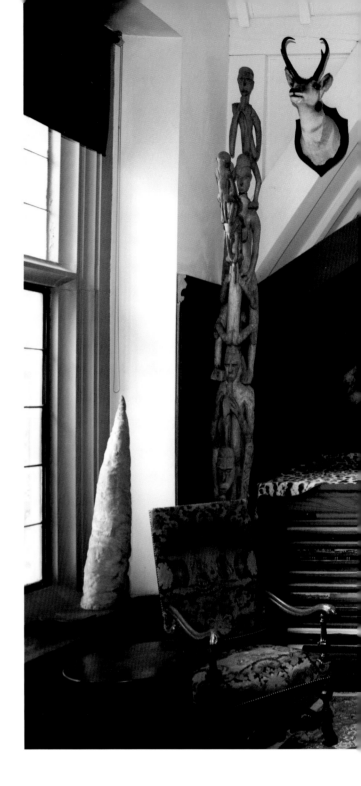

LORIE IS THE SECOND female president in the history of the Explorers Club. Founded in 1904, the club works to promote the exploration of land, sea, air, and space. Lorie has ventured to the South Pole, the North Pole, and the dense jungles of Borneo. She also publishes multiple books a year and volunteers her time for many different environmental causes. The clubhouse has a menagerie of stuffed animals on the top floor, a library of books about exploration, and a storehouse of ancient and obscure maps.

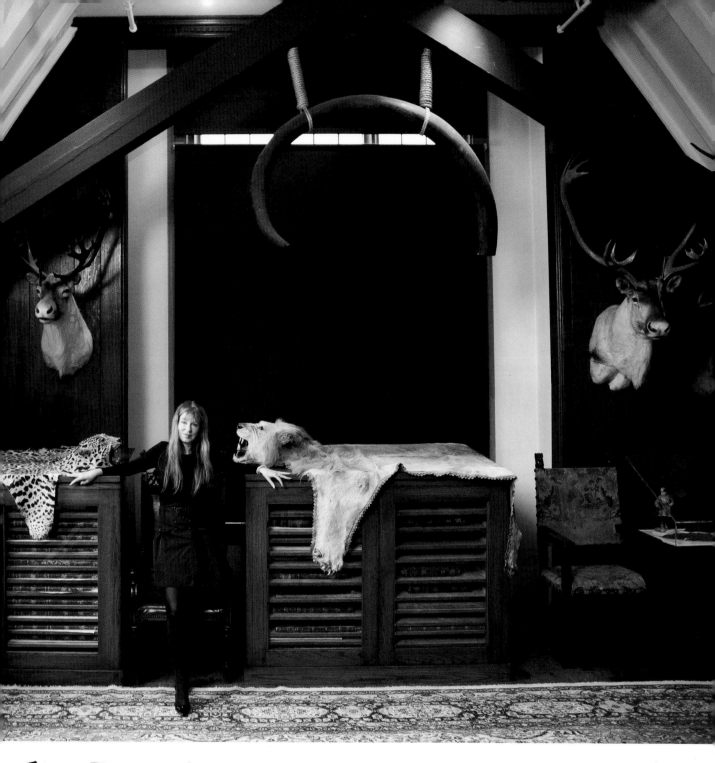

The Trophy Room was originally designed as the
playroom for sewing machine heir Stephen Clark's
children; the Explorers Club headquarters was built
as his home. The tusk hanging from the ceiling is from
a mammoth, and to the left is a tribal carving
from Papua New Guinea.

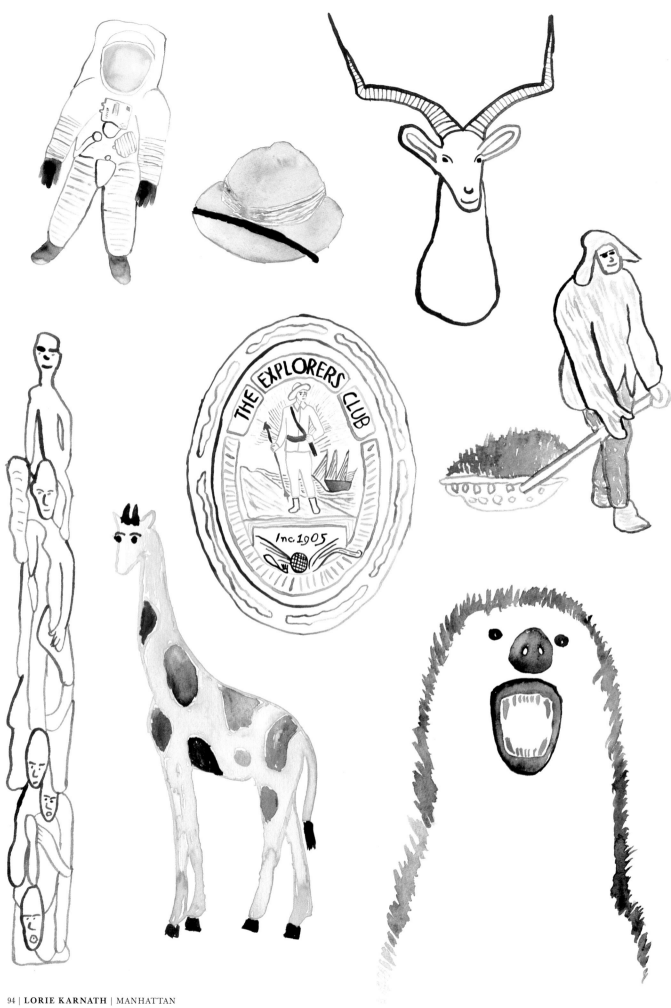

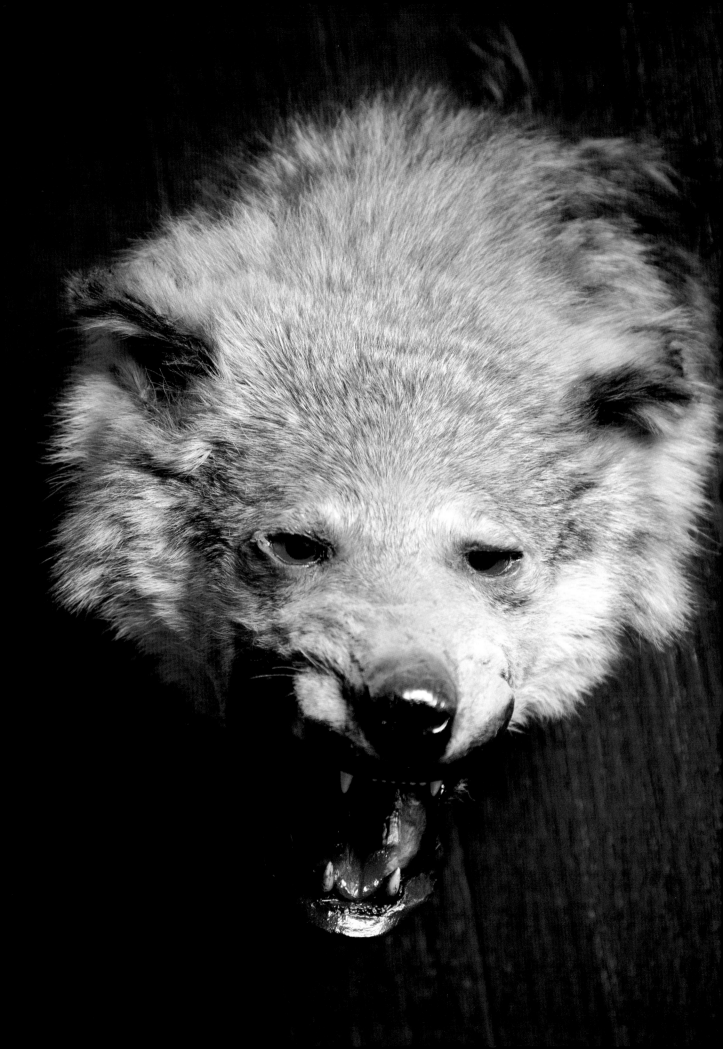

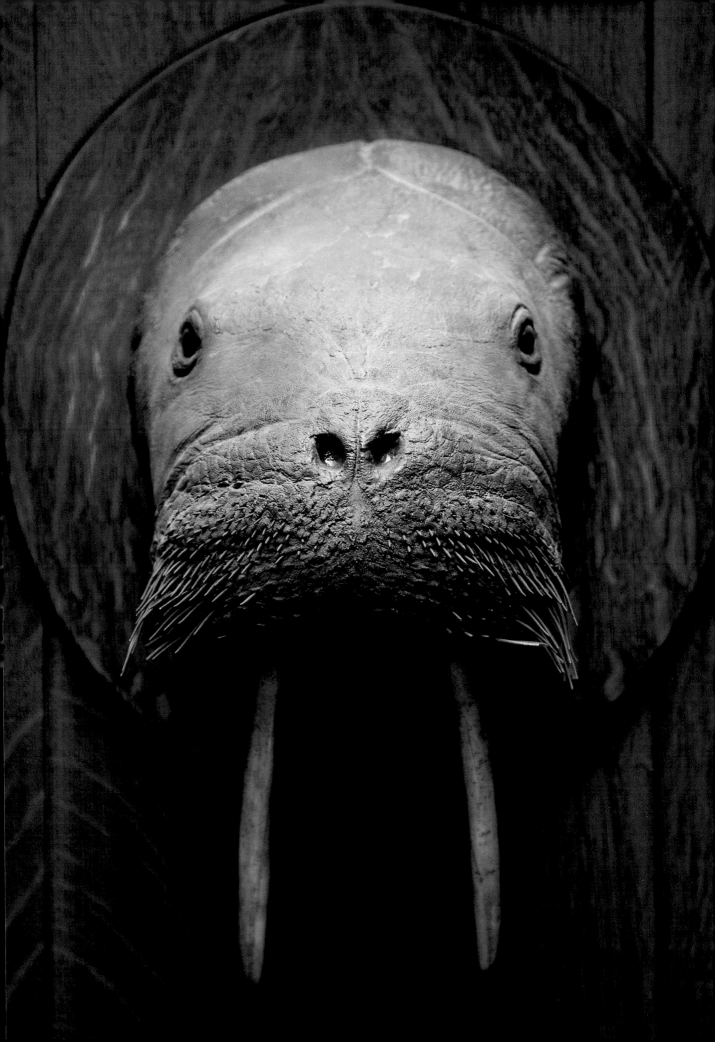

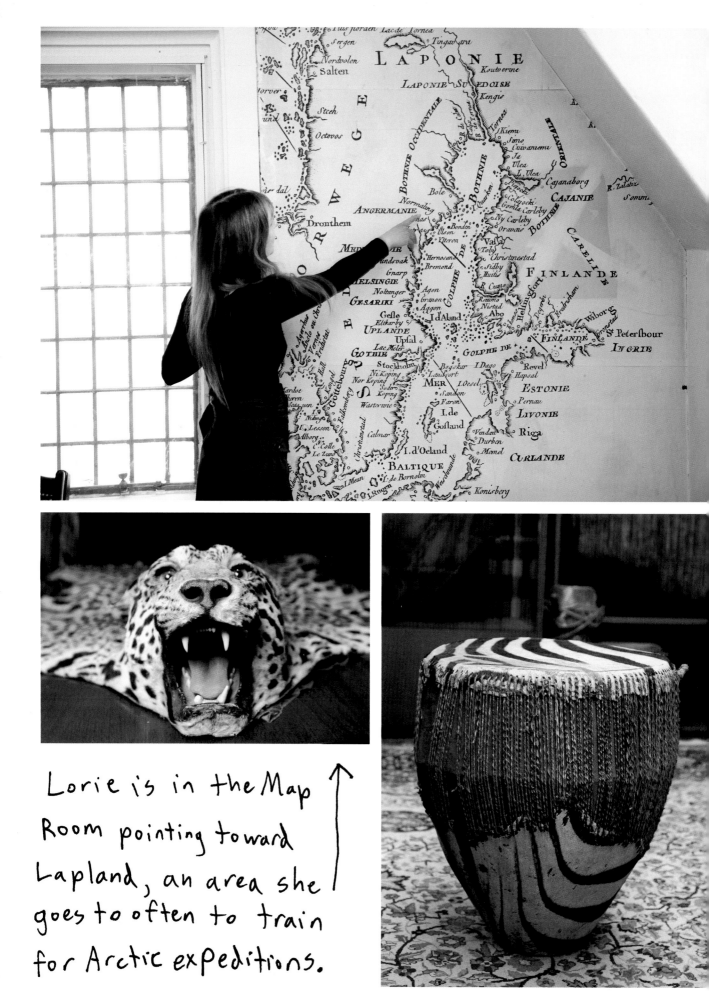

Lorie is in the Map Room pointing toward Lapland, an area she goes to often to train for Arctic expeditions.

Hi Lorie! Could you draw a map of Mount Kinabalu?

a number of spindly peaks

what are 4 characteristics of the top explorers in history

① flexibility

② creativity

③ determination

④ perseverance

70% of the world's flora + fauna on the way up

what can storks teach us?
to live in tangent with nature and to adjust as nature requires

what do you love about exploring?
The discovery process, whatever you are able to imagine, it always exceeds this

what historical explorer's journey would you have most liked to been on and why?
Any of the earliest ones who truly were venturing into the unknown each day was a challenge that yielded truly new knowledge

Could you draw a map of the Gobi desert

Where are you afraid to go?
no place except perhaps to the dentist's office in Berlin

MONGOLIA
CHINA

what are your top 6 favorite objects in The Explorers Club?

① "Sledging on the polar sea" painting Albert Operti

② The White Dolphin photo

③ The Flags in the Clark Room

④ The smell of the dust which I am sure some has been around since the time of the early explorers

⑤ The Globe in the Lobby

⑥ The Books Collection

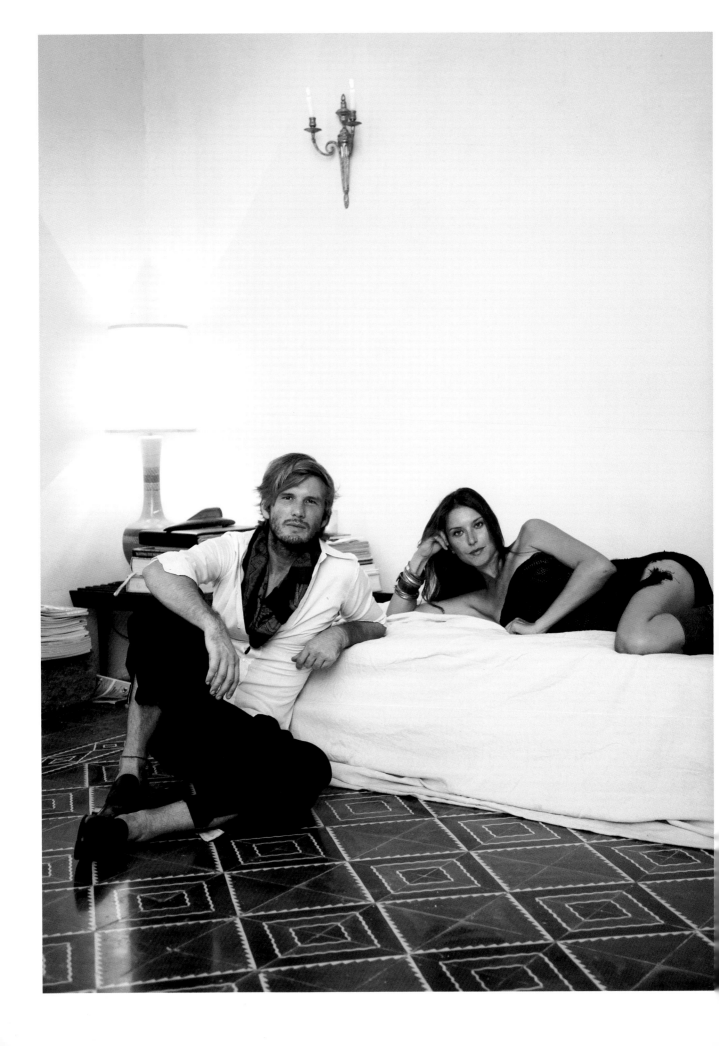

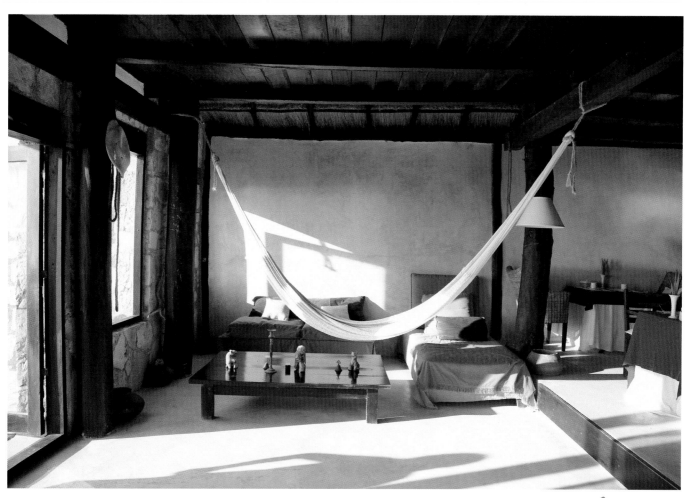

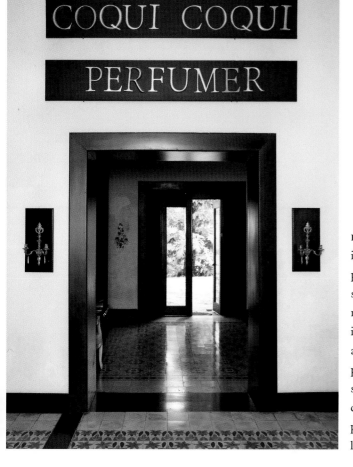

I MET NICO AT a party he threw in Brooklyn. He had built an illegal chill-out space on top of his apartment with sofas, a white picket fence, and a billowing silk canopy. When he attempted to seal up the skylights on the roof and build a pool, he was forced to move out. Nico took the money he made as a model and poured it into the Yucatán Peninsula in Mexico. He is a construction addict and has, so far, built a hotel in Tulum and a perfumery and personal residence in Valladolid. His new project is a high-end spa in the middle of the jungle with two huge Maya-like pyramids connected by a rope bridge. Nico loves coconut trees, reflecting pools, and leather sandals. Francesca is gorgeous, speaks five languages, and is the definition of jungle, boho chic.

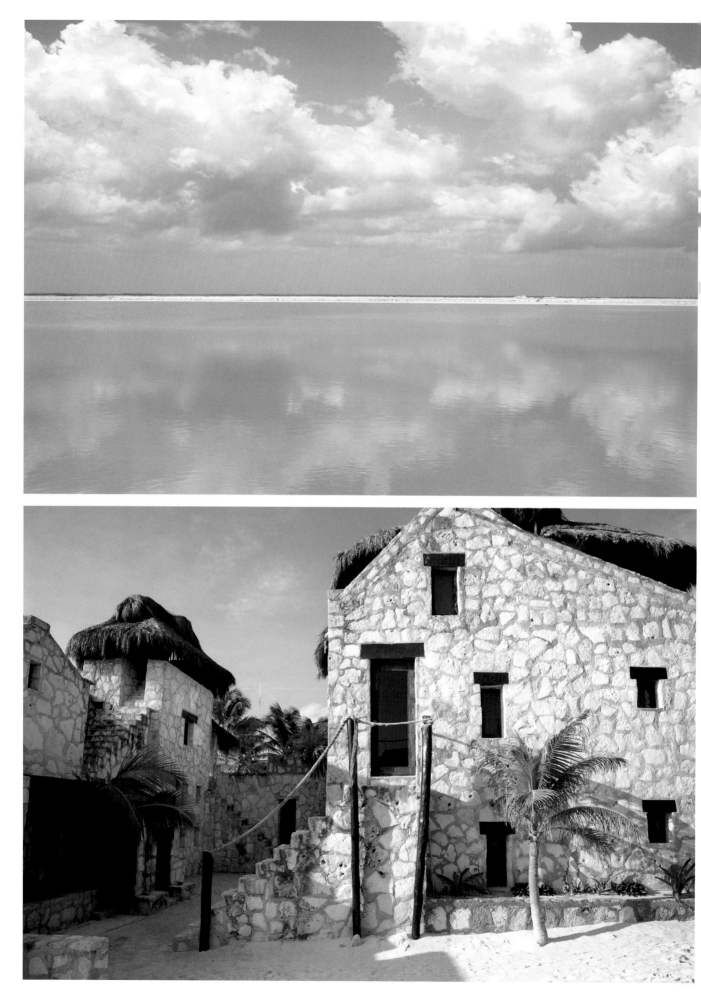

The wide streets and giant facades of colonial Valladolid.

Their hotel on the beach in Tulum. The tower on the far left was built for Nicolas to star gaze from with his telescope.

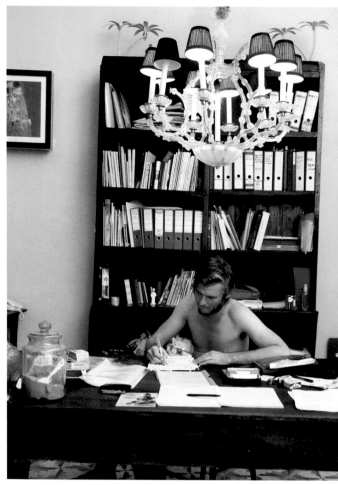

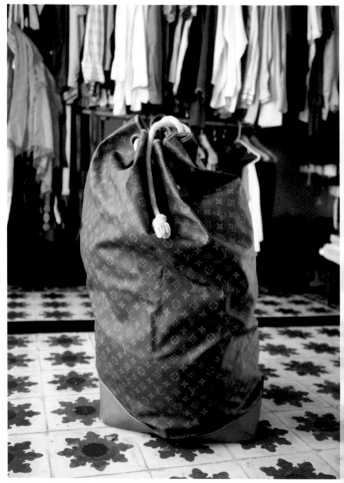

A Louis Vuitton bag bought by Francesca's grandfather in Paris in the 1950s. ⟶

Nico + Frenchie hola! Nico can you describe with a few words your inspirations for your places in:

Tulum → TURQUESA - COCOS - White CREAM REFLECTIONS
WAVES

Cobá → DEEP GREEN - DEEP LAGUNES - ANCESTRAL BEAST
SAVANAS AND SUNSET - PRIMITIVE

Valladolid → ORIENTAL COLOR WARM TONES - FLOWERS
RAIN - SACRO ART AND FOLKLORE

Frenchie can you draw Nico if he was some sort of animal ↘

Nico could you draw me your concept
for Cogui Cogui NJ shore ↓

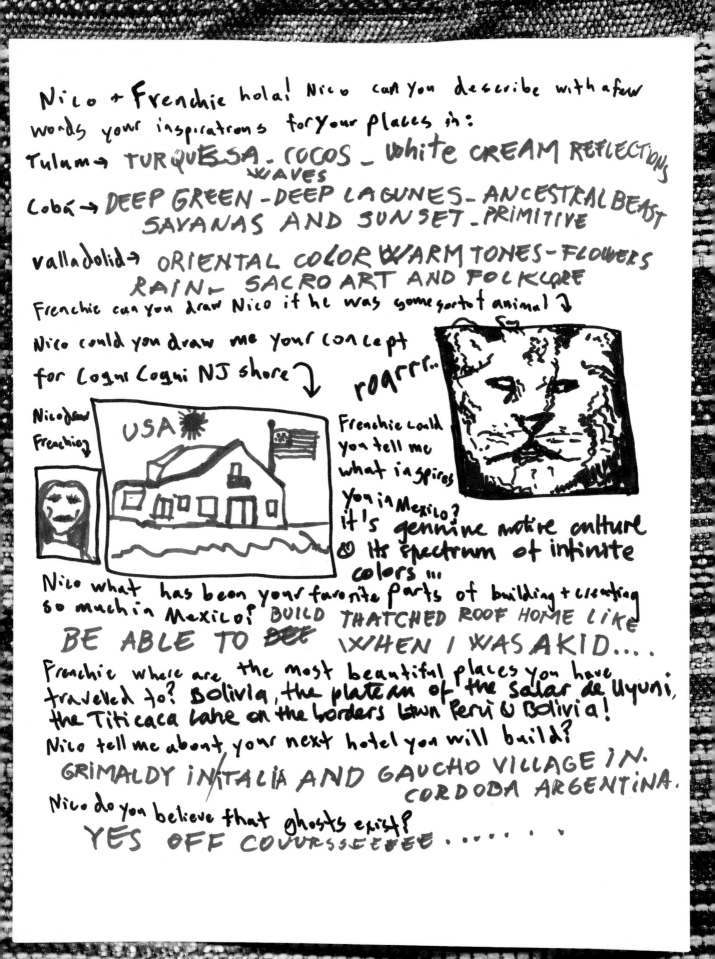

roarrrr...

Nico draw
Frenchie

USA

Frenchie could
you tell me
what inspires
you in Mexico?
It's genuine native culture
& its spectrum of infinite
colors ...

Nico what has been your favorite parts of building + creating
so much in Mexico? BUILD THATCHED ROOF HOME LIKE
BE ABLE TO ~~SEE~~ WHEN I WAS A KID

Frenchie where are the most beautiful places you have
travelled to? Bolivia, the plateau of the Salar de Uyuni,
the Titicaca Lake on the borders town Perú & Bolivia!

Nico tell me about your next hotel you will build?
GRIMALDY IN ITALIA AND GAUCHO VILLAGE IN.
CORDOBA ARGENTINA.

Nico do you believe that ghosts exist?
YES OFF COUVRSSEEEEE

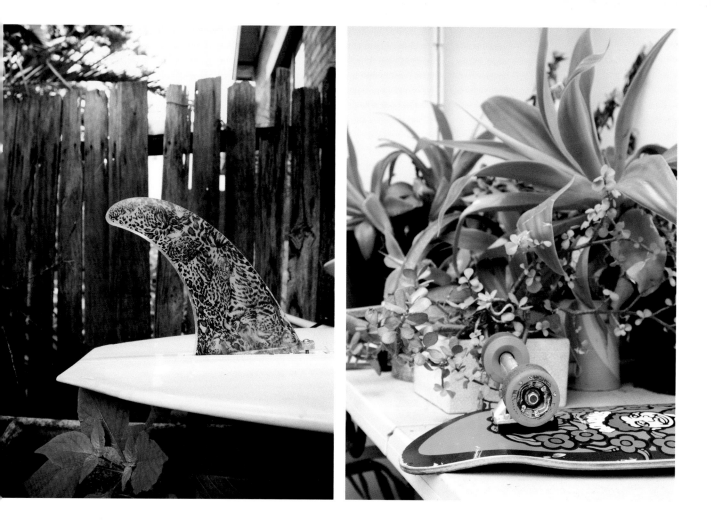

dangerous dan

DAN IS A FASHION MOGUL and DJ who has more energy than any other person I have ever met. Hanging out with Dan is an endurance race that you will never win. He lives in a terrace house just up the hill from the beach and can often be seen barreling through Sydney in his vintage Bentley blasting music, texting, and drinking iced coffee while driving to the Ksubi offices. He is a legend, and he seems to be the only person everyone in Sydney talks about.

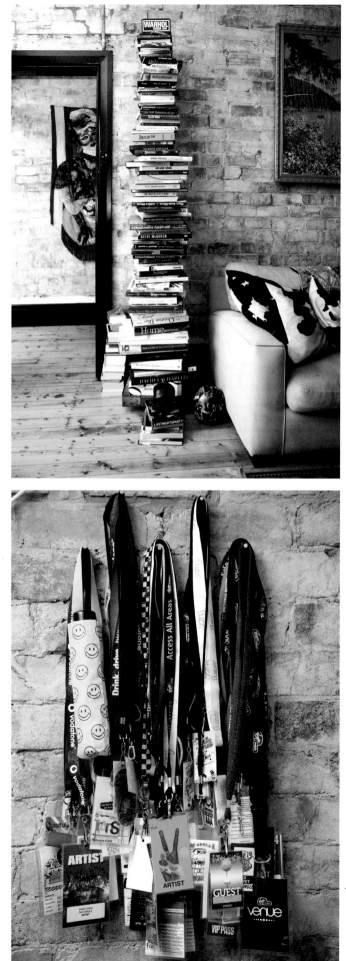

Dan's collection of backstage passes from his DJ gigs.
←

This sound system is so powerful it knocked the painting off one of its nails. →

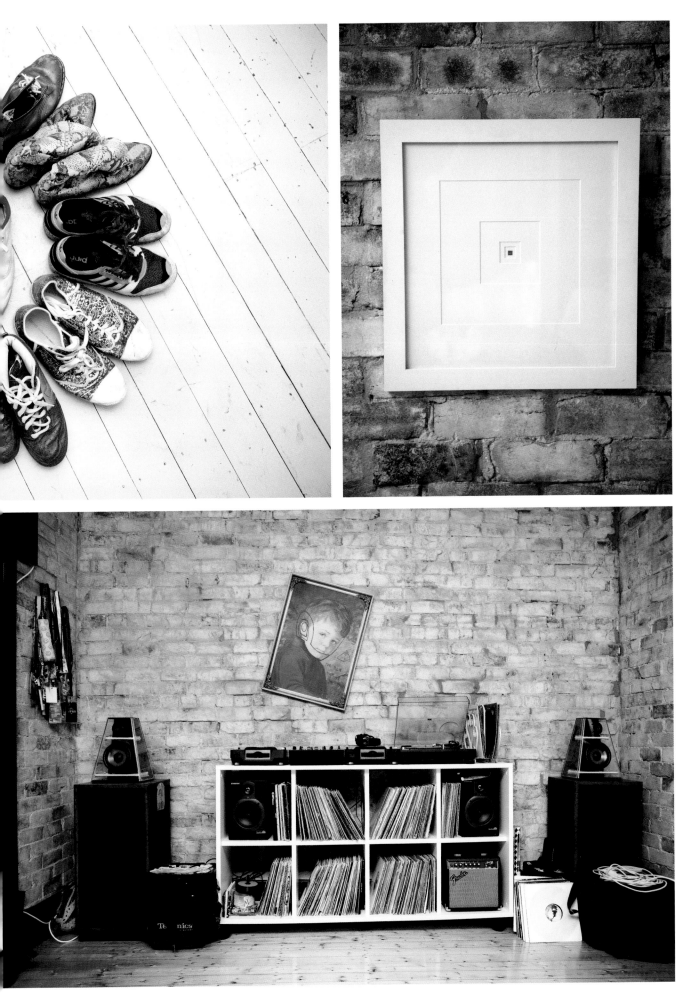

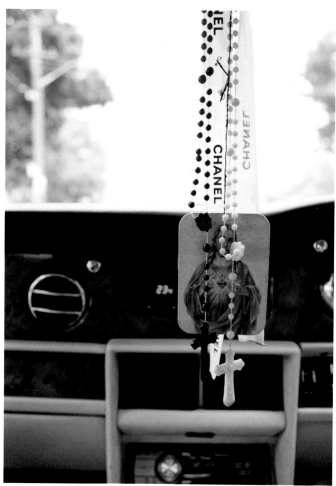

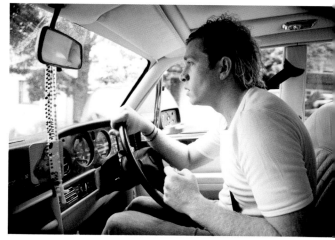

When Dan was a kid he dreamt of living in the jungle. Having this overgrown backyard is as close as he can get for now. ⟶

Dan's car is a Bentley Mulsanne '87.

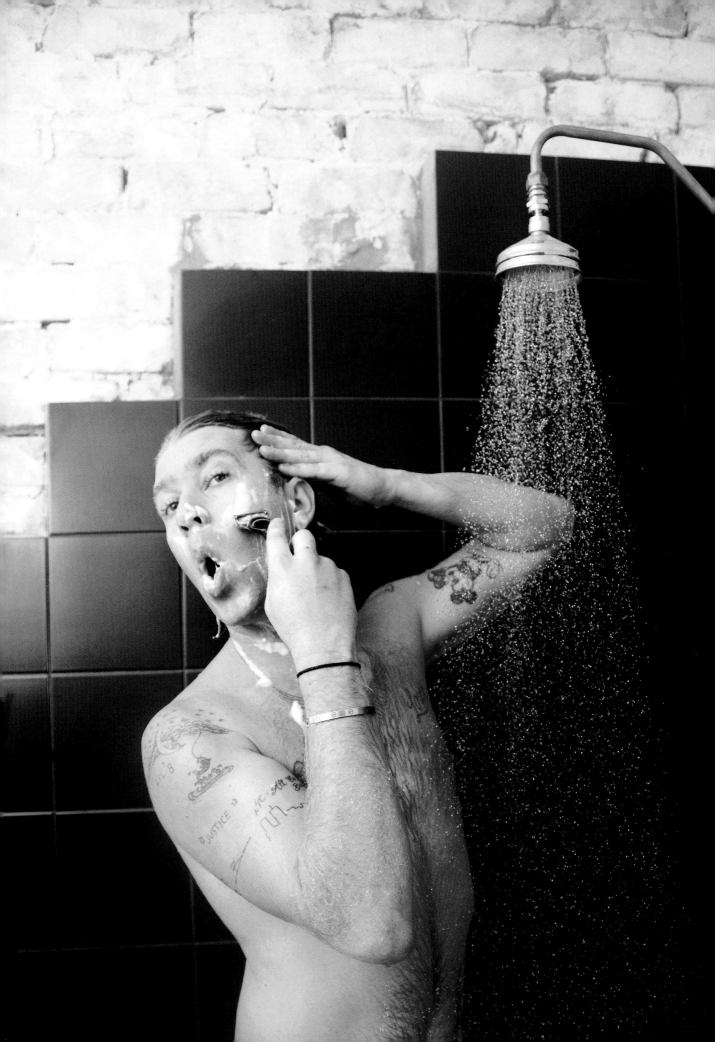

Hey Dan! What are 4 things everyone in NYC should know about australians? We love your city

1. thats not a knife, this is a knife! 3

2. go to the Kingswood w 10th + Greenwich ave 4 um. i was joking. dickhead get a sense of humour.
ask for kenny the bartender

Dan, please draw your most prized possession ↓

Where are your top 6 favorite dinner spots in Sydney?

1 Icebergs for service.

2 Nth Bondi. for ease

3 Daimon's House for fun + friendship + GOOD FOOD!

4 Bossvale Brasserie for

5 Spice I am for taste

6 Chinatown (golden century)

Could you give me a 4 song playlist for new years 2010

1 Love don't Dance here anymore TIGA.

2 Maximus, come dance w us BENI

3 lookin for the beat. DANGEROUS DAN, MYLO + RITON

4 Love is in the air. Paul Young

Dan, could you draw your son in your backyard
No. i wouldn't do him justice.

What do you want to do with Ksubi that you have not done yet? Just more of the same, more projects with more friends, more travel with my son working together (he's super smart) More fun

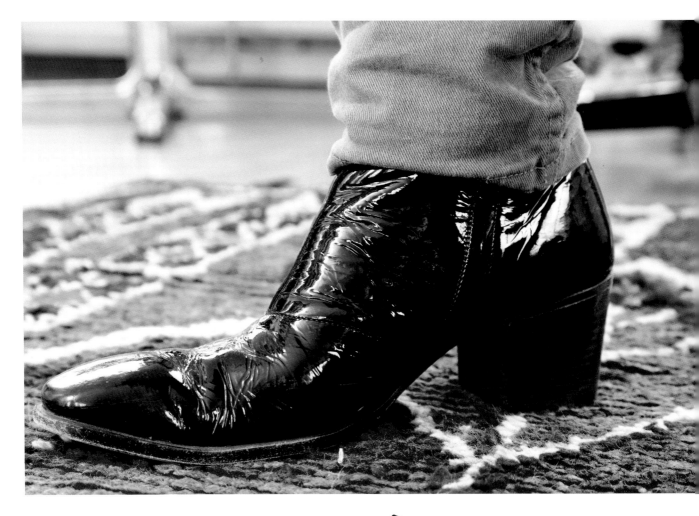

olivier zahm

↖ olivier's black patent leather YSL boots are for walking, dancing, and to be taller for the ladies.

BY DAY OLIVIER IS the editor of *Purple Fashion* magazine, an accomplished art critic, and an intellectual. But by night he is a social butterfly without any inhibitions who is a master of erotic games. He lives right next to the canals in a small penthouse apartment that has amazing views of the Paris skyline. His place is filled with highbrow paperback books, a serious collection of tight leather jackets, and an impressive wall of cologne.

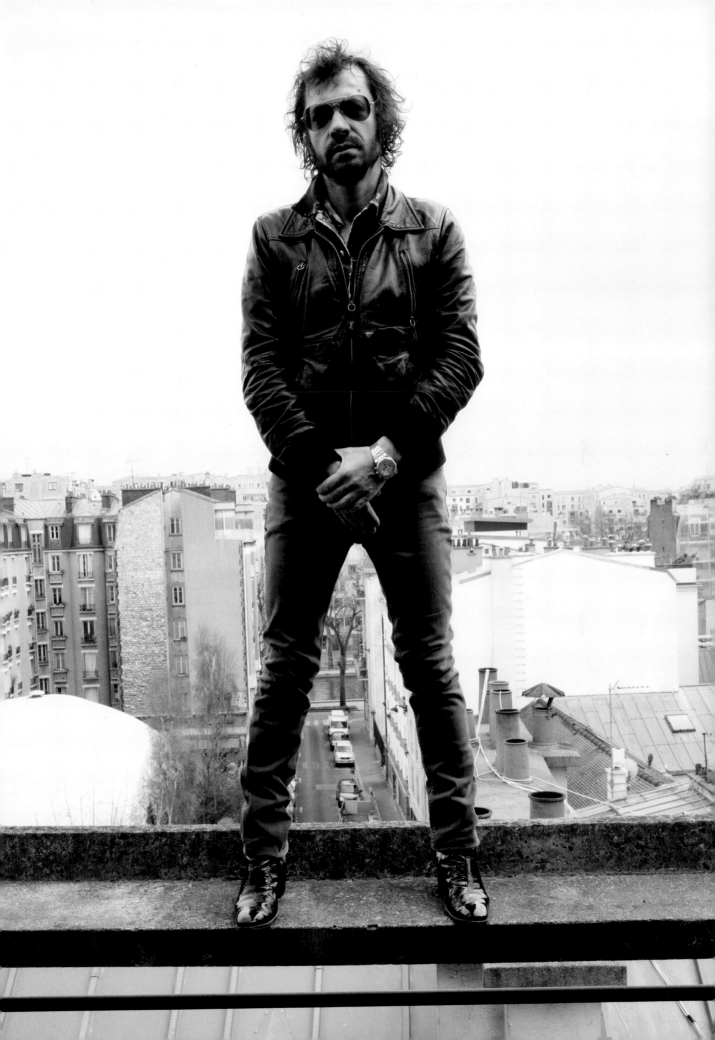

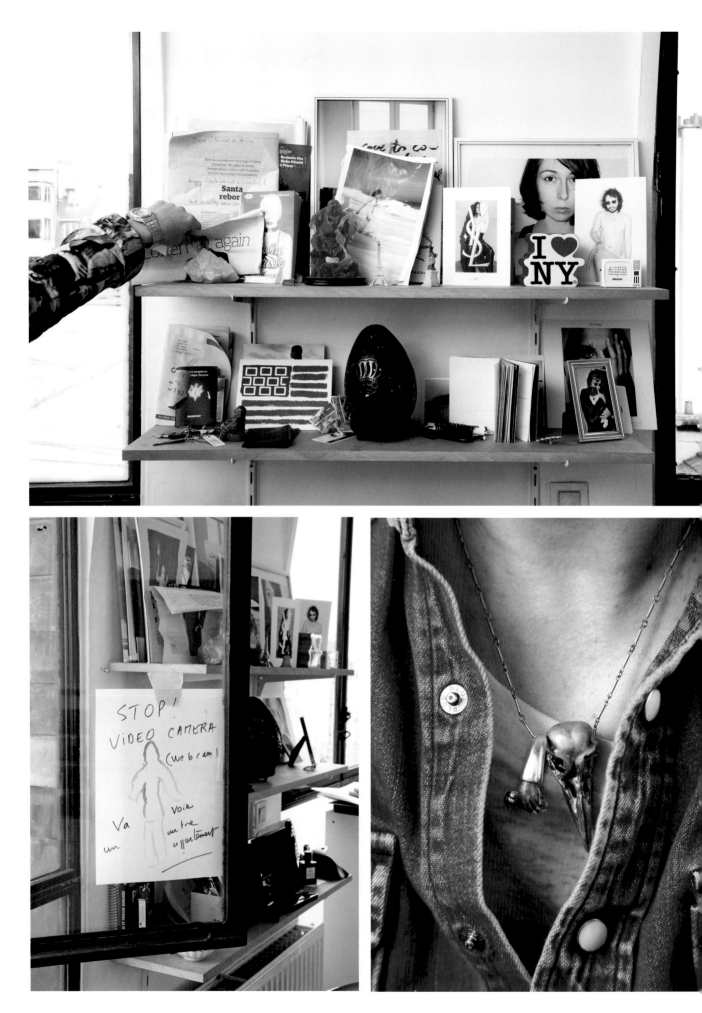

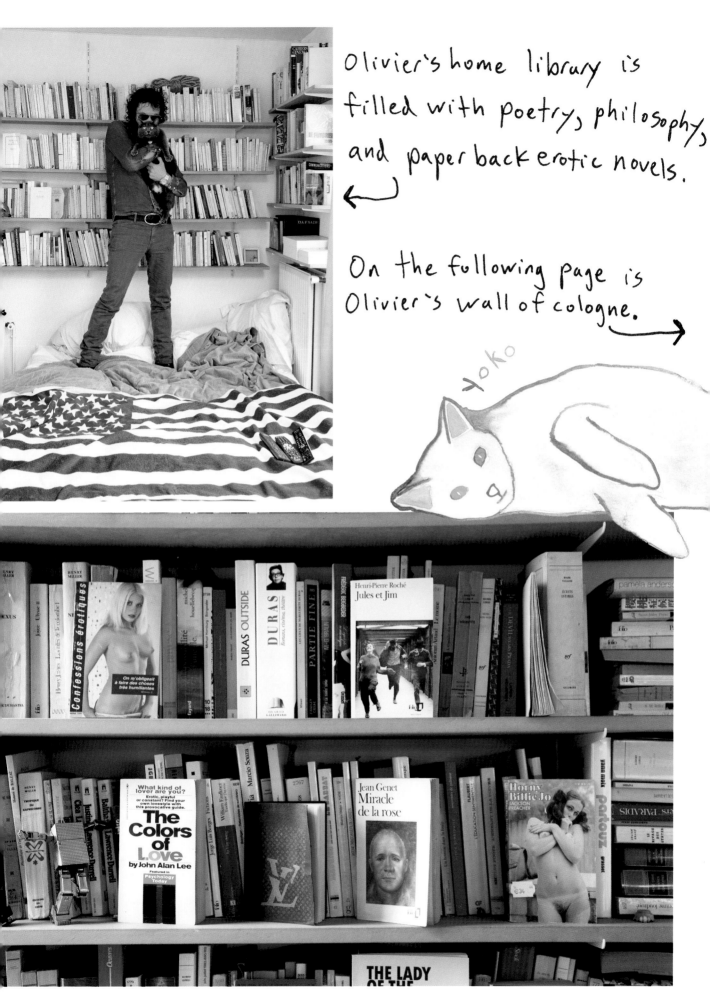

Olivier's home library is filled with poetry, philosophy, and paperback erotic novels.

On the following page is Olivier's wall of cologne.

YOKO

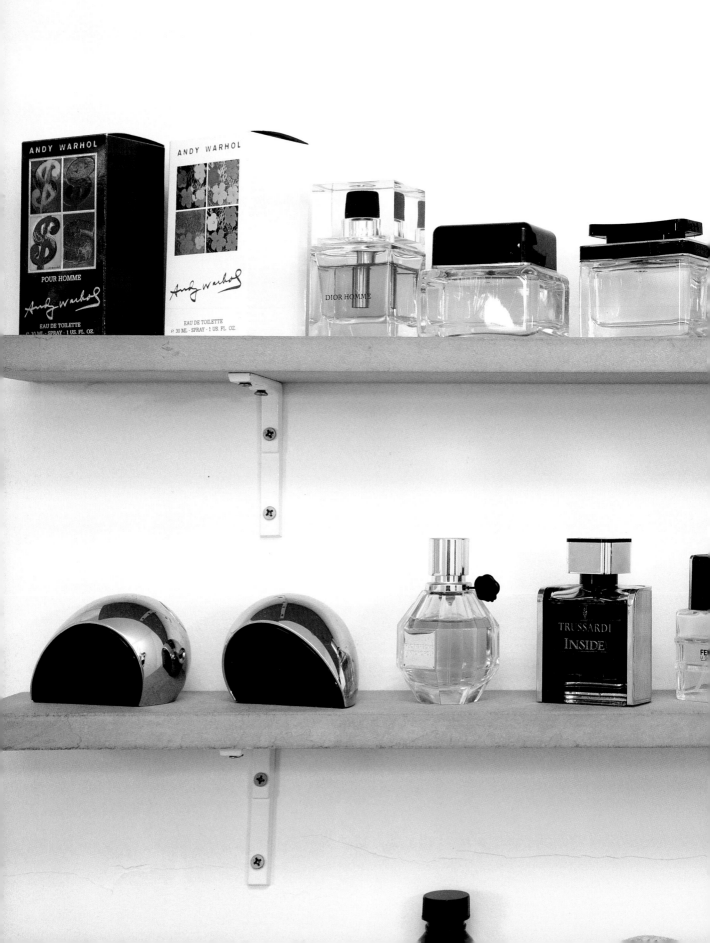

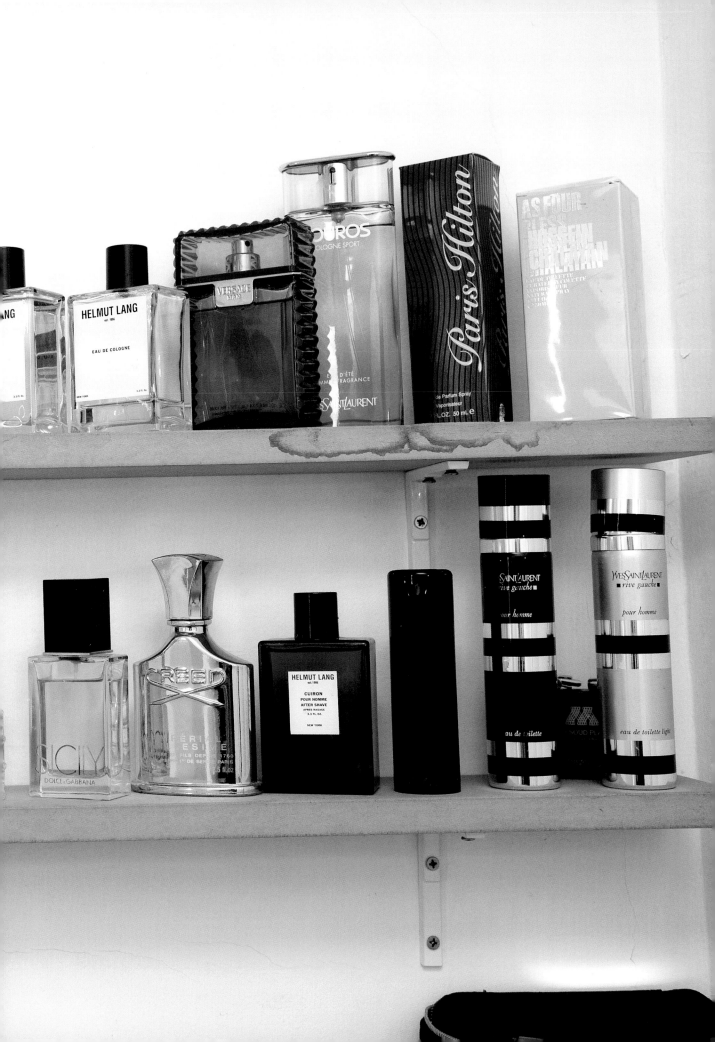

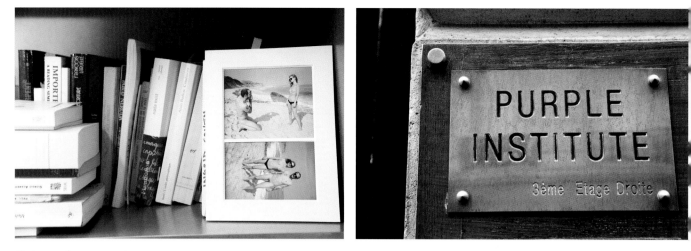

Olivier taking a smoking break while reorganizing the office.

The purple Institute is where Purple Fashion magazine is produced. ↘

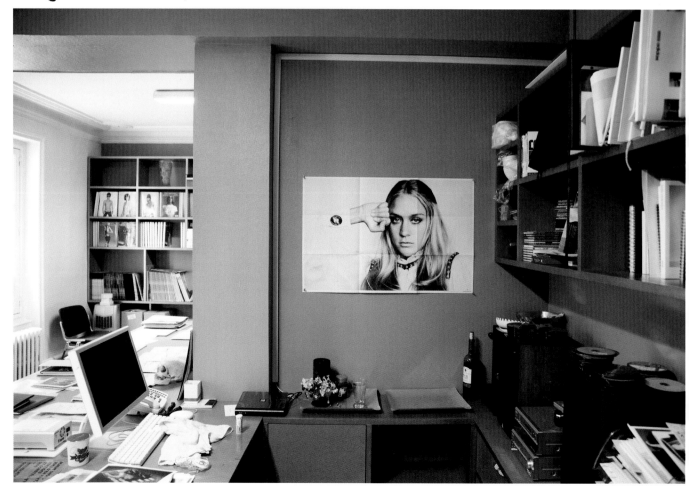

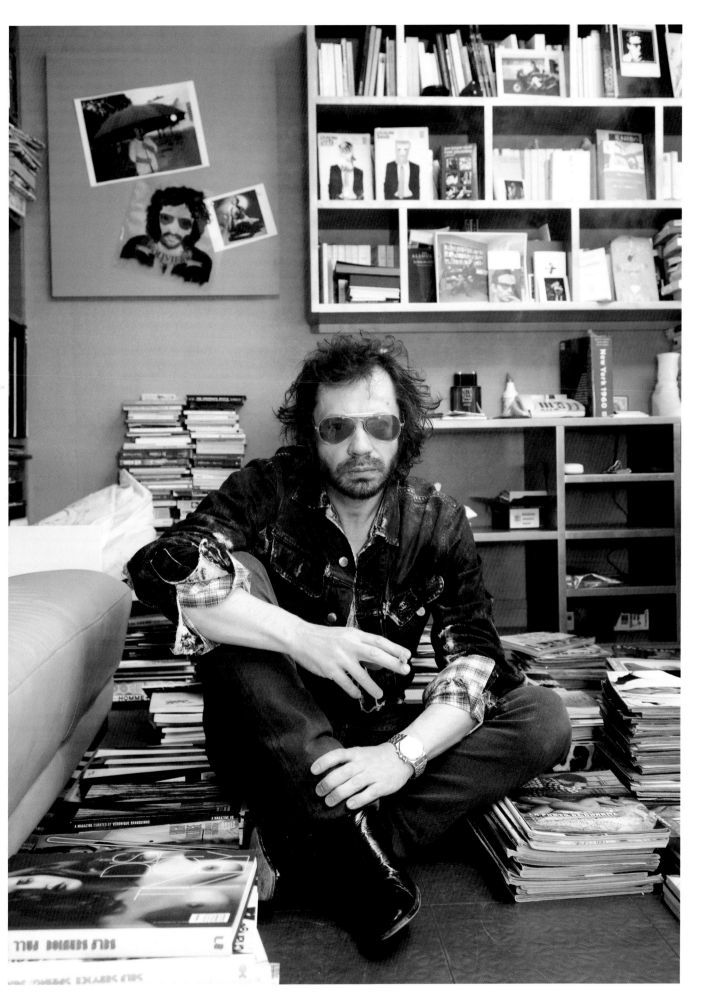

Olivier headed to work
on his scooter. ⟶

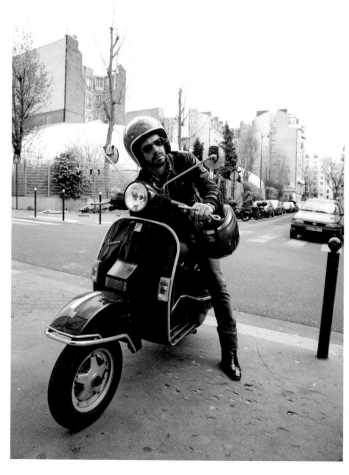

Hi Olivier! Could you design a bong in your own image?

Could you tell me why you started purple?

IN FALL 1992 AFTER THE COLLAPSE OF THE 80's *

Could you tell me a story? BECAUSE OF THE "CRISIS"

Olivier Zahm Bong
SORRY TODD,
I KNOW ~~ABOUT~~ "GANG BANG" as WELL AS ~~ABOUT~~ "GANG GANG DANSE" BUT I'VE NEVER USED A BONG
OK ~~I~~ TRY TO DRAW IT

IN DEC 2008 I LOST ALL MY COMMERCIAL JOBS (PURPLE IS NOT A BUSINESS) - I WAS DEPRESSED. NO MONEY AND OUT OF TIME

tell me the top 6 things you do in your home?

① SLEEP not in that order ASIA ④ (MY DAUGHTER)
② SEX SHOWER ⑤ VOILA TODD D.2.
③ READ THINK ABOUT MOVING! ⑥

SO ~~I~~ DECIDED TO GO ON INTERNET I STARTED THE PURPLE-DIARY. I'M A BLOGGER NOW - AND i LOVE IT.

What is the future of Purple?
THE FUTURE IS PURPLE !
I WANT MY MAGAZINE TO LIVE LONGER THAN i WILL.

ANOTHER STORY: LAST NIGHT, i KISSED MS BUTTERFLY IN ROOM 230 (HOTEL COSTE)

what 6 things do you love about Chloe Sevigny

① HER NAME HER BROTHER ④ PAUL
② HER FILMS HER BODY ⑤
③ HER STYLE HER ⑥ VOICE

* I DON'T LIKE THE 80's. THIS DECADE KILLED THE DREAM OF THE 70's. WE HAVE TO LIVE WITH NO UTOPIA BUT NO "UTOPIA IS STILL AN UTOPIA" SAID R.W. FASSBINDER IN AN INTERVIEW.

what are your top 4 goals?
① ② BECOMING ANDY ③ ④ WARHOL (French version)

To become MYSELF.

what does your work teach you?
I CAN'T PRETEND BECOMING PASOLINI ANYMORE...
This artist was able to write at the same time. articles. essays. novels. poems and to makes FILMS...

IN GERMAN: "KEINE UTOPIE IST AUCH EINE UTOPIE !"

Thanks.

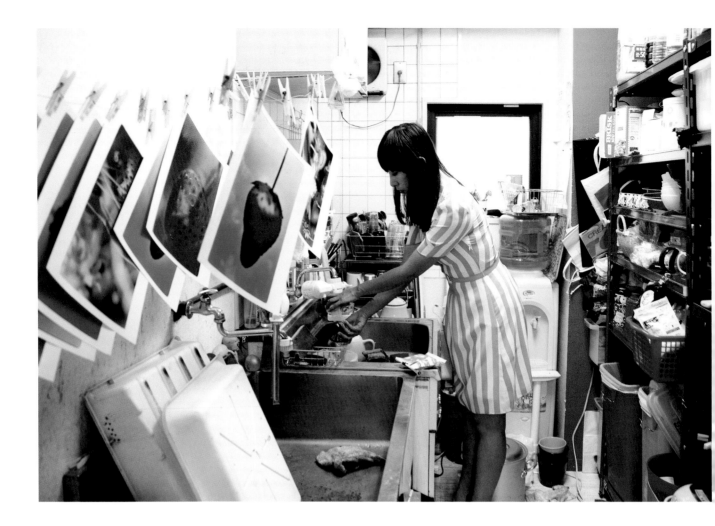

hinagawa mika

MIKA IS A FILMMAKER and photographer whose aesthetic consists of super-bright and punchy colors not normally found in nature. She takes photos of cherry blossoms, goldfish, and of her son. Many of her images are reproduced on clothes, packaging, sunglasses, and key chains in collaboration with different fashion companies. Her studio is a lot like her art: neon and ultrasaturated.

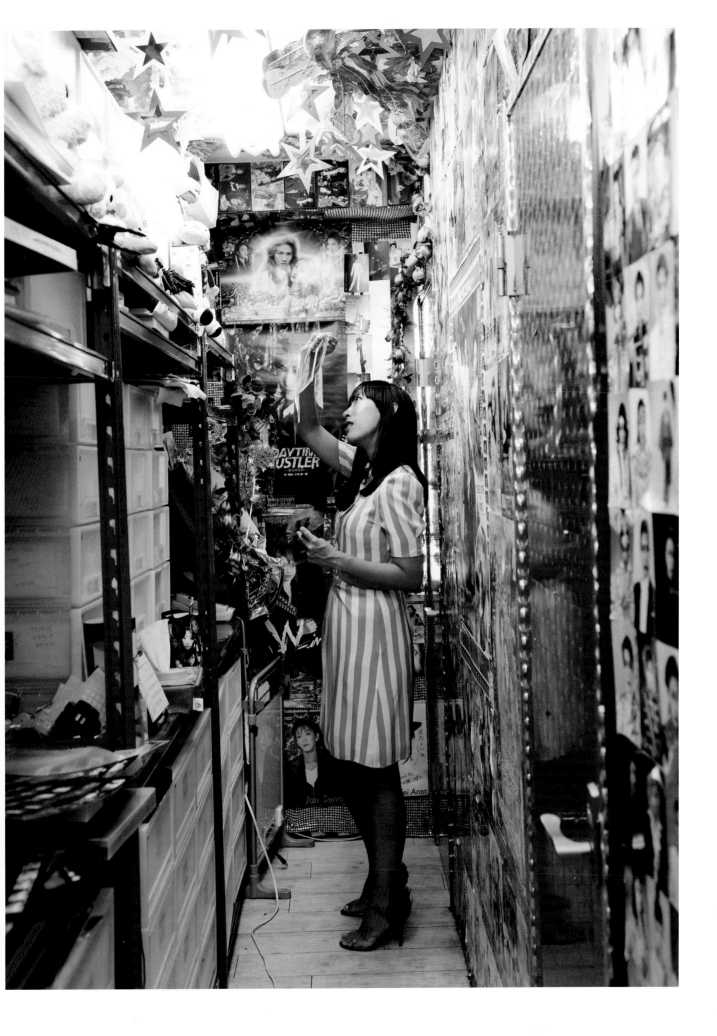

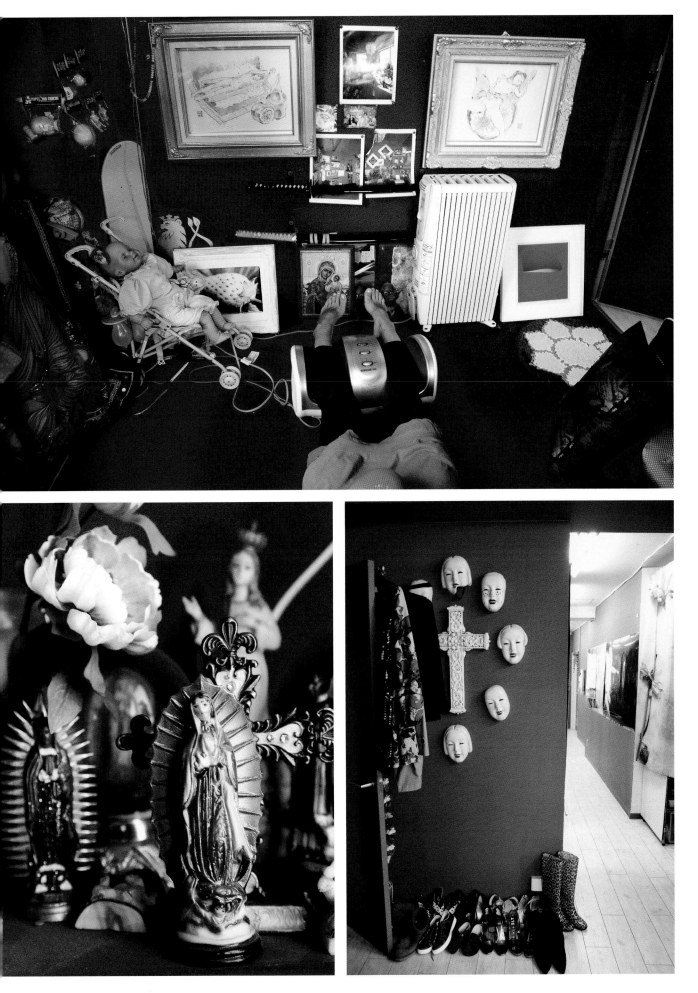

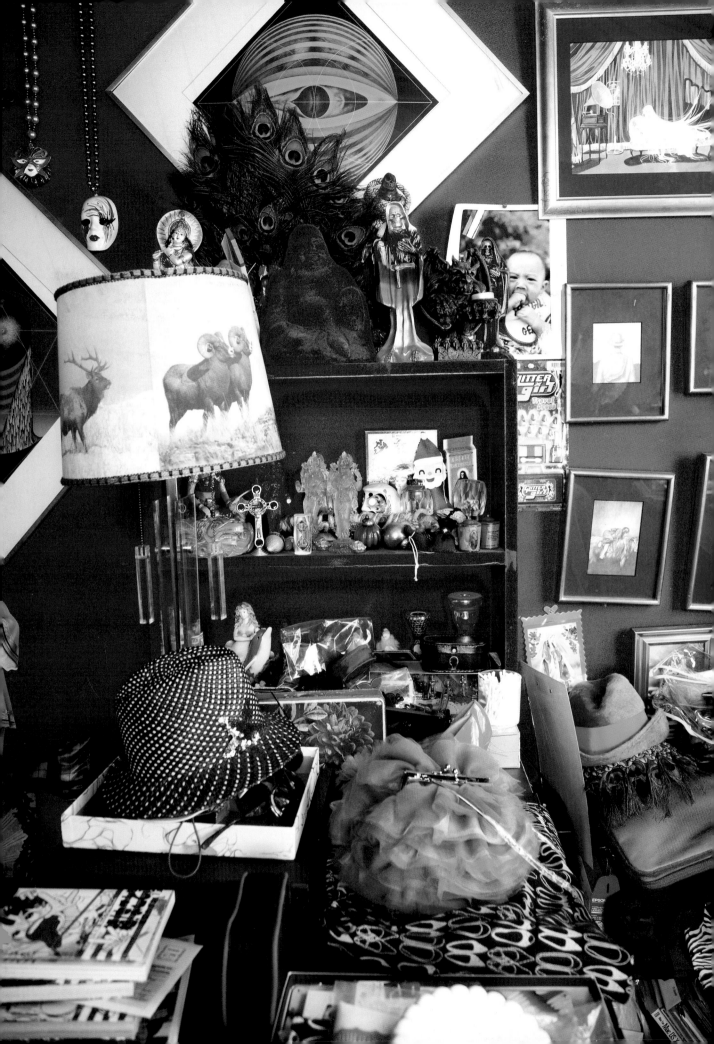

Hi Mika-san! Mika could you please design a
Mika Ninagawa style car? Could you design your
own new kind of flower?

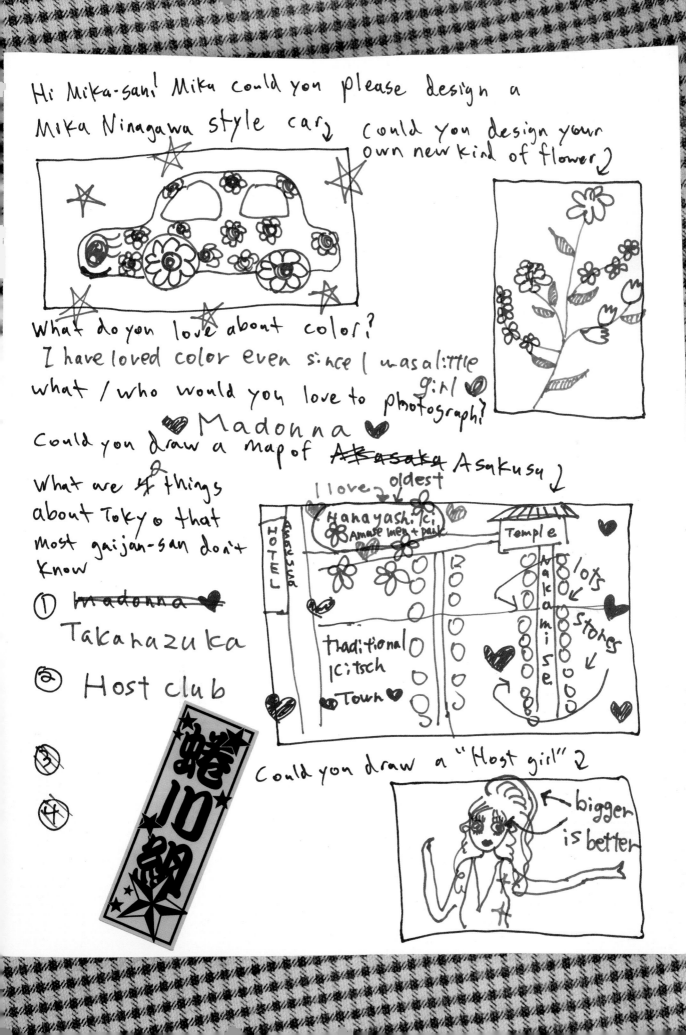

What do you love about color?
I have loved color even since I was a little
girl ♥
what / who would you love to photograph?
♥ Madonna ♥
Could you draw a map of A̶s̶a̶s̶a̶k̶a̶ Asakusa?

What are 4 things
about Tokyo that
most gaijan-san don't
know

① M̶a̶d̶o̶n̶n̶a̶ ♥
 Takarazuka

② Host club

③

④

I love, oldest
HOTEL
ASAKUSA
Hanayashiki
Amusemen + park
Temple
traditional
kitsch
Town
Nakamise
lots of stohs

Could you draw a "Host girl"?
← bigger is better

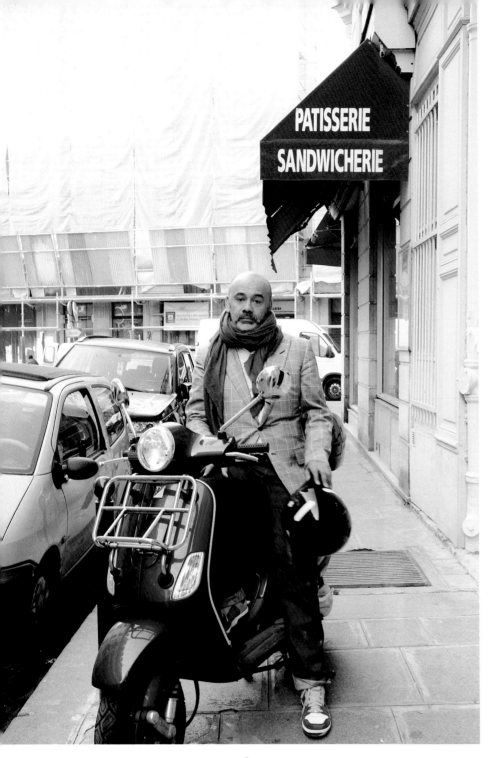

CHRISTIAN IS A BALL of positive energy that keeps on going and going. He has been renovating his apartment for about four years and it still seems nowhere near completion. His atelier has a trapeze hanging from the ceiling so that when he has spare time, he can literally swing from the rafters. For someone whose products are the definition of luxury, he is shockingly down-to-earth and humble. He drives around Paris in his sneakers on a beat-up scooter. His pet peeve is women telling him his shoes are uncomfortable to walk in. As he says, some of his shoes are "for the bedroom and not for the workroom."

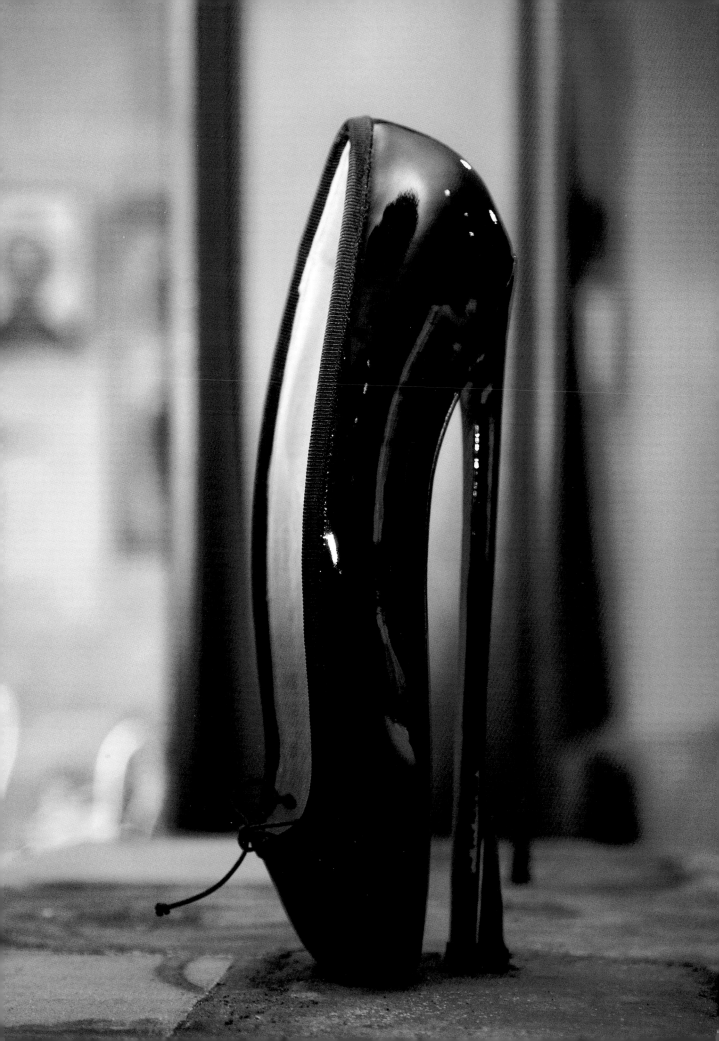

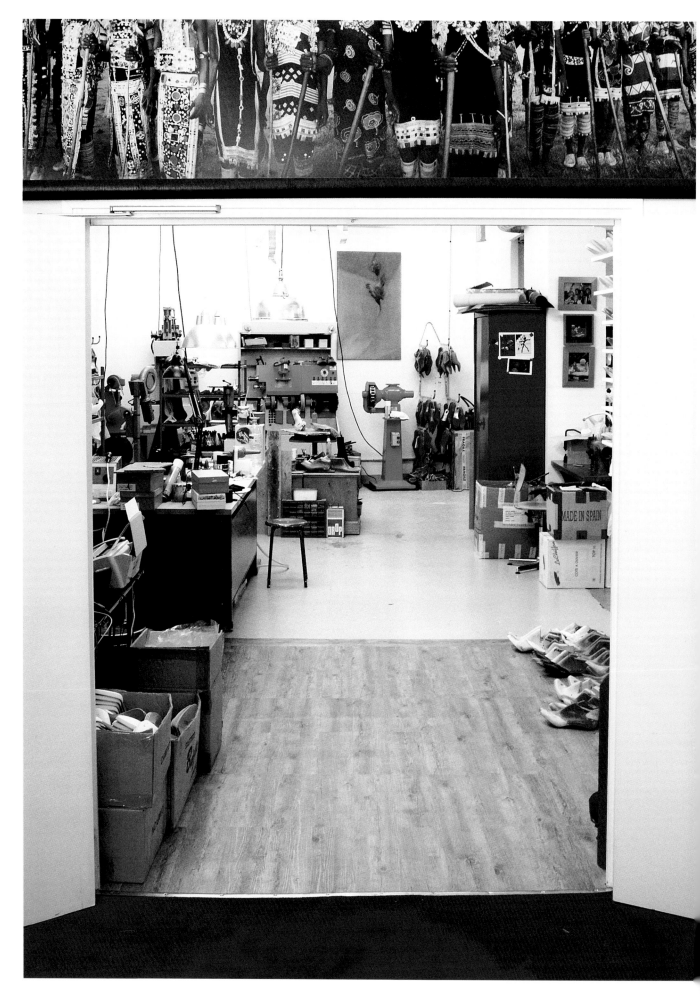

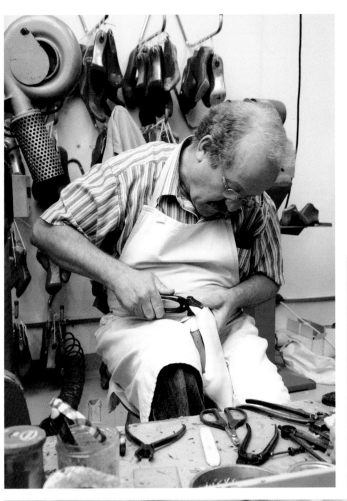

Christian designed this
Siamese twin shoe for
the exhibition "Fetish" in
collaboration with David
Lynch.

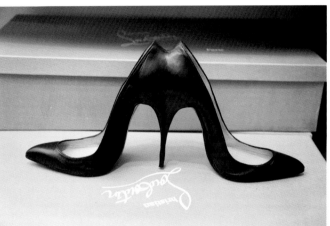

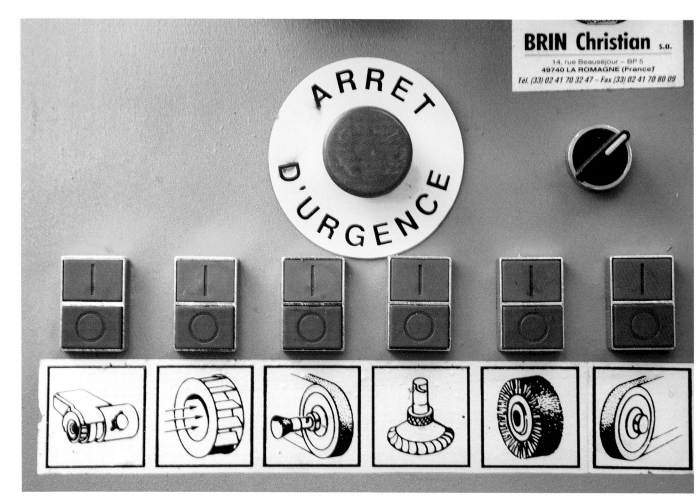

The chandelier in Christian's atelier.

Wooden shoe lasts in the workshop.

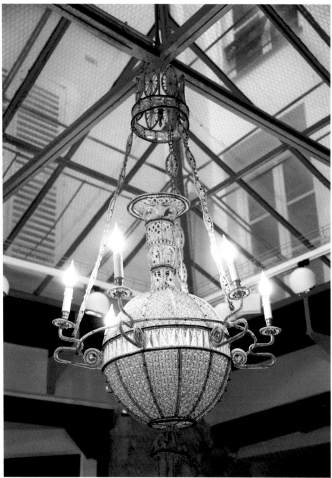

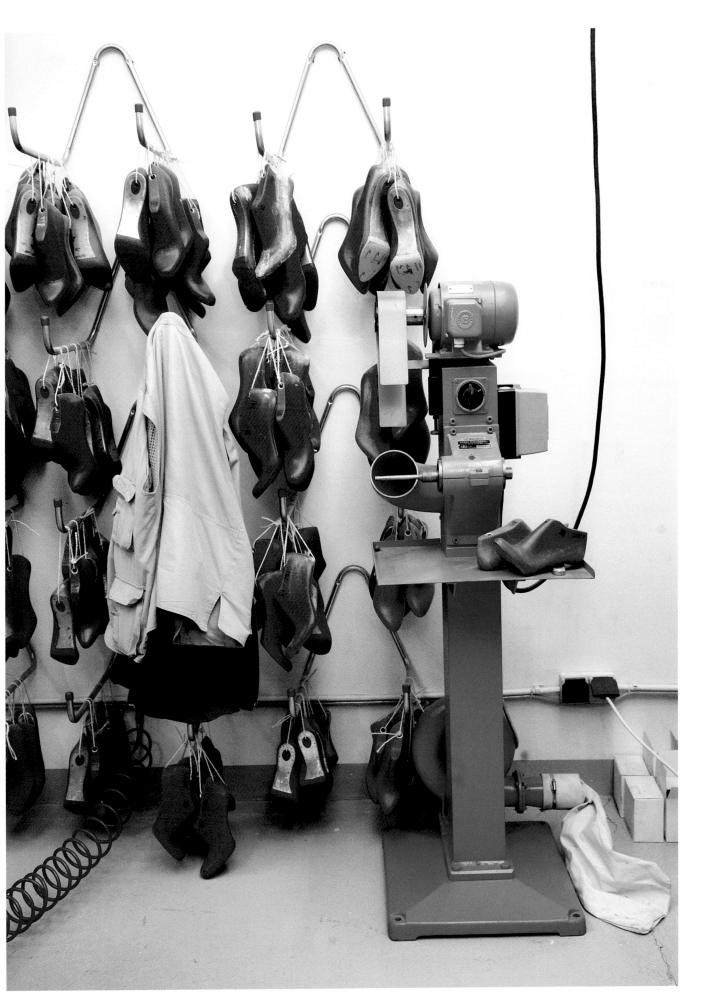

Christian could you draw the first high heel you ever designed?

I WAS 12 - xT.

Why did you start putting red on the bottom of your shoes? IT IS A green-light "Follow me young man....!!!" style with The color of passion.

What are your favorite places to find inspiration in paris? My Bed-

What are your best words of advice to aspiring designers? Follow your INSTICT. Believe, and only To This, To your imagination. DoNT THink Technique!

What was your inspiration for the skylights in Your new home? Paris' rooFs. I wanTed also To have The possibilities To see cats strolling on my roof.

What about your new place are you most excited about? I waiT ThaT IT rains, so I can hearn The drops above my Head-

Could you design a new scooter

What is your dream?
Being happy MYSELF, I wish hapiness Foh The would, And A good president ToThe US so iT Rolls again-
I would dream also To live 3 on 4 others lives in diFFenenT Time and ZoNes And diffewent places.

A Flying scooter.... I missed !!!

thanks!

jeff johnseh

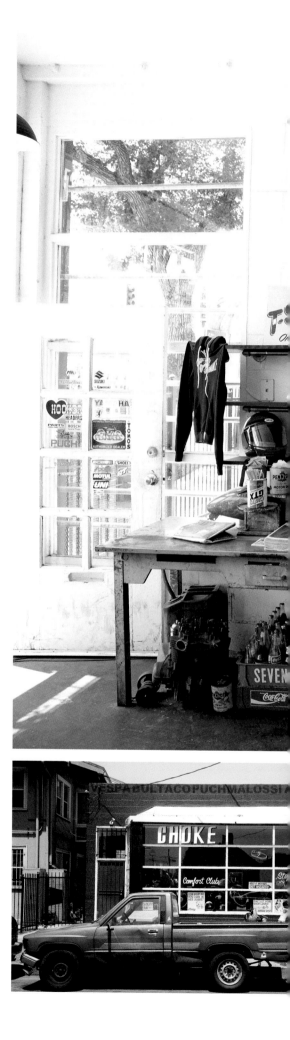

JEFF IS KIND OF a legend. When I first met him in New York City, he was an established coffee guru. Soon after we met he left the city to race Formula One cars. A year later I got word that he had moved to Los Angeles and opened a scooter garage/coffee shop called Choke. The coffee became so popular that people were lining up on the street to get a cup. So, of course, Jeff stopped serving coffee because it interfered with his pinball time and his work on the bikes. He is the kind of person who is so focused on doing his own thing he does not pay attention to the outside world. And the outside world loves him for it.

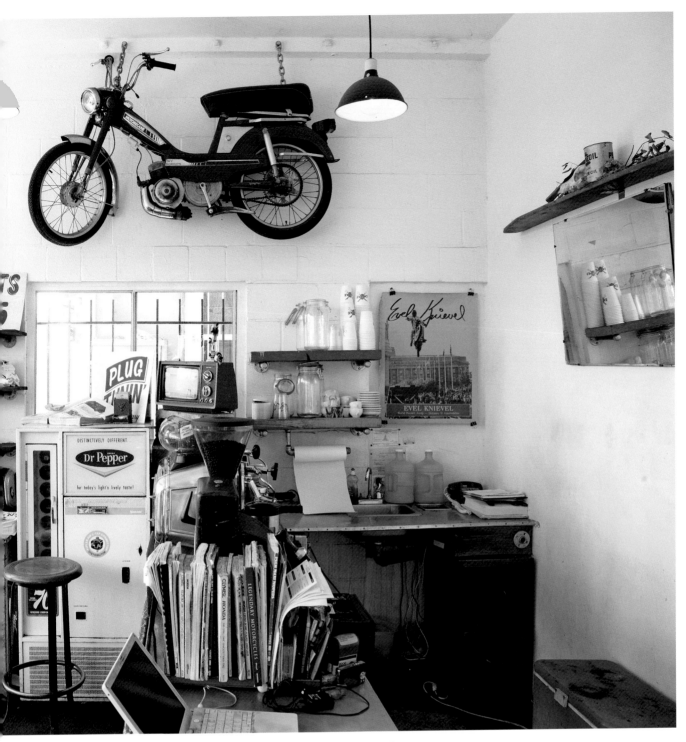

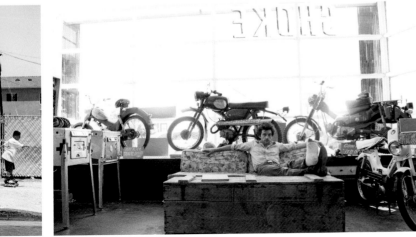

That is a French Motobecane 50v hanging from the wall.

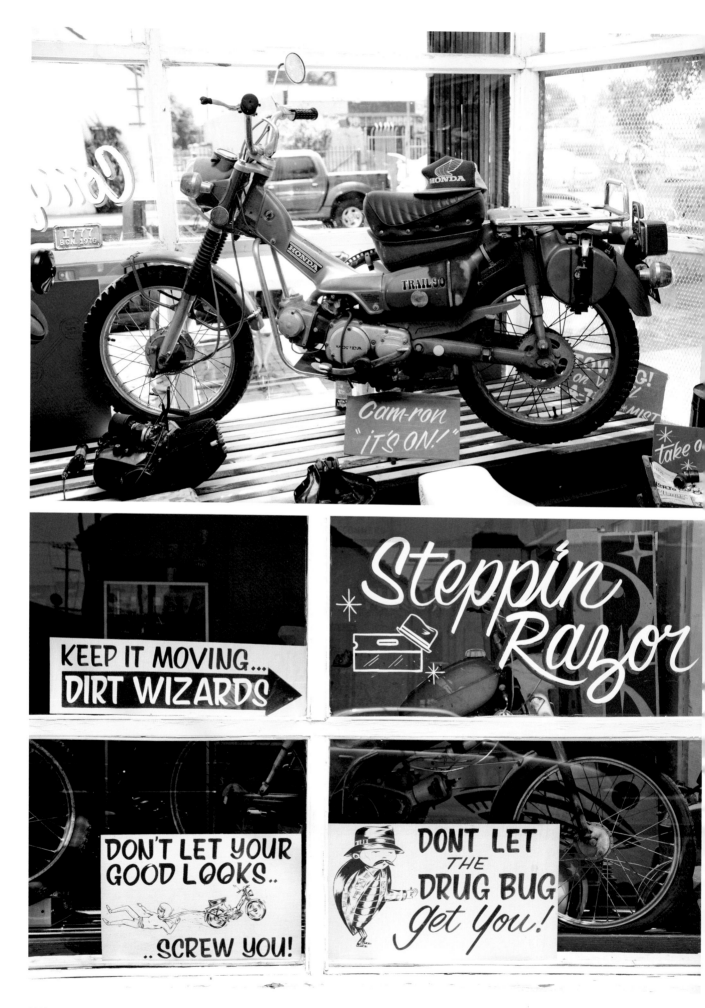

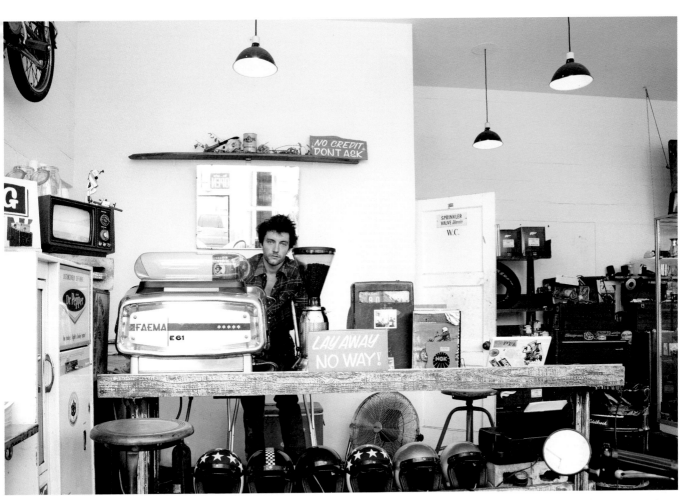

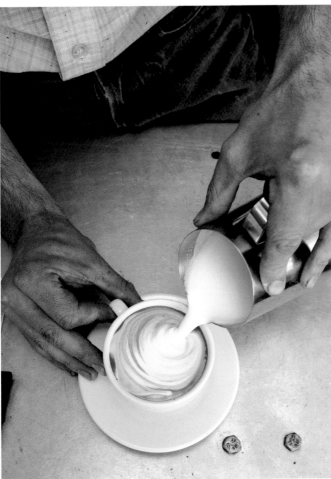

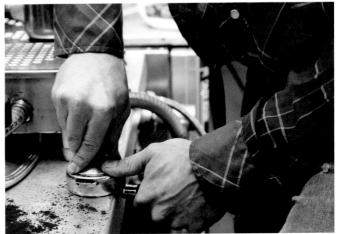

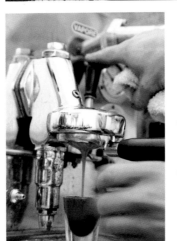

Tamping a shot from the 1962 Faema e61 espresso machine.

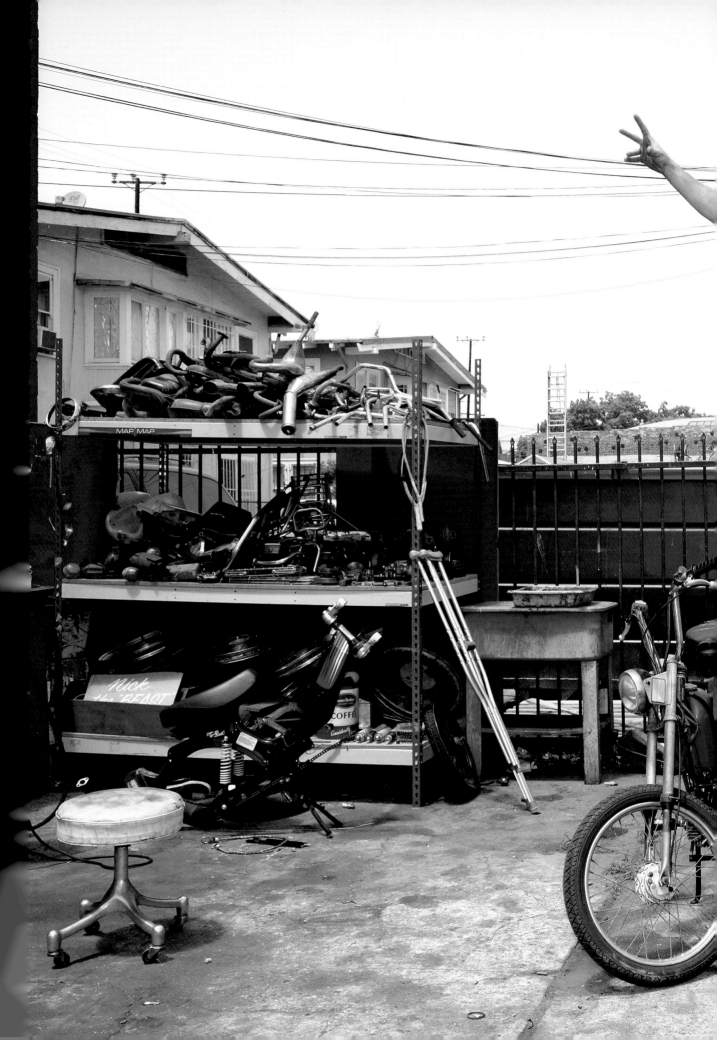

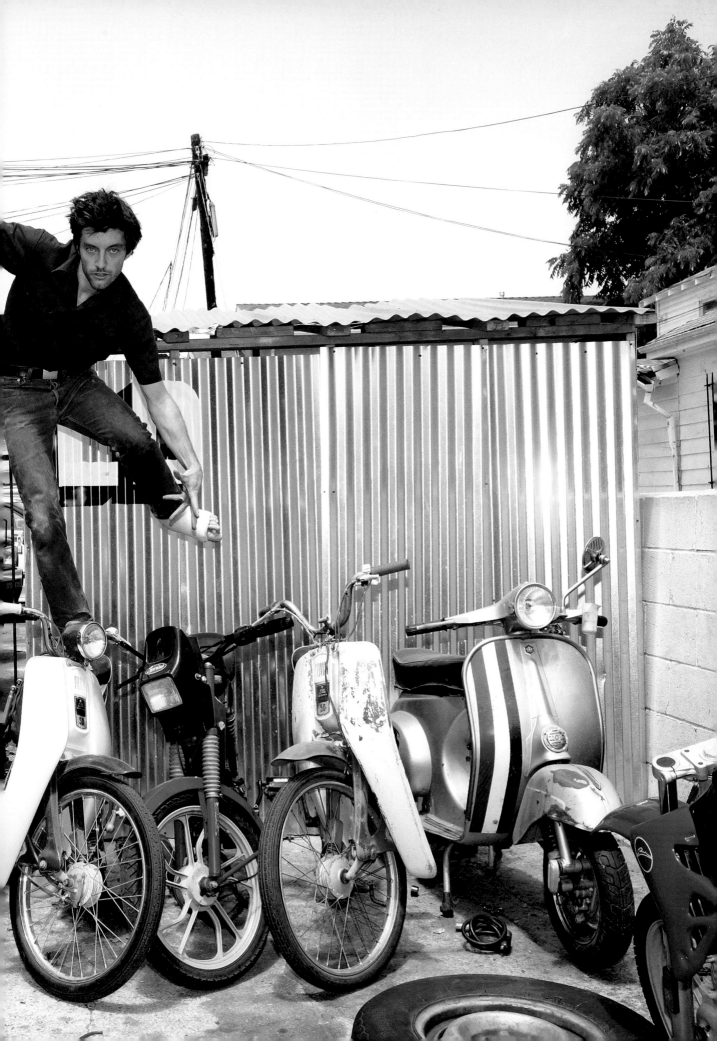

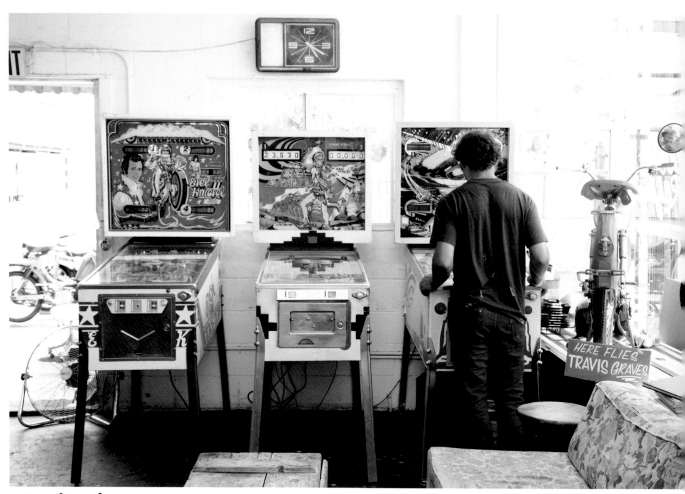

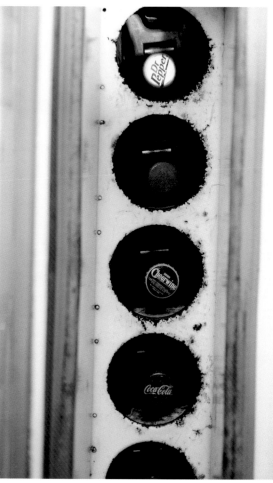

Jeff's favorite pinball machine is Big Brave made in 1974 with art by Gordon Morison.

An old Dr. Pepper Soda machine filled with Bubble Up, Mexican Coke, Cheerwine, and Dad's Root Beer. Soda definitely tastes better when it is made with cane sugar.

Hey Jeff tell me what you want to add to choke?

Dirt track in the side yard for 8cc dirtbikes

mini-motocross track son! also, pool on the roof. the roof looks like this now

what's the strangist thing about LA?

NORMAL AVE

who makes the signs here?

AlEXIS & FIN

who is your #1 customer?

WILLIAM FERNANDO ALAVARES

describe the ultimate scooter-

Honda Passport, stock motor, stock carb, tons of accesories

describe the ultimate espresso-

ecco reserve pulled on the faema E61 on a cloudy wet day tons of moisture in the air-

who is the best at the evel knievel pinball?

JOE Matt has the high score, 592,200. He is amazing at old pinball

draw your ultimate motorcycle ↓

PASSPORT.

Jeff what is your secret?

711 Hot dogs. seriously. so good

what are those amazing sodas called?

Bubble up. nesbitt orange. cheerwine drpr. miller highlife

where are the most attractive women in LA? The women of Bel Air, but they wont talk to me.

Any words of advice for carlos' new business?

Dont put doors on the bathroom.

Thanks Jeff + congrats on choke!
—Todd
thanks todd

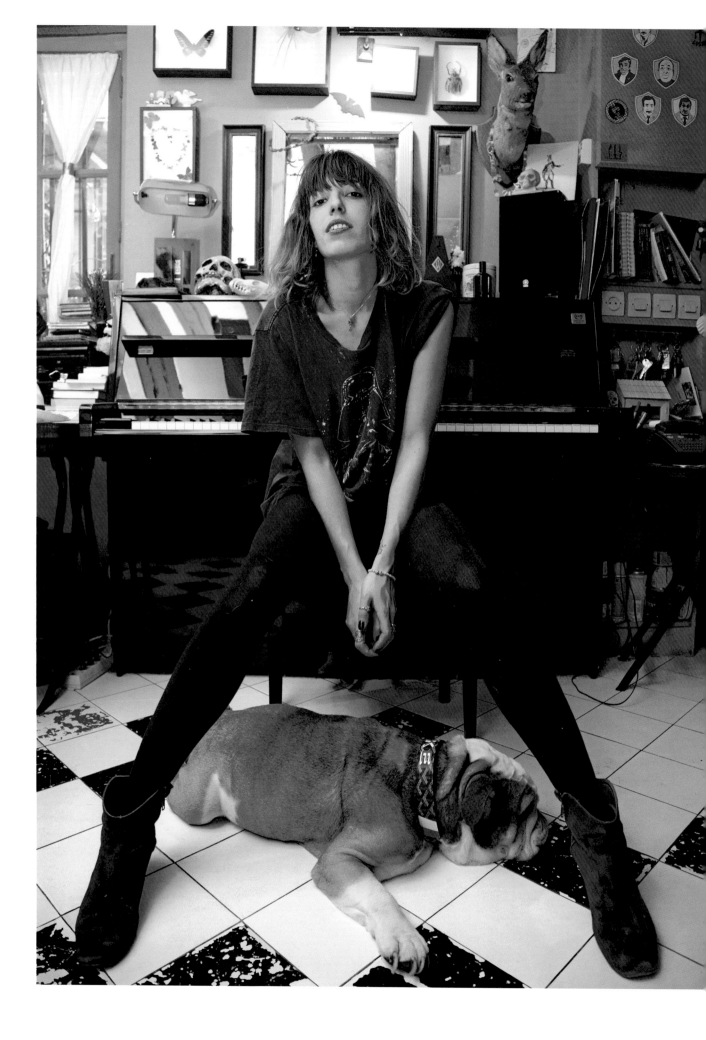

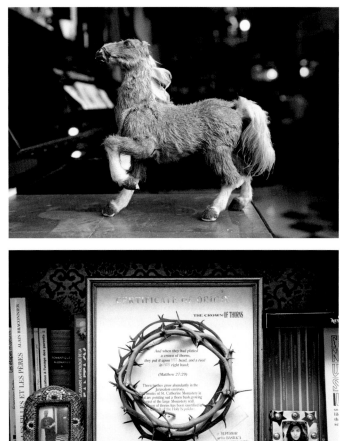

lou daillon

LOU LIVES WITH HER son in a skinny three-story house in Paris. She collects taxidermy, which her English bulldog loves to chew on. When she is home, she draws, plays music, hangs out with her son, and cuddles with her rabbits. Her friends often stop by to hang out and catch up. Lou defines effortless chic; she lives a carefree, bohemian lifestyle and serves as a muse to many people. In a family of super achievers, she seems to have achieved the most difficult thing: happiness.

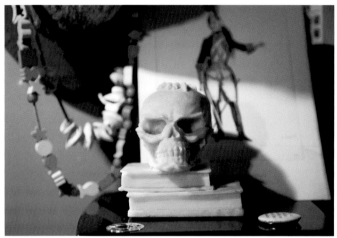

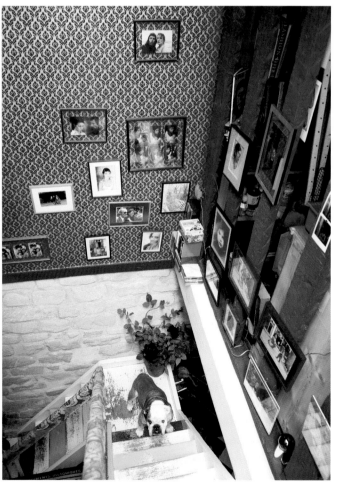

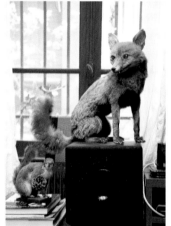

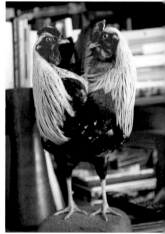

A two-headed rooster and many other flea market finds.

Spyke the English Bulldog deep in French Bulldog territory.

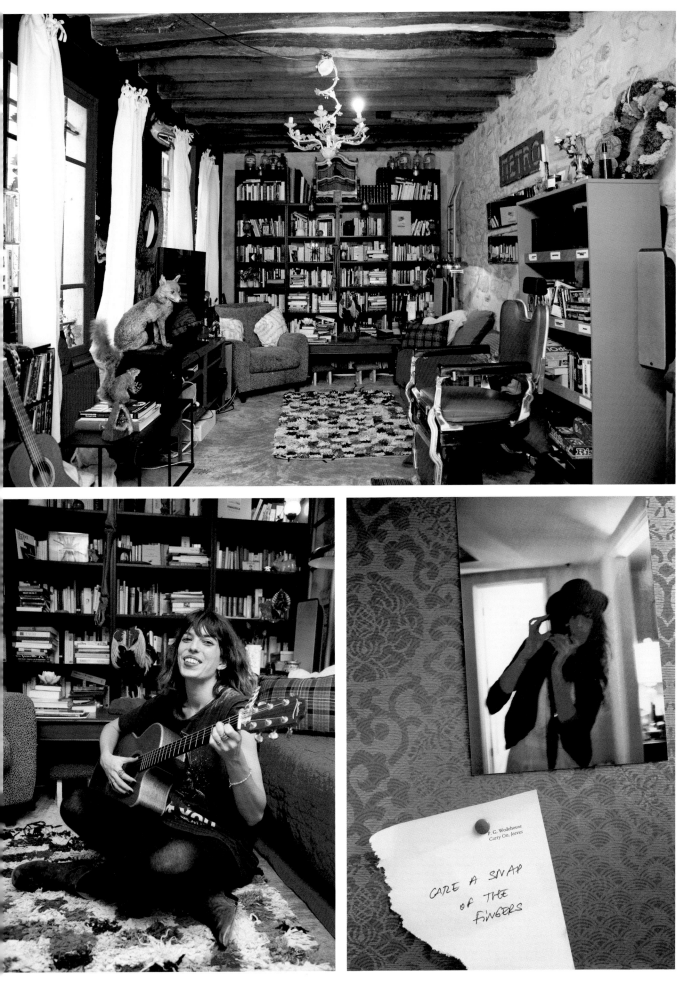

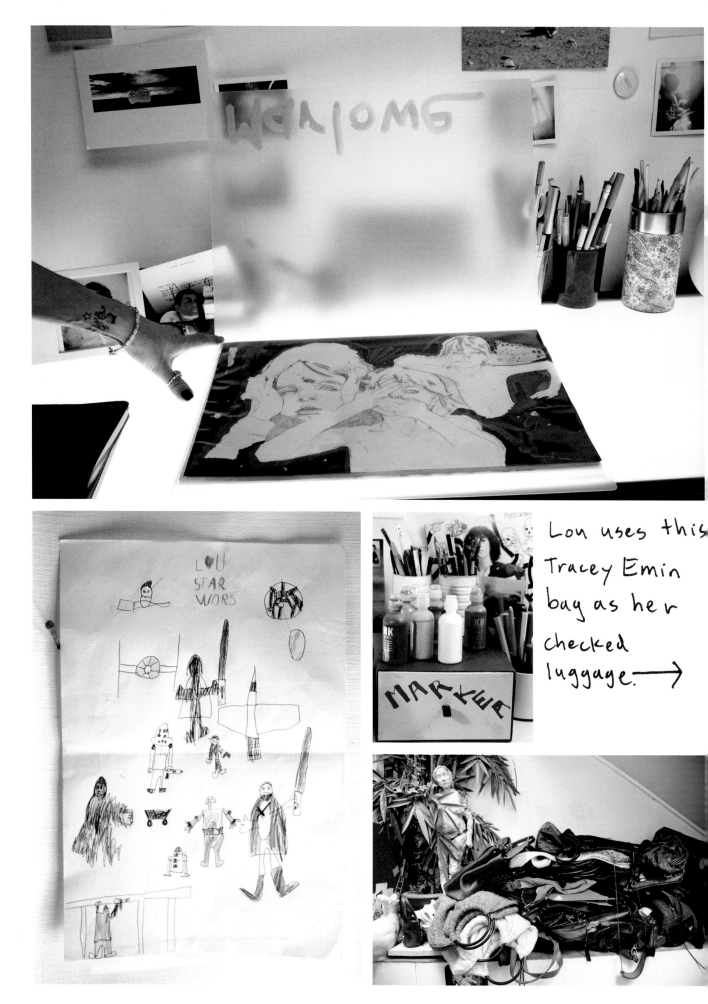

Lou uses this
Tracey Emin
bag as her
checked
luggage. →

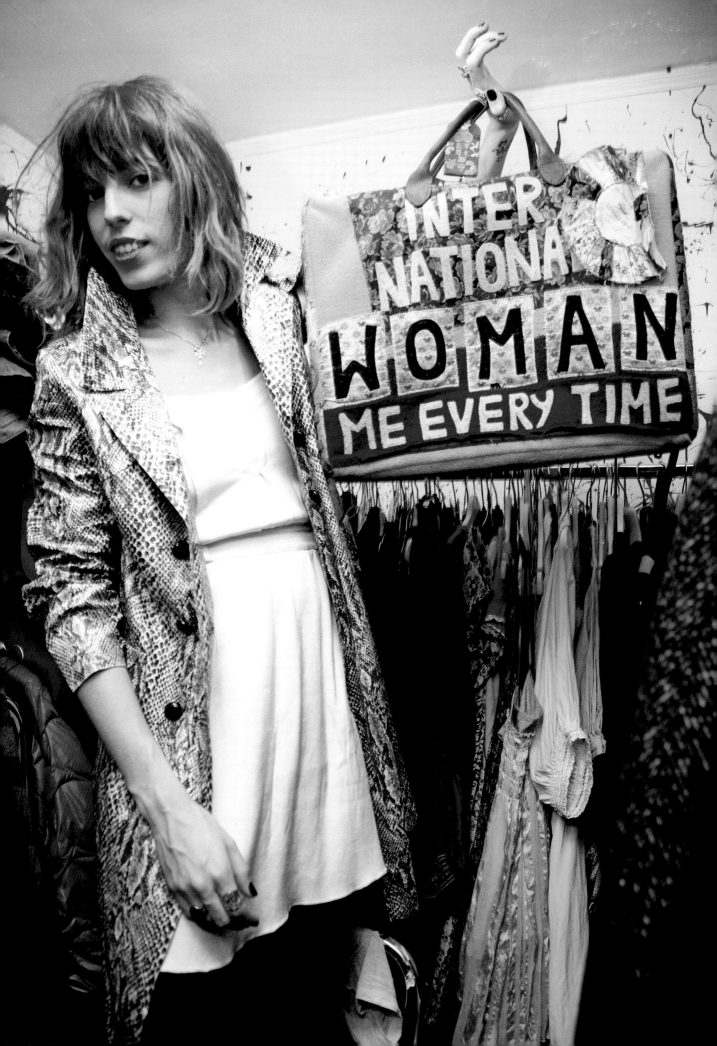

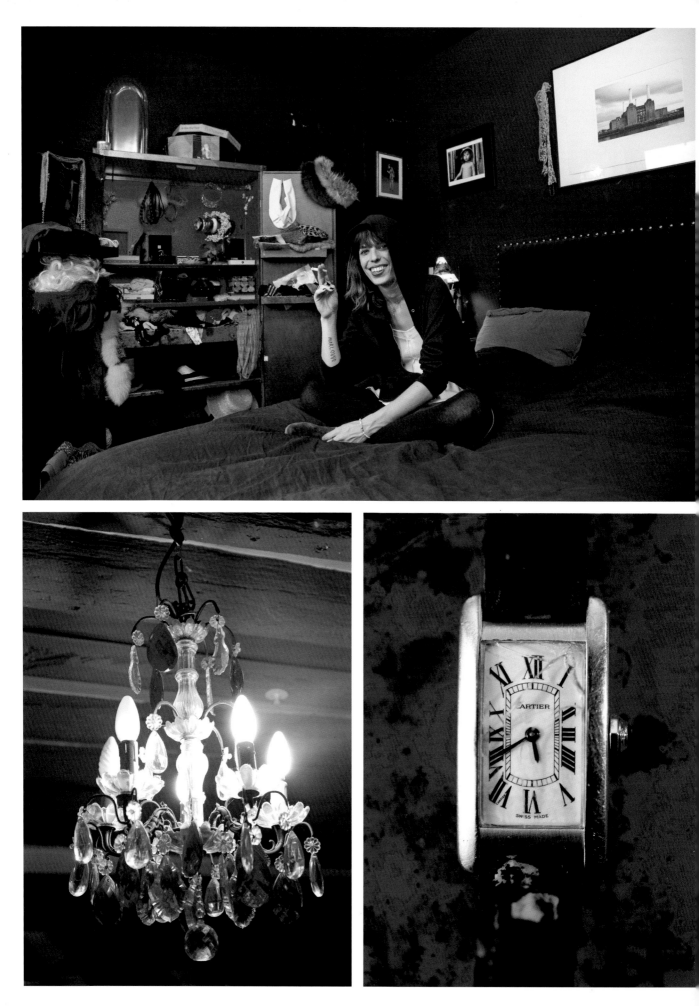

Hi Lou! Can you tell me how your dog spyke got food on film sets?

by standing under the catering table. He'd wait for a grip, or a stand in to hover around, and he'd start growling, thus (for sound reasons) they would give him everything on the table!

Could you draw your son's face)

marlowe's shot here so it's a hell!

How do you decide what film projects you want to work on?

don't know ...!
(tell me)

Could you draw your two headed rooster

what did you learn this year?
I'll tell you next year

could you draw Spyke at age 6 months

(the same but smaller)

What are your 6 favorite places in paris
1 my house
2 the fantaron (bar in the x1)
3 musée veterinaire
4 les catacombes (center)
5 musée romantique
6 le père lachaise

what surprises you?
human kind

what has changed in your personality in the last 10 years?
I'm softer than before,
And I compire now.
don't think it's a good thing ...
(At 16, I was better!)

Thanks!

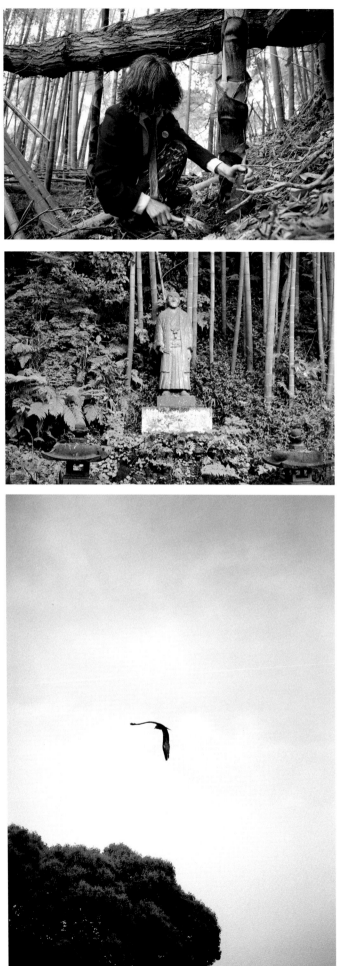

TAKÉ'S HOME IN JAPAN is a cottage in a bamboo forest that is only accessible by passing through a 50-foot-long dark cave. His house is filled with old fashion magazines, vintage clothes, brightly colored rugs, and photo books. Right now, Také splits his time between Kamakura and Paris. During Paris fashion week he goes to see the shows and then writes about his findings. He has a reputation for being brutally honest. He also has his own insane personal style, which makes him distinctive in an eclectic, rugged-dandy kind of a way.

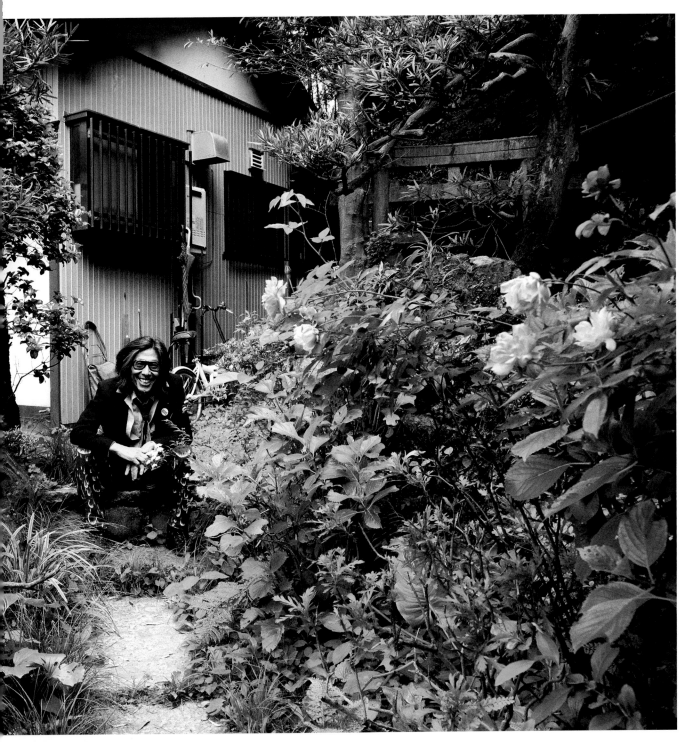

← Tuké is digging up bamboo shoots to make bamboo soup.

hirakawa takéharu

The Tv is a remnant from Discipline, Také's store (now closed) that was located in the back streets of Harajuku. Discipline sold vintage clothes that Také would bring back from Paris.

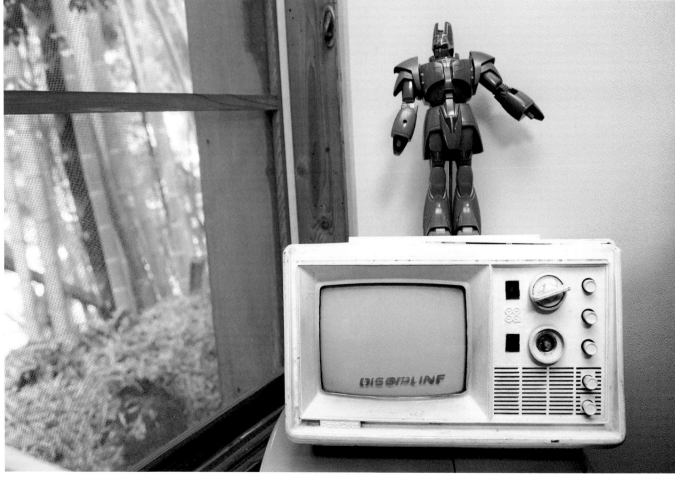

One of the seven lucky Gods from the shrine next to Také's house.

Hi Tuke! Could you draw yourself as a robot from the 80s ↙

Why is honesty important?
Sorry. I have a heart.

why is fashion exciting?
Sorry. not so exciting now.

Could you give me a recipie for bamboo soup?
① wash bamboo
② boild bamboo with boild water
③ add solt & sesami oil full of

what 6 things do you love about paris?
① Town. ④ metro
 ⑤ vegtable
② Street
③ Elegance ⑥ love

what 6 things do you love about Kama Kura
① Bamboo ④ moon
 ⑤ Sea
② Tunnel ⑥ old Book store
③ Temples

what is your advice for the young generation of clothing designers?
~~good~~ ① with heart, ③ good brave ⑥ good image
 ② "may I help you?" ④ good balance,
 ⑤ good concept

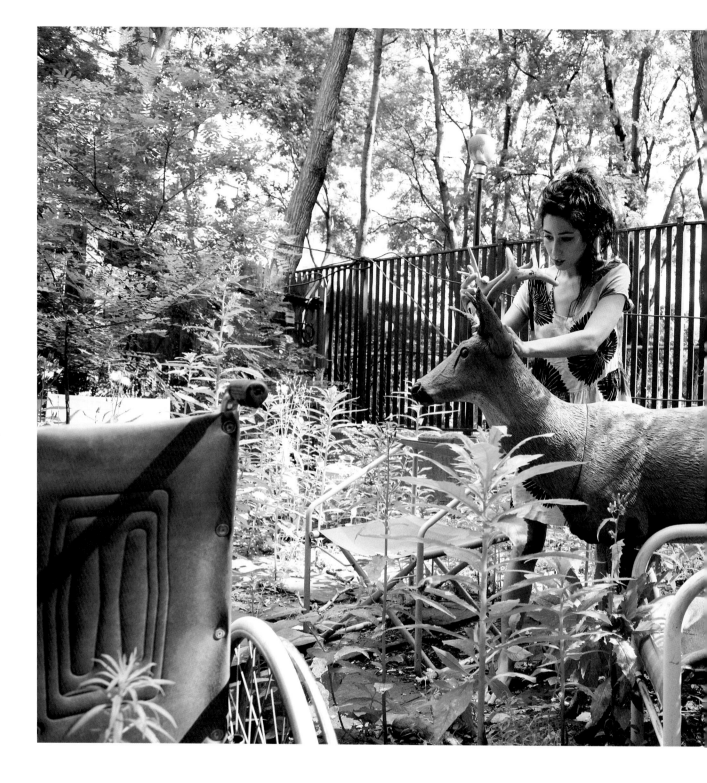

MERYL IS AN ARTIST who lives near my house in the East Village. She is the only person I know who has her own backyard in Manhattan. Her house and garden are filled with her artwork, which includes zombie babies, deer made from salt, and sea horses fashioned from peanut shells. You would never know how dark her art is if you met her outside her home, as she is super upbeat and has a huge smile. A mutual friend once agreed to house-sit for Meryl but was so scared by the zombie babies that she couldn't spend the night there.

meryl Smith

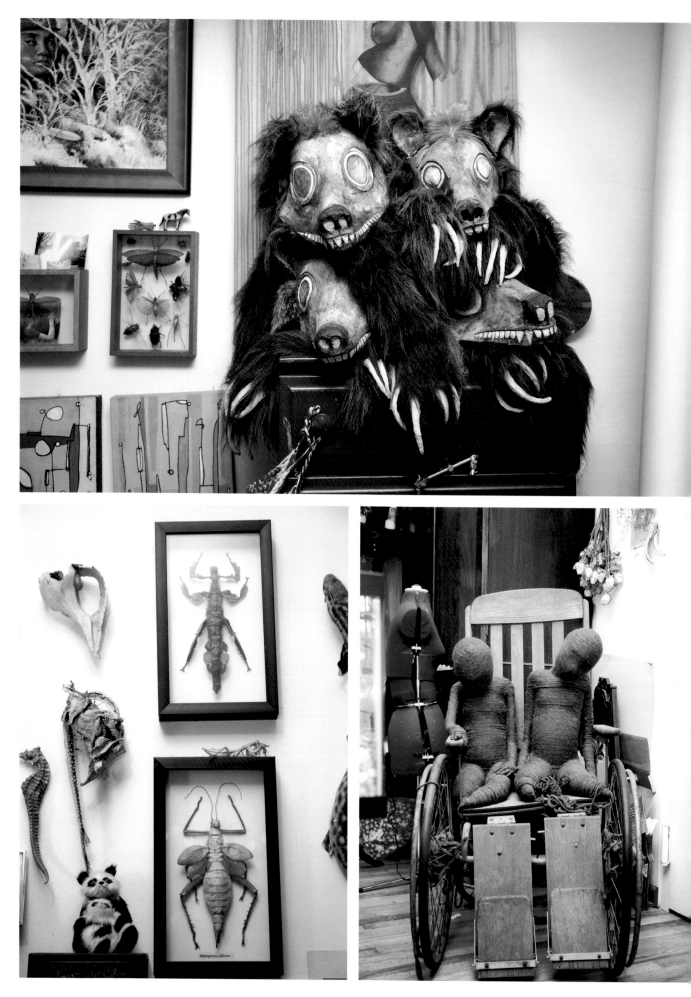

Figgin and Puddin the parakeets like to make out all day and scratch each other's heads.

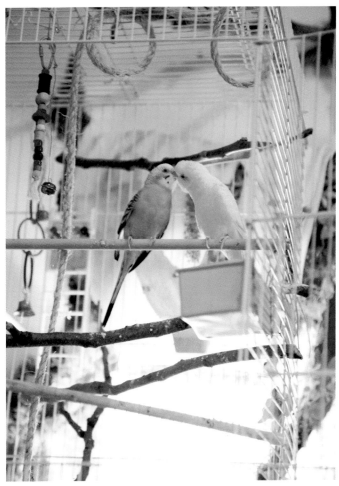

Meryl sculpted this sad greyhound out of athletic bandaging tape.

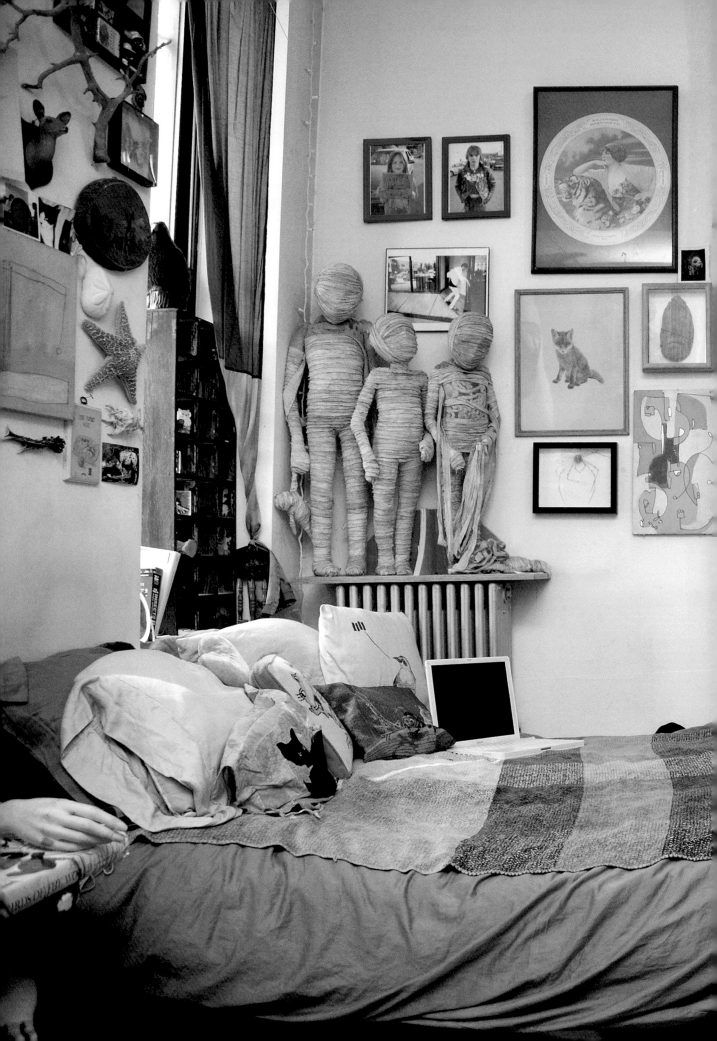

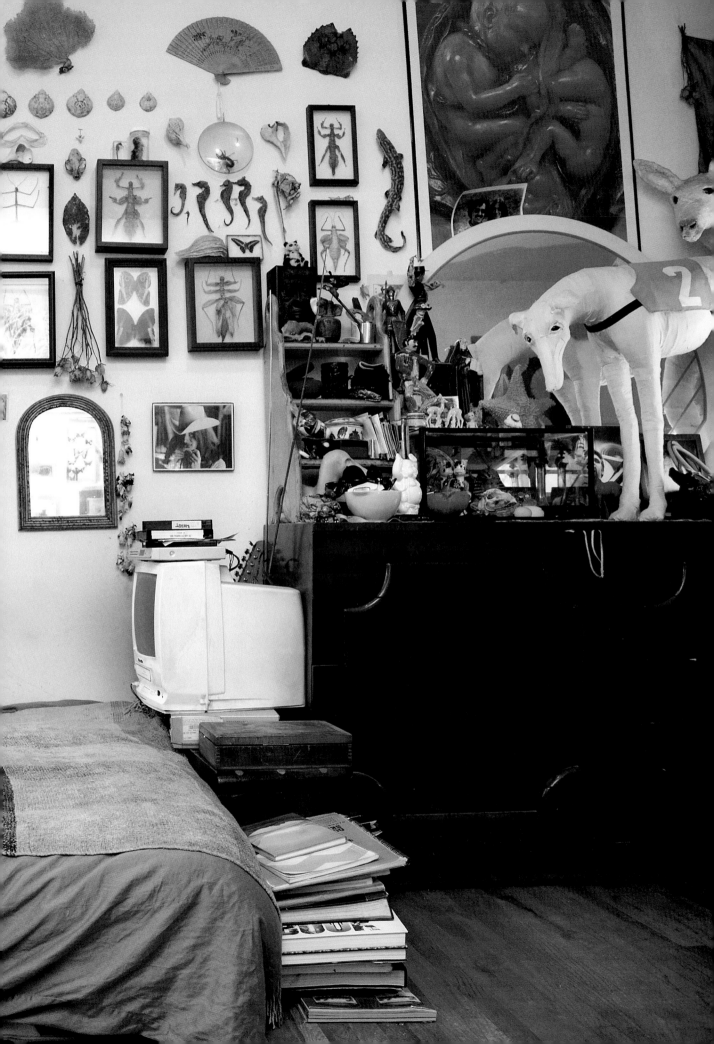

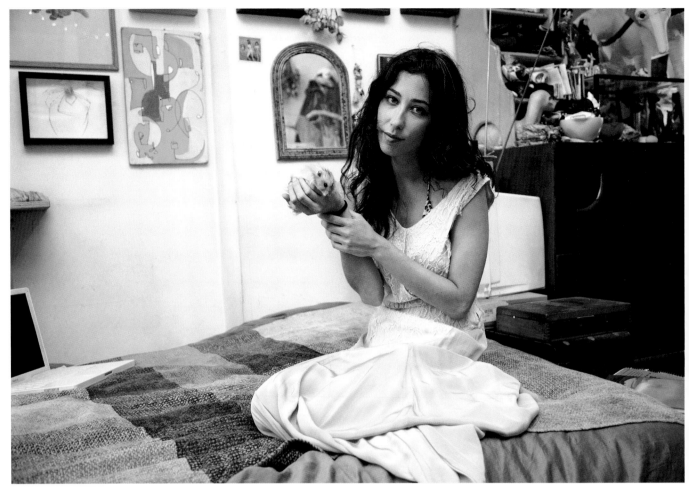

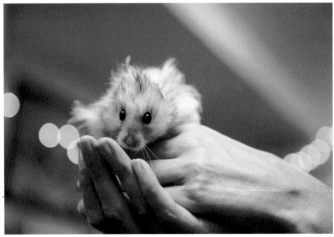

Boomer the hamster
was Meryl's best friend.

Meryl made the Tea Shirt
for an art show. It's a
functioning tea bag plus
T-shirt.

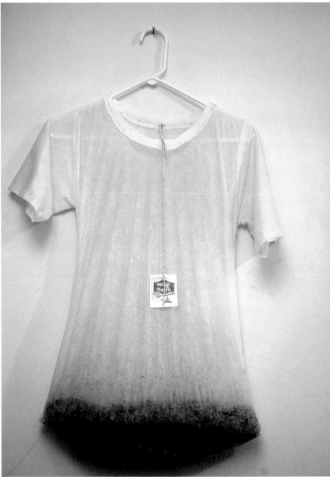

Hi Meryl! Can you draw the dog purse you made ↘

What's your favorite part of a 80's movie? THE PART IN SPLASH WHEN MADISON SAYS HER REAL MERMAID NAME AND BREAKS ALL OF THE TELEVISION SCREENS.

Can you draw 3 of your halloween costumes + label
↓ ↓ ↓

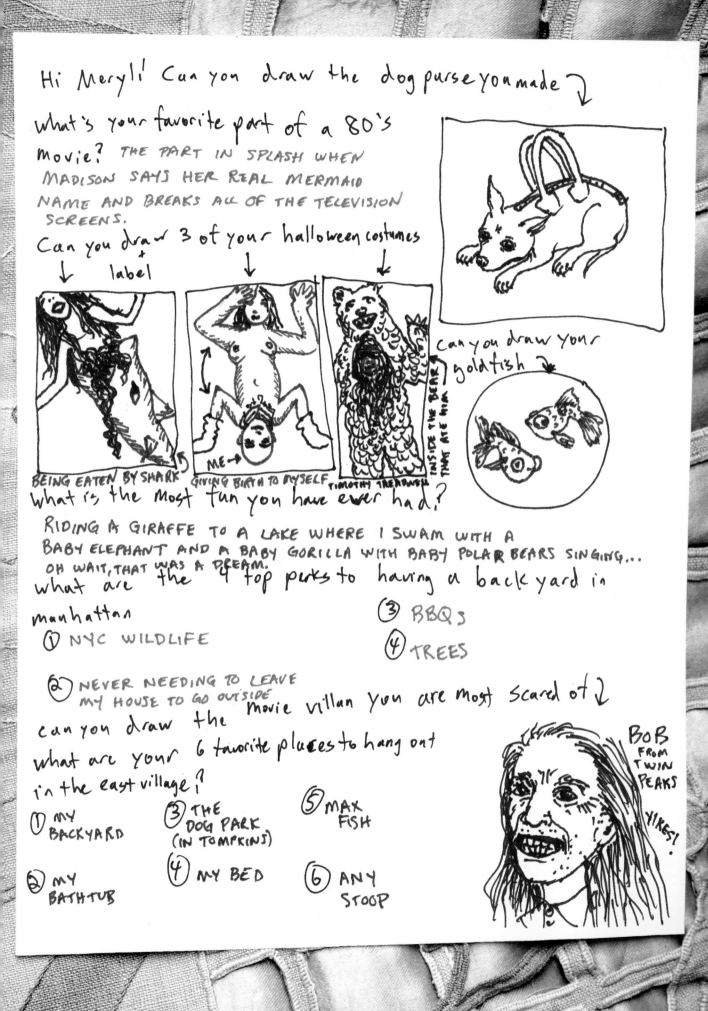

BEING EATEN BY SHARK

ME→ GIVING BIRTH TO MYSELF

TIMOTHY TREADWELL / INSIDE THE BEAR THAT ATE HIM

can you draw your goldfish ↘

what is the most fun you have ever had?

RIDING A GIRAFFE TO A LAKE WHERE I SWAM WITH A BABY ELEPHANT AND A BABY GORILLA WITH BABY POLAR BEARS SINGING... OH WAIT, THAT WAS A DREAM.

what are the 4 top perks to having a back yard in manhattan
① NYC WILDLIFE
② NEVER NEEDING TO LEAVE MY HOUSE TO GO OUTSIDE
③ BBQs
④ TREES

can you draw the movie villan you are most scared of ↘

what are your 6 favorite places to hang out in the east village?
① MY BACKYARD
② MY BATHTUB
③ THE DOG PARK (IN TOMPKINS)
④ MY BED
⑤ MAX FISH
⑥ ANY STOOP

BOB FROM TWIN PEAKS

YIKES!

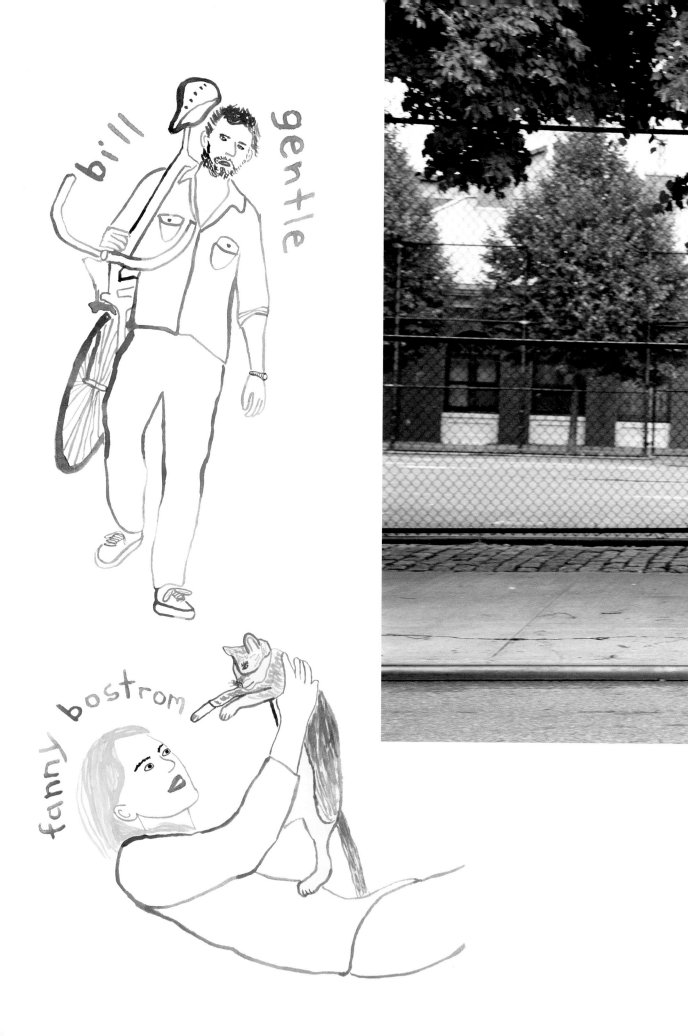

bill gentle

fanny bostrom

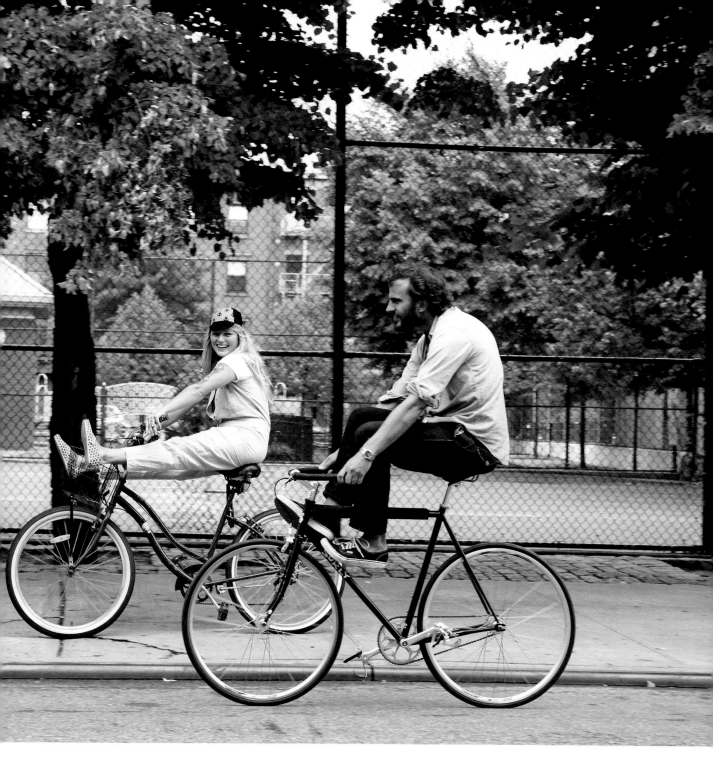

FANNY AND BILL LIVE in a ground-floor apartment in Williamsburg, Brooklyn, and have a big backyard that is covered with ivy and tomato plants. Fanny is a multimedia artist from Sweden and has made most of the artwork in their home, including the tepee in the backyard. You can see a lot of Fanny's love for folk art and crafts in both the things in her house and in her artwork. Bill is one of my best friends and is a great photographer and a warehouse of information about clothing, cars, beauty products, watches, and camera equipment. They are both big personalities, and being in their house is like being at a nonstop sleepover party.

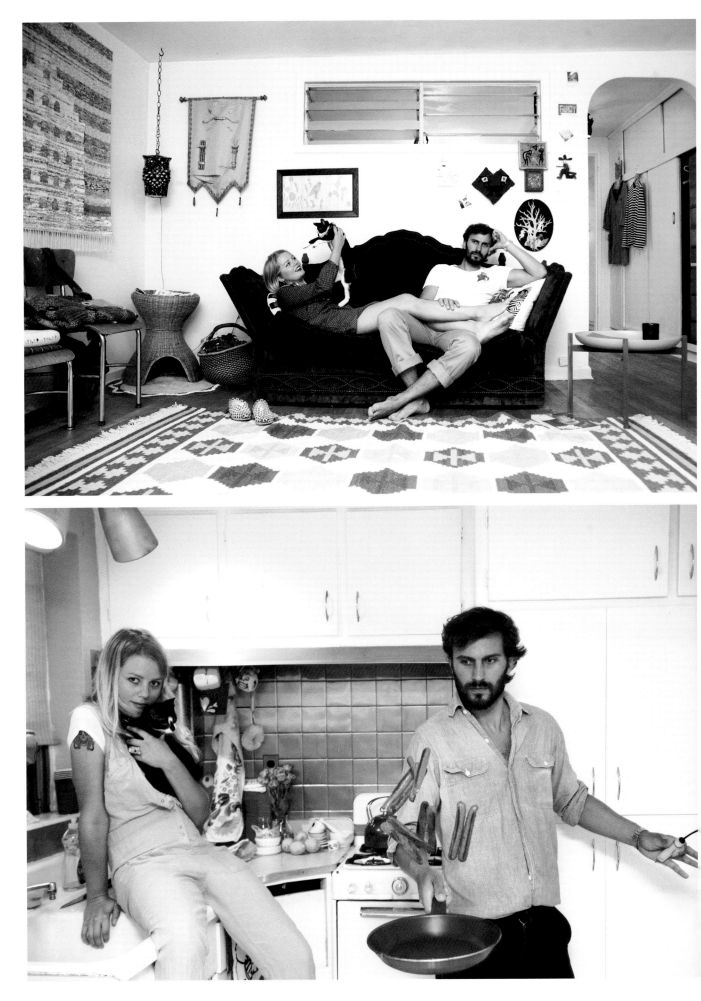

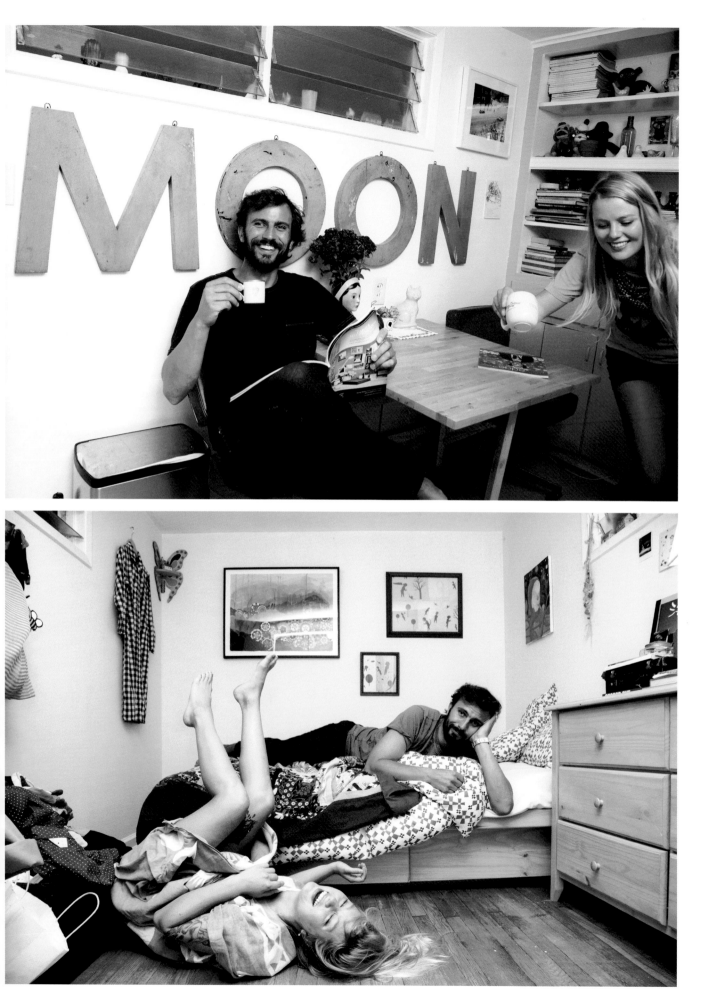

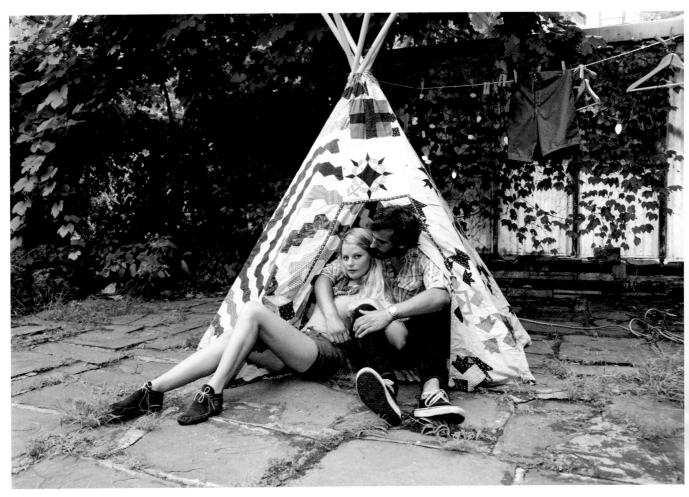

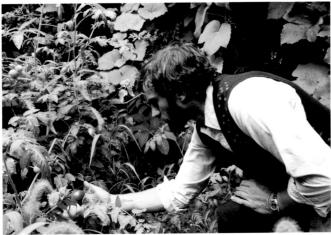

Bill checking the growth of his tomatoes.

Hey Bill + Fanny nice place! Serious question for you guys and no lying how many cats are in here? 2

only two, as far as I know... i wish there was more

Fanny draw bills face here 2

Bill Draw Fanny's face →

Bill what are the top places to eat in london? AGUO + DALO FULHAM ROAD LOBSTER SPAGETTI

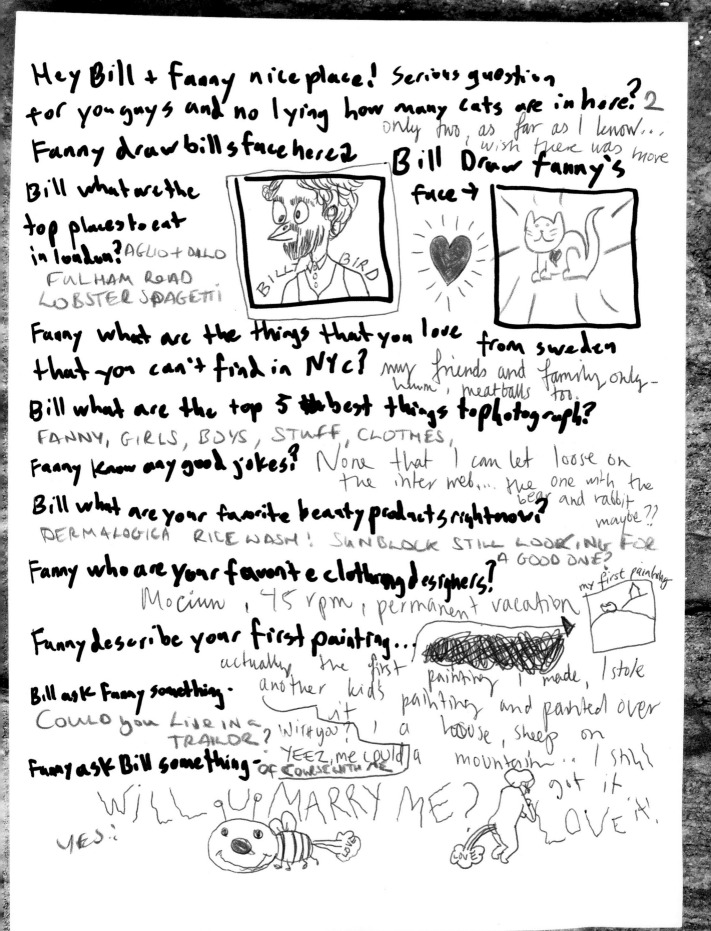

Fanny what are the things that you love that you can't find in NYc? from sweden my friends and family only - hmm, meatballs too.

Bill what are the top 5 the best things to photograph?
FANNY, GIRLS, BOYS, STUFF, CLOTHES,

Fanny know any good jokes? None that I can let loose on the inter web.... the one with the bear and rabbit maybe ??

Bill what are your favorite beauty products right now?
DERMALOGICA RICE WASH! SUNBLOCK STILL LOOKING FOR A GOOD ONE?

Fanny who are your favorite clothing designers?
Mocinn, 45 rpm, permanent vacation

my first painting

Fanny describe your first painting...
actually the first painting I made, I stole another kids painting and painted over it a house, sheep on mountain... I still got it LOVE it!

Bill ask Fanny something.
COULD YOU LIVE IN A TRAILOR? With you? YEEZ me could of COURSE WITH ME

Fanny ask Bill something - OF COURSE WITH ME
WILL U MARRY ME?
YES!

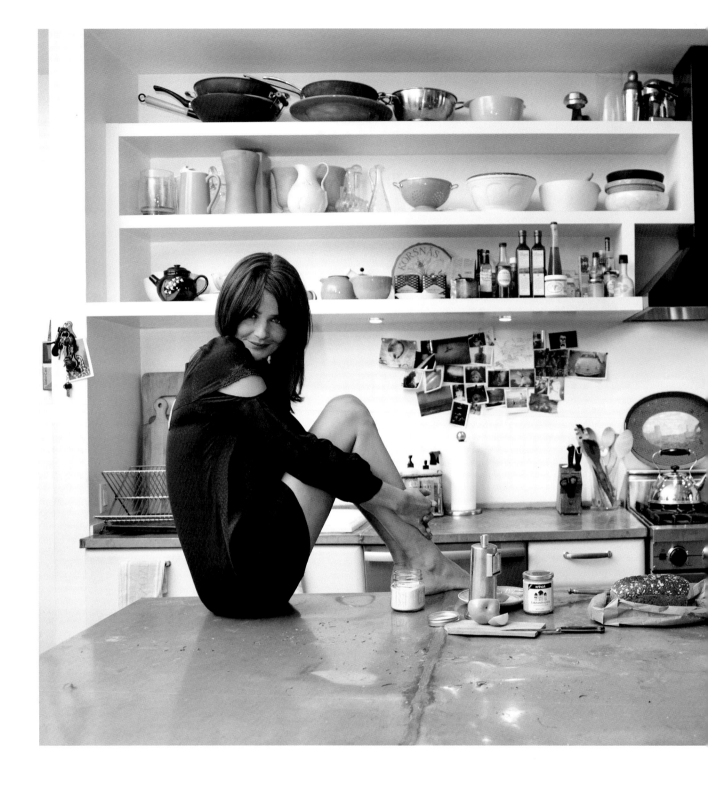

HELENA IS A SUPERMODEL with a capital "S," which usually means diva attitude. But she is actually a down-to-earth, chilled-out free spirit. She used to own a vintage clothing and furniture store in the West Village, which she stocked with wonderful treasures that she hated having to sell. Her apartment is a bright, brick-walled Greenwich Village floor-through filled with furniture and bric-a-brac in a perfectly executed Victorian-Americana style.

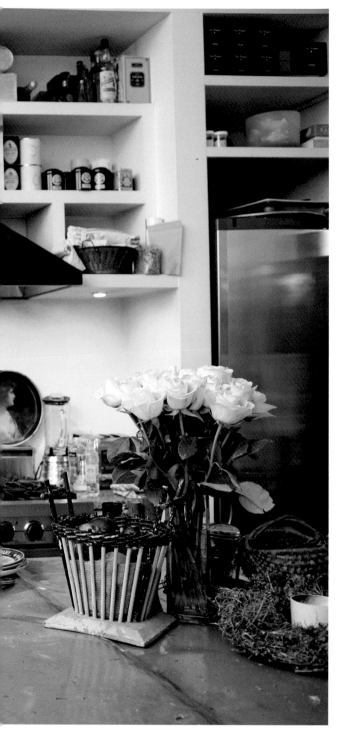

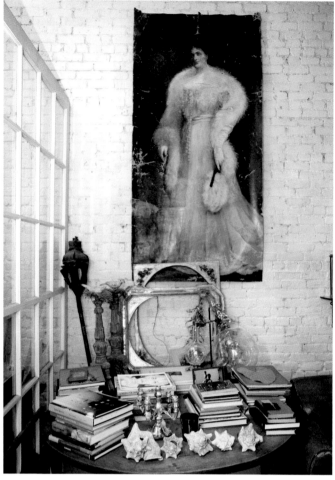

helena christensen

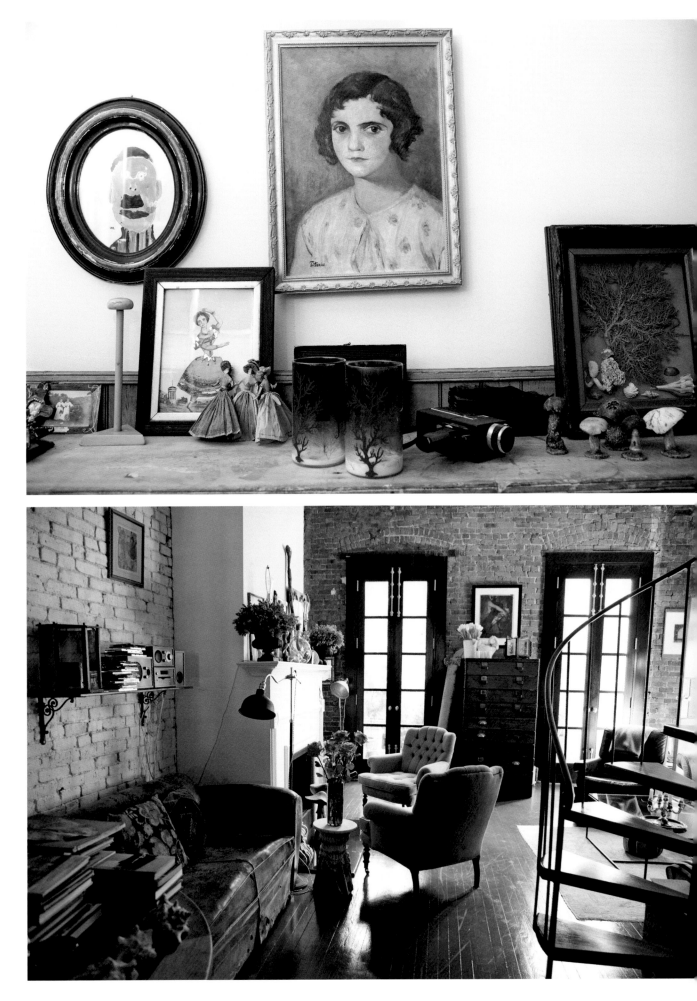

Helena takes photos and then makes paintings based on those images.

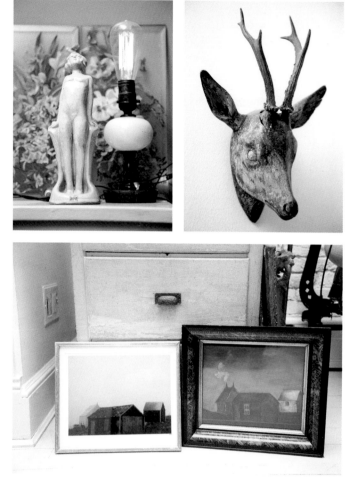

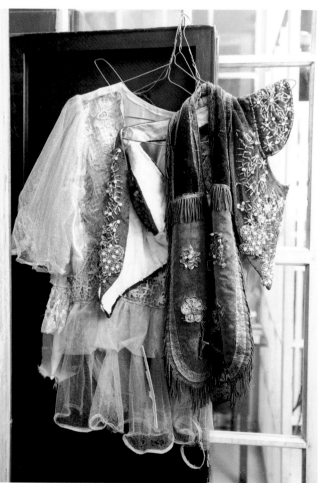

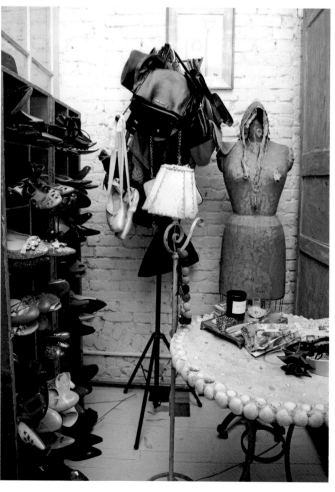

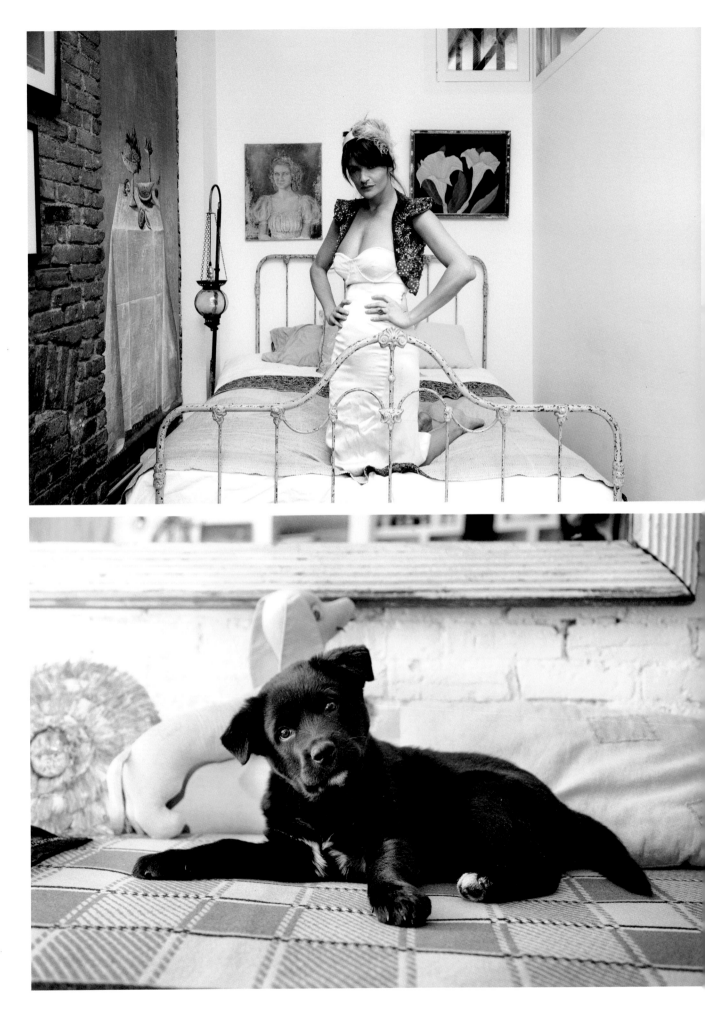

Hi Helena! What 4 things that you sold from your shop
do you wish you never sold?
① an old wicker chair ③ little old gold ring for baby
② a little elephant toy from ④ everything else that was in there
 Japan Morris Minor
Could you draw your Morris Minor car ↘

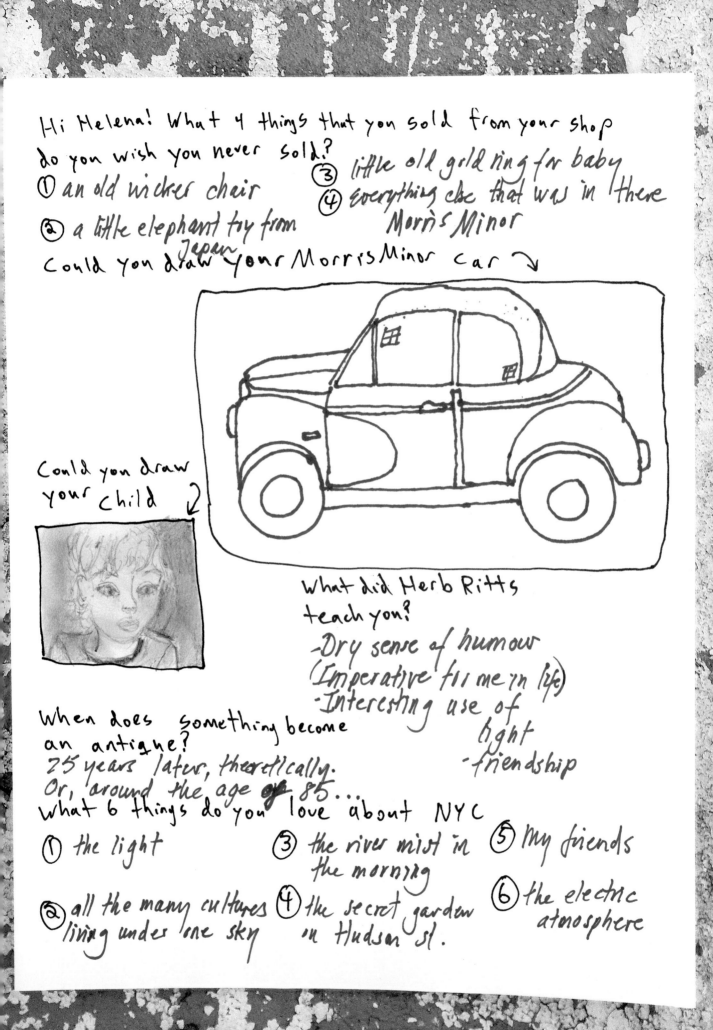

Could you draw
your child ↘

What did Herb Ritts
teach you?
-Dry sense of humour
(Imperative for me in life)
-Interesting use of
 light
-friendship

When does something become
an antique?
25 years later, theoretically.
Or, around the age of 85...
what 6 things do you love about NYC

① the light ③ the river mist in ⑤ my friends
 the morning

② all the many cultures ④ the secret garden ⑥ the electric
living under one sky on Hudson st. atmosphere

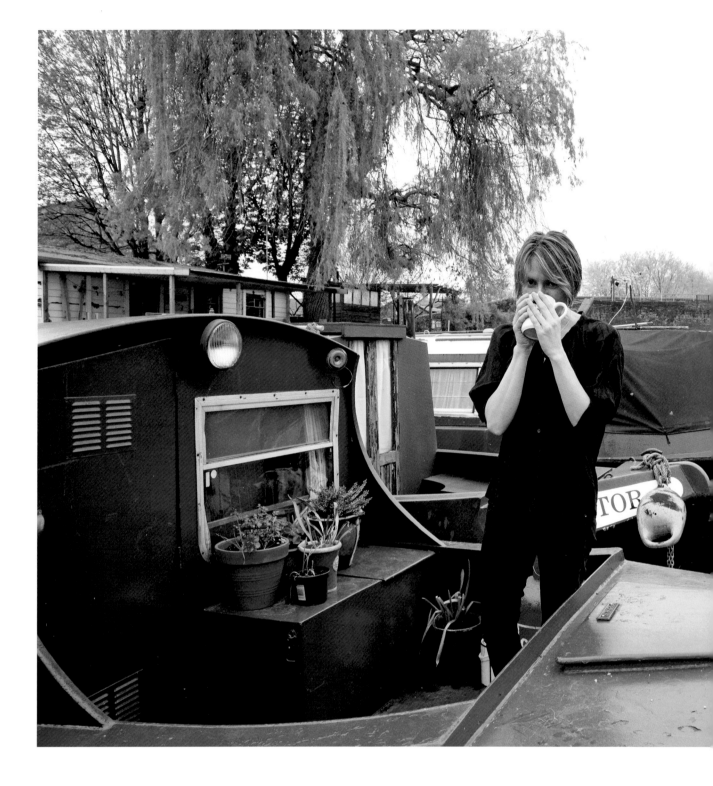

RETTS'S HOME IS MY favorite in this book. She lives on a canal boat moored at a private marina in central London. Retts bought it and, never having navigated a boat before, piloted it for five days by herself through the canals to London. I often daydream about living on her boat, reading *Towpath* magazine, hanging out with the local houseboaters at their private tavern, and feeding coal into the mini-stove. Funnily enough, her home is the only one I have ever photographed that is smaller than my own.

Retts's boat is named Borboleta, which is Portugnese for butterfly. ↓

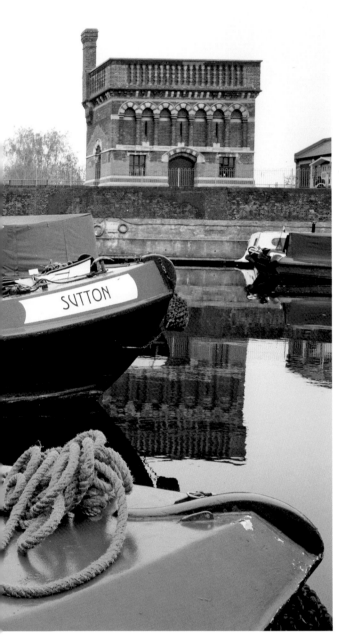

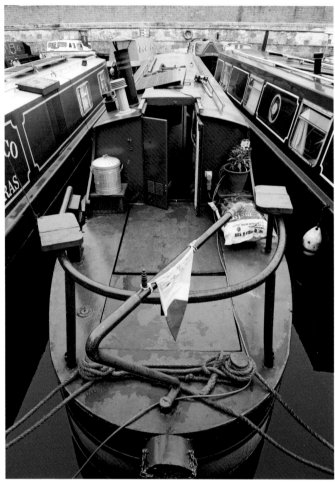

retts wood

Peacock butterfly

The boatyard is amazingly peaceful given that it is right in the middle of London and next to train tracks. →

Sir George Gilbert Scott designed this water tower, which now serves as a private bar for the canal boat club that Retts belongs to. ⟶

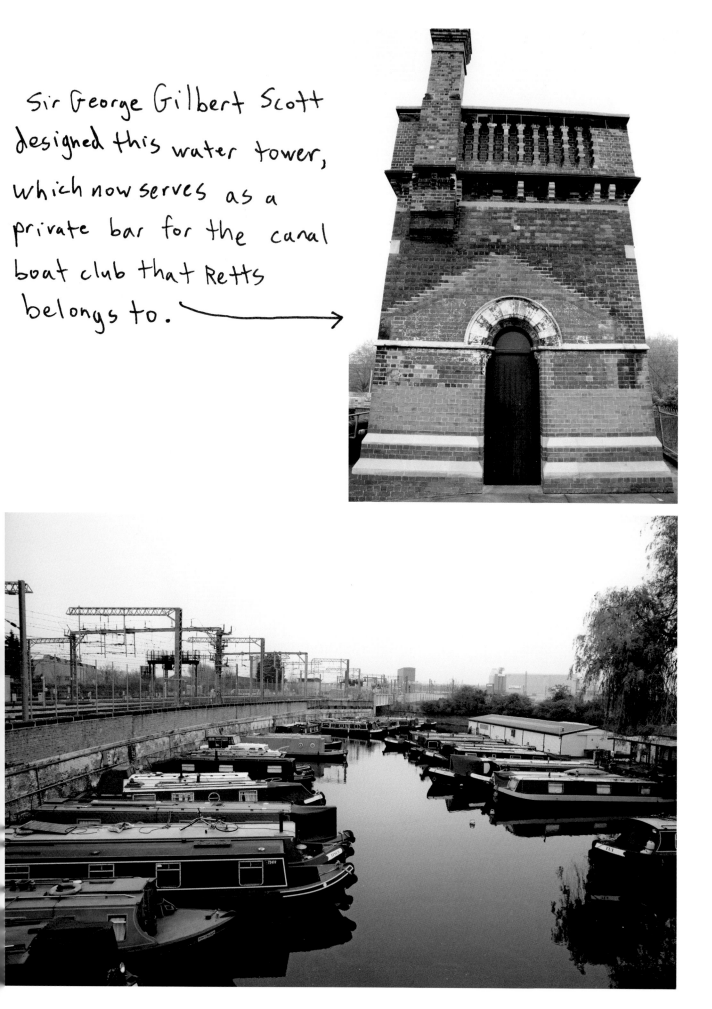

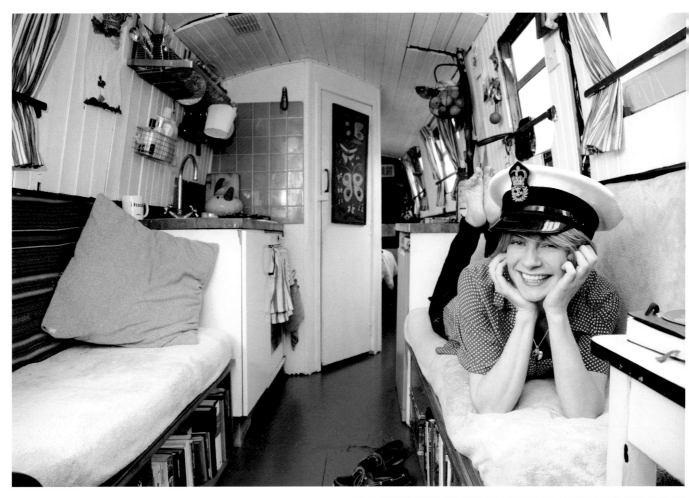

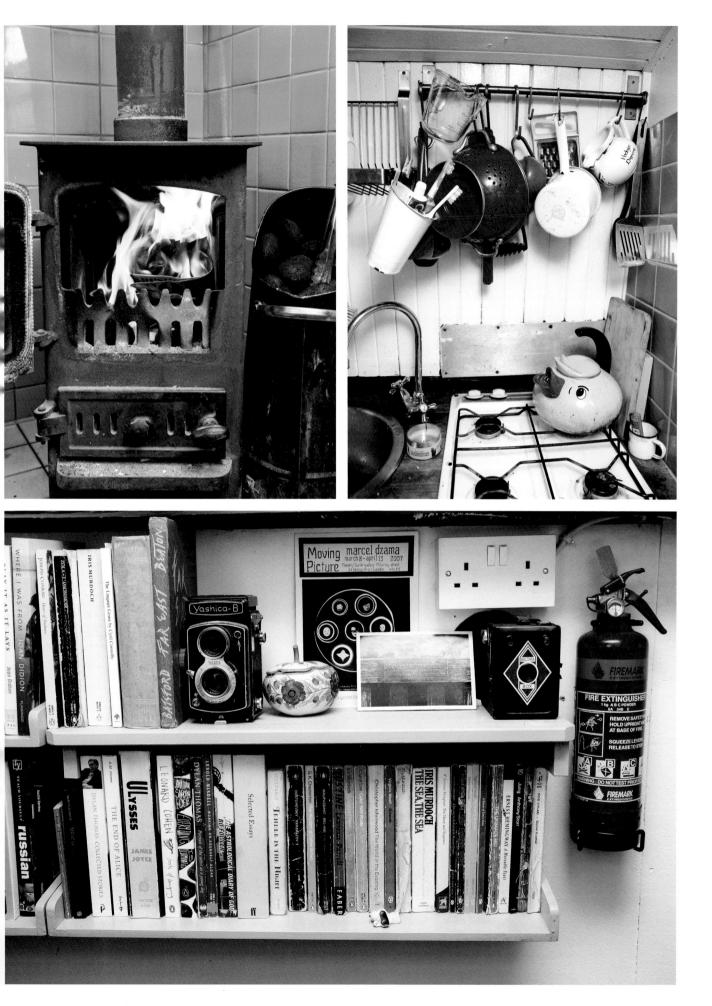

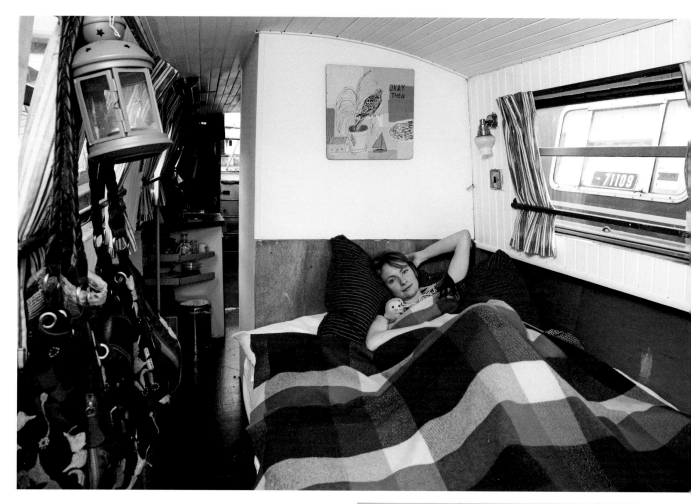

These slippers are like little duvets wrapped around your feet. ⟶

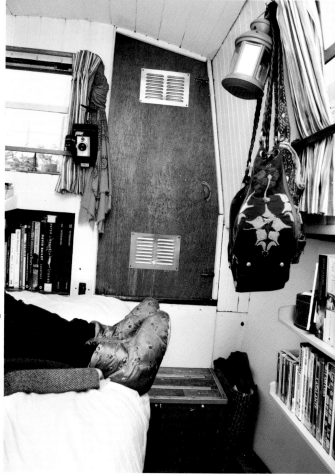

Hi Retts! What are the 6 advantages to living on a canal boat

① I can take my house on holiday with me!

② its ^super cheap way to live in London

③ taking everyone out for rides in the summer

④ my amazing community of neighbours

⑤ have a little fire for heating instead of central heating

⑥ its tiny so it stops me ~~from~~ accumulating rubbish!

Could you draw your boat from the side ?

Could you draw your kettle ?

What 4 things have you learned from having your boat

① Bags of coal are very heavy!

② You don't really need 'mains' electricity

③ there are good things about being short

④ Doing your own diy. is fun! I've even learned to fix my engine a bit....

What excites you about photography? Its great to meet people who feel awkward about being photographed + then manage to get them to relax + look amazing + its such a privilege to be allowed into peoples lives + to go to places + try to capture what you're feeling....

Could you draw your boat name. (its 'butterfly' in portuguese)

What are the 6 most important things to keep in mind while boating the river Thames

① no matter how chilly it is a night swim will be amazing.

② swans are vicious

③ its more fun if you moor in the middle of

④ no more don't fall in in tidal waters, but on the non-tidal bit its like a good cold bath

⑤ lovely Thames pubs!

⑥ narrow boats are better than plastic boats.

Where are some places you would like to take your boat? out to sea! can i come and visit you in Manhatten? It would only take a year or so to drive over, i go at 4 mph!

Thanks!

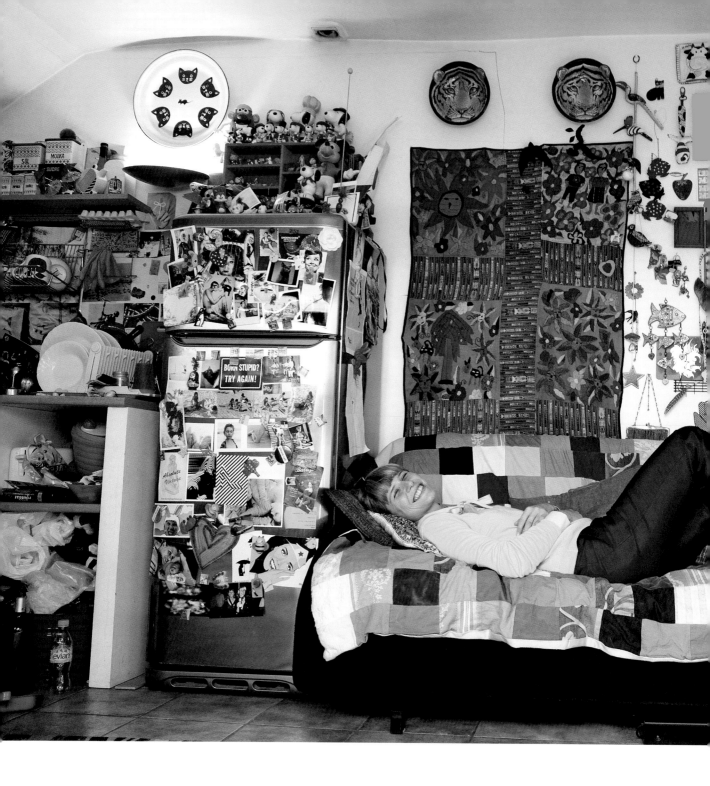

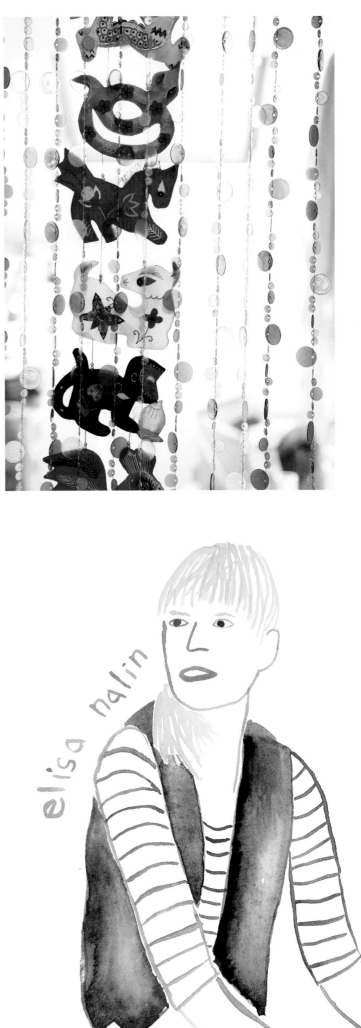

ELISA NALIN IS A stylist from Paris and an old friend of mine. As you can see from her place, she is a kid at heart who is obsessed with shoes and brightly colored everything. She is hands down the best person to go thrifting with in Paris as she knows every stall in every flea market. Each time she smiles, she squints, which is very cute. All of the toys in her house are going to come in handy because she just had a baby boy.

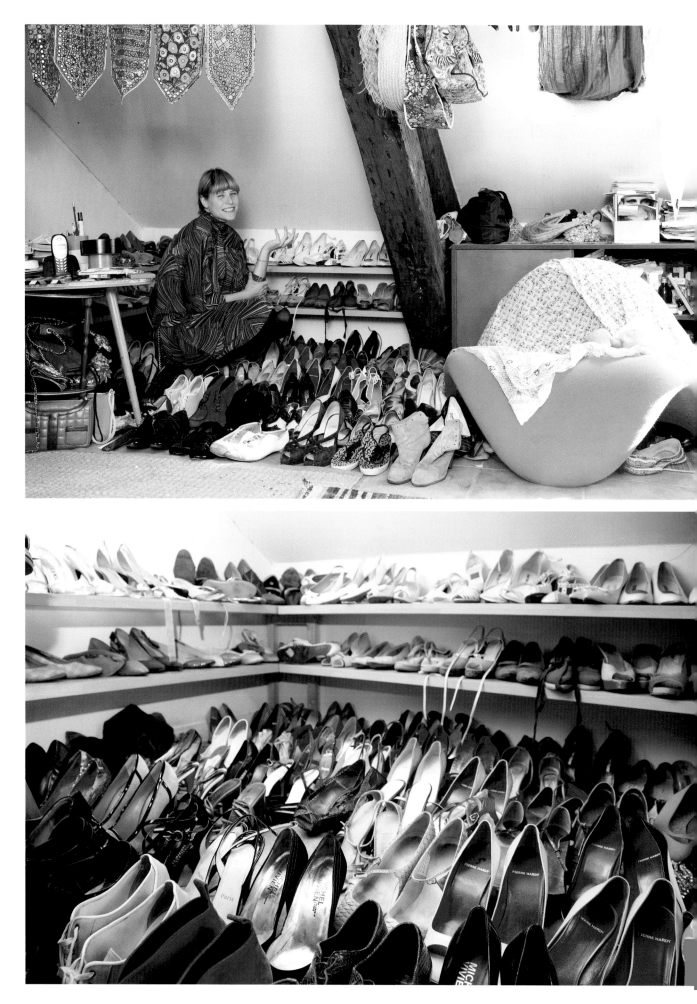

Elisa is a pisces so she loves to collect anything having to do with fish.

←The puffer fish with the straw hat was bought on the Greek island of Naxos.

Elisa gets most of her shoes from the vide-greniers, the local weekend flea markets in paris.

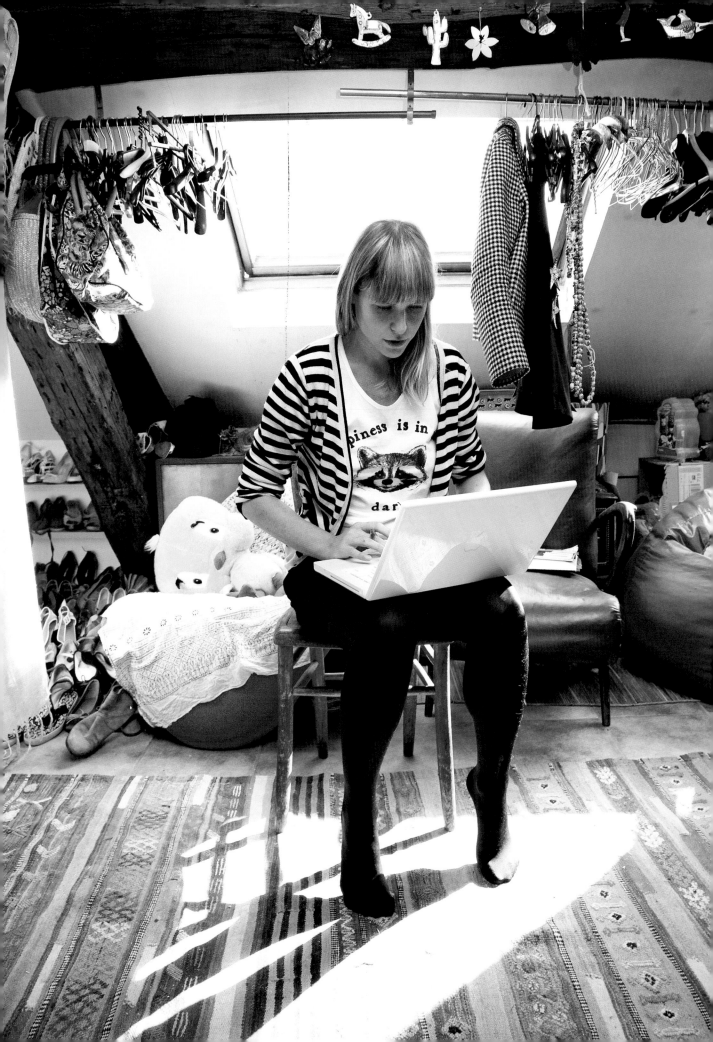

Hi Elisa! Where in Paris do you find most of the things for your house? DURING the week-ends I always go to differents VIDE-GRENIERS. It's TIPICAL French, it's like little flea markets made only by th peoples of the neighborhood who are selling their things! Could you describe what you look for when you are shopping at flea markets? I normally never look for something in particular. I just follow my eagle's eyes. ON whatever my attention get caught on. I do love silly objects and kitch. What do you love about Japan? TOYS like my snoopy collection! well it's difficult to say cause I've never been there ... but I'm sure I will love the food, the shopping ... the insane quantity of silly what does Japan love about you? Crazy objects I GUESS MY look, how I dress and also who I AM! Always smiling KInd and my curiosity for things too probably.

Could you draw a Cartoon with a strong Elisa style outfit ↴

Where is the best place to get drunk in Paris? In little bistrot-bars that Nobody knows ... full of odd mans already drunk ☺
What are your top 4 favorite places to eat in Paris
1 Hotel du Nord 3 CHA-CHA CLUB
2 Café de l'Epoque 4 KRUNG-THEP
 and their "fondant de boeuf" ... delicious

What do you love about styling? the creative side of it. the "having fun" in dressing people and mix unexpected things ... stripes with flowers, polka dots with tartan and make it look good ♥
Where would you love to visit? INDIA, ARGENTINA, CAMBOGIA, JAPAN, TIBET, CHILE, PLUS AN ISLAND BUT I WON'T TELL YOU THE NAME
What can you imagine for the future? My family with lots of animals, many cats 4 sure and if I'm lucky an OPUSSUM!

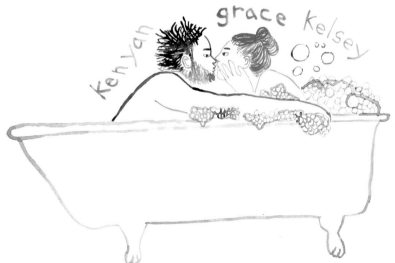

kenyah grace kelsey

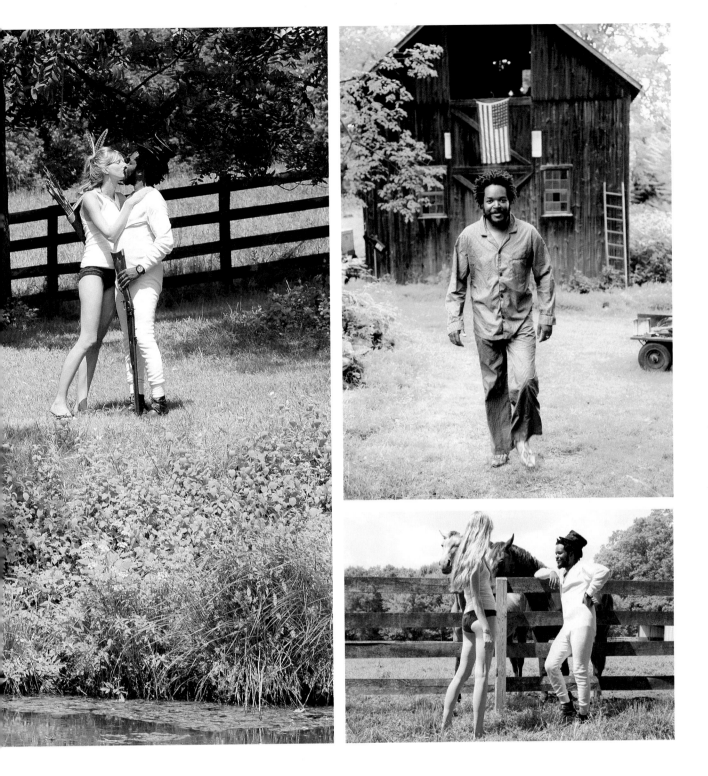

GRACE AND KENYAN ARE New Yorkers who recently fled the city for a life on a farm. The farm seems like a million miles from the city, but it is just a couple of hours away. They still have a small apartment in downtown Manhattan, but they get out to the country every weekend to spend time creating art in their converted hayloft. Kenyan restores antiques and assembles bric-a-brac into vignettes, while Grace works on her artwork and her photography in another section of the loft. Kenyan's style, with his collection of peg legs, moustache dummies, and vintage ice skates, is a fresh take on classic American gothic.

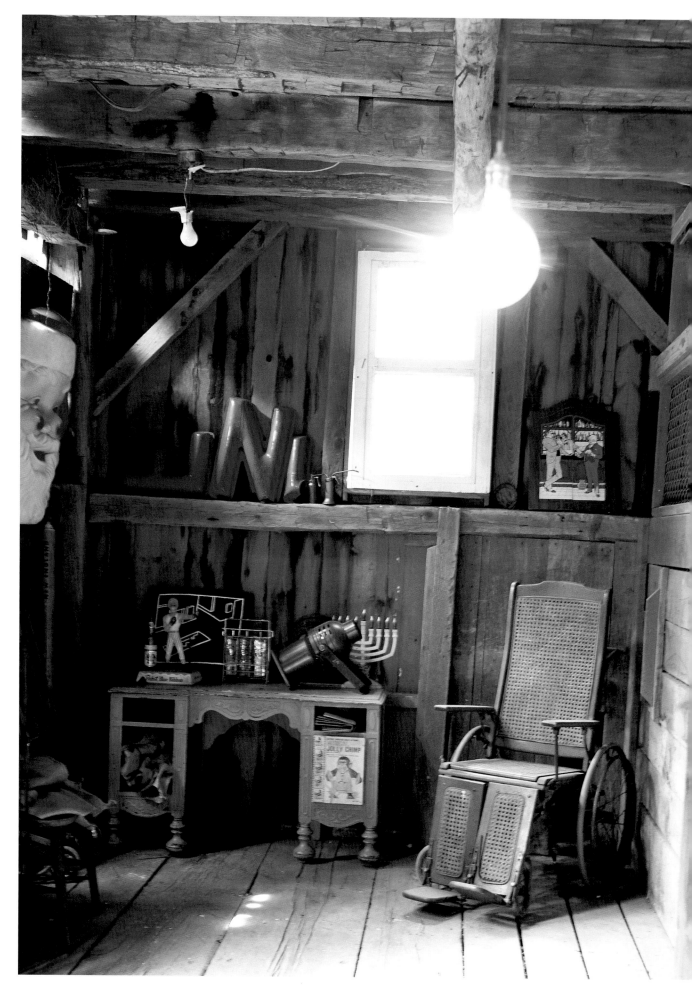

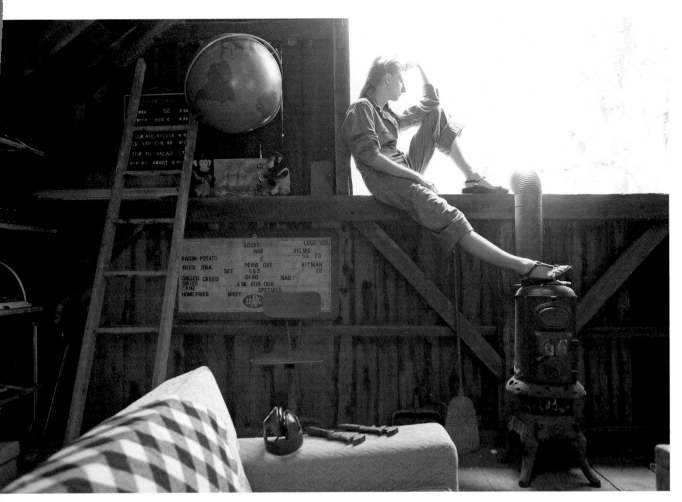

Grace getting fresh air next to some menu boards and a 1920s Denoyer – Geppert Naval Strategy globe.

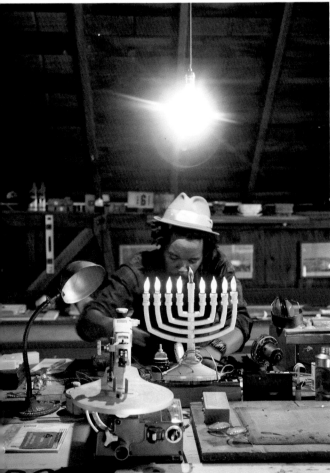

Kenyan in his workshop.

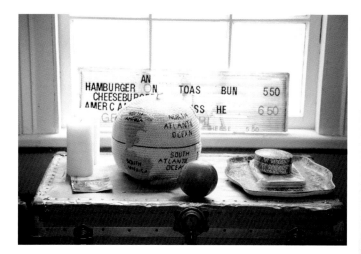

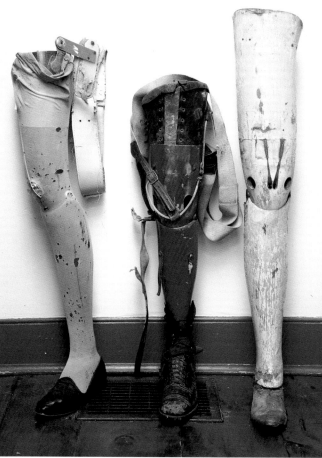

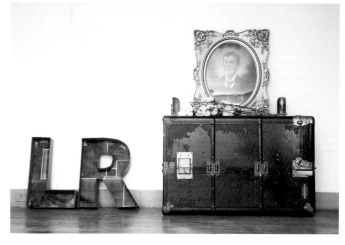

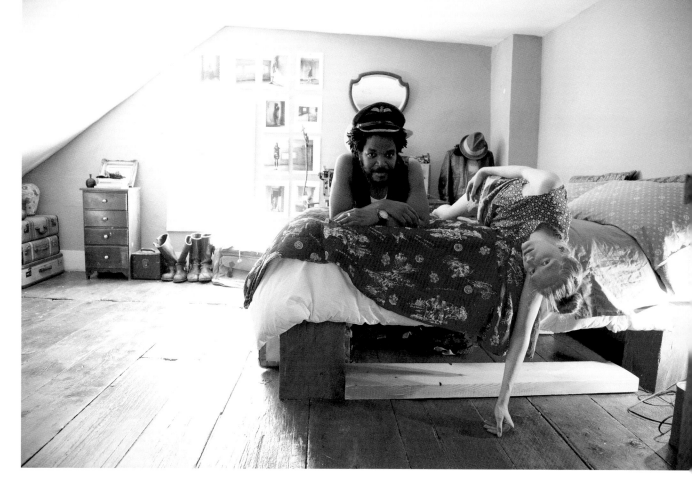

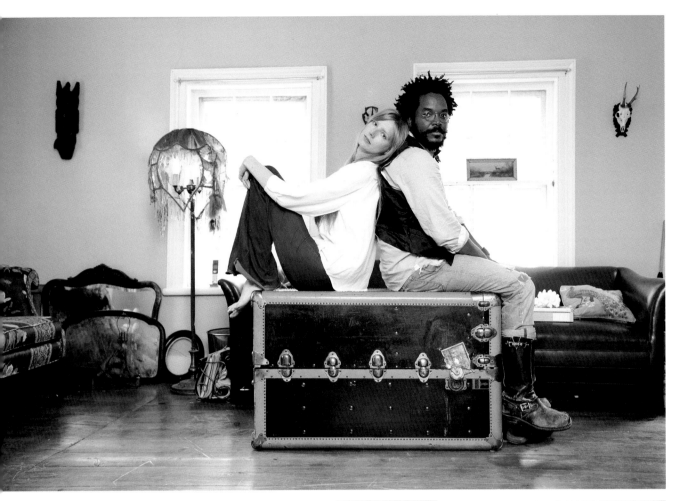

A collection of prosthetic legs, some complete with shoes and mangled stockings.

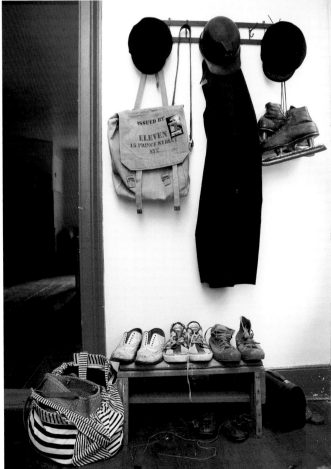

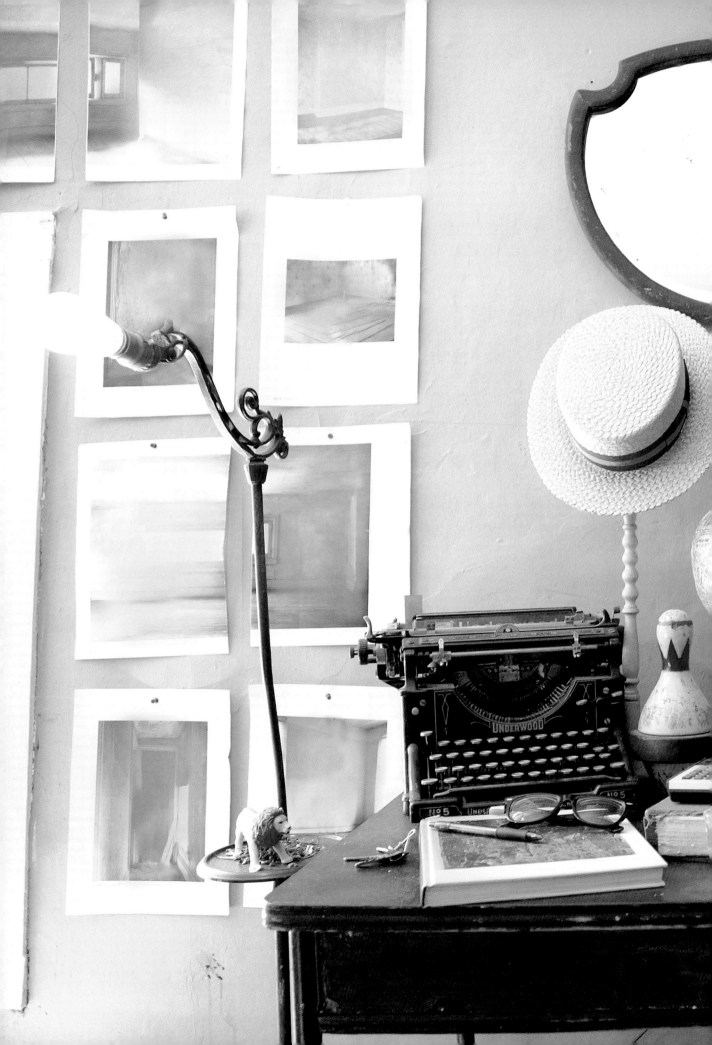

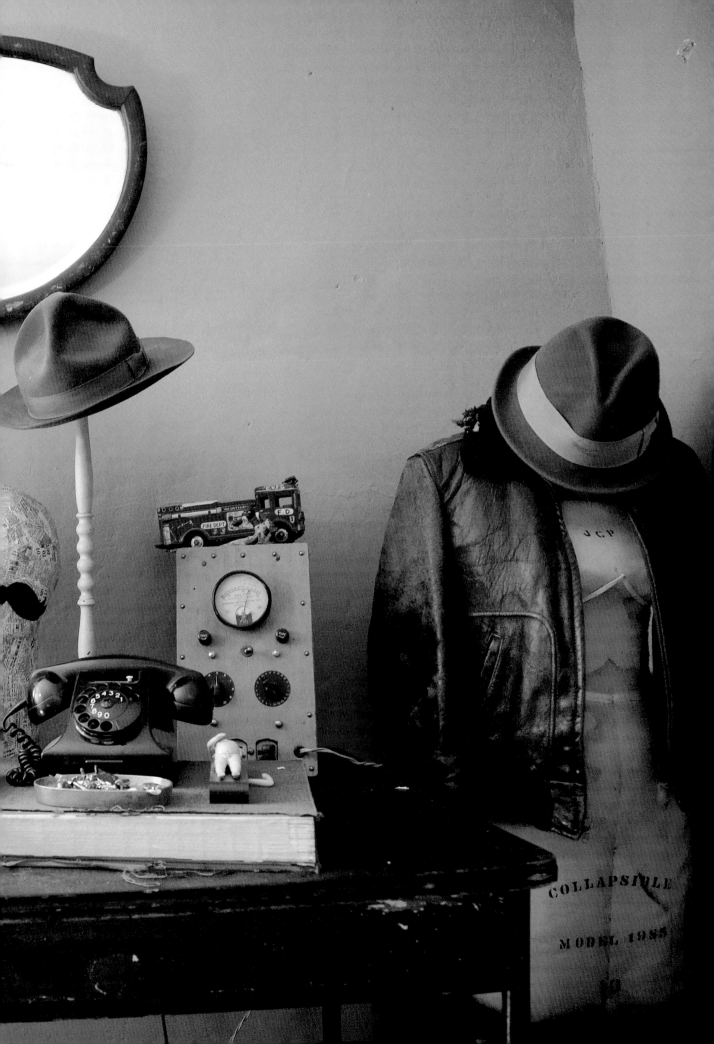

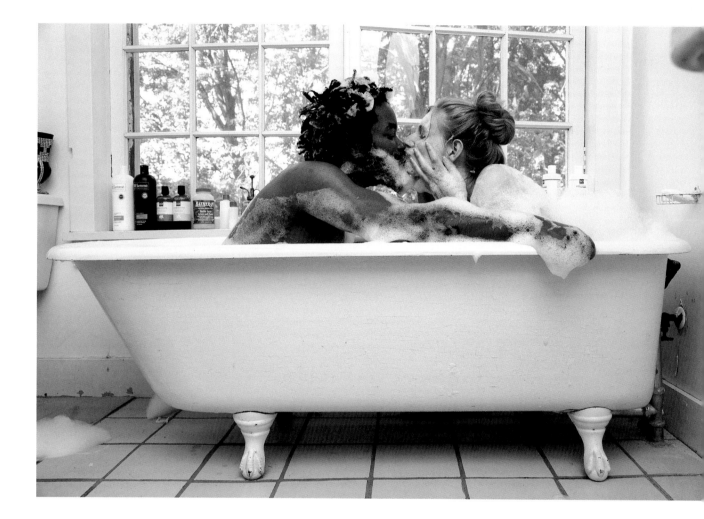

Hey Kenyan and Grace tell me a little about what you do? me? grace? I'm a model and a photographer and an illustrator too. I do things. HEE HEE... I REALLY DON'T KNOW OFF-HAND PROP MASTER...

Kenyan could you describe to me your dream house?
GREAT GRAND DADS SERIAL SUMMER RETREAT...

Grace could you describe your dream house?
I guess a lot like this... we'll see when winter rolls around though brrr... I wanna dig snow tunnels...

Kenyan draw Grace here

Grace draw Kenyan

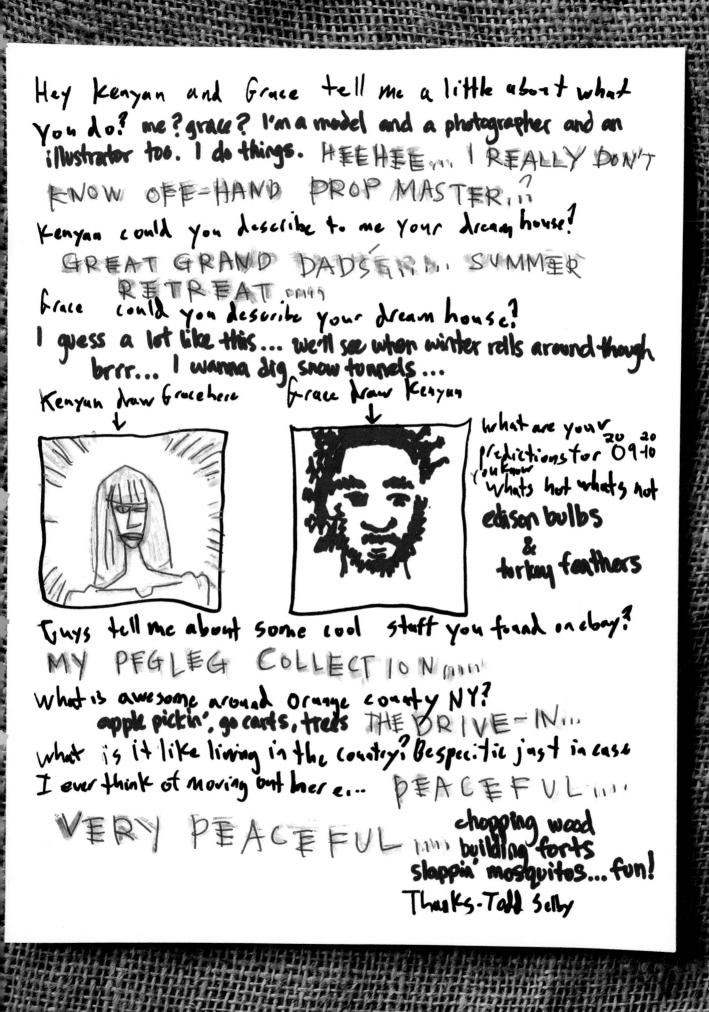

what are your predictions for 09-10 20 20 you know whats hot whats not
edison bulbs & turkey feathers

Guys tell me about some cool stuff you found on ebay?
MY PEGLEG COLLECTION...

What is awesome around Orange county NY?
apple pickin', go carts, trees THE DRIVE-IN...

what is it like living in the country? Be specific just in case I ever think of moving out here... PEACEFUL...

VERY PEACEFUL... chopping wood building forts slappin' mosquitos... fun!
Thanks - Todd Selby

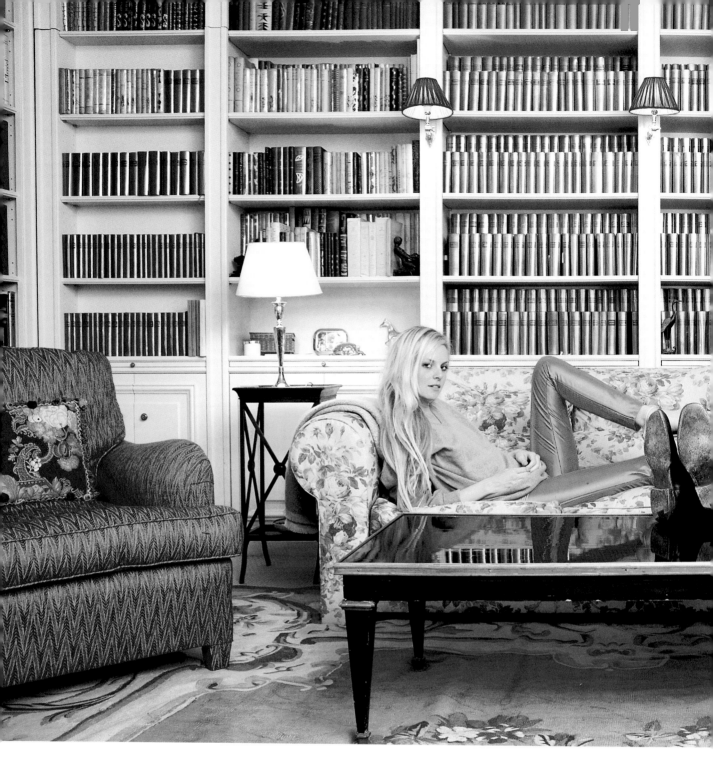

SOFÍA IS A SUPER-CHIC stylist from Argentina, and Thibault is an
author from Paris. These photos were taken at Thibault's elegant
family home in Paris, which houses the most impressive private
library I have ever seen. In the library they have a marvelous
antique bamboo ladder, an ancient bamboo opium pipe, pink
crystal goblets, and a hidden passageway behind a bookshelf. I am
particularly fond of the wallpapered bathroom under the stairs
and all the amazing gold lamps.

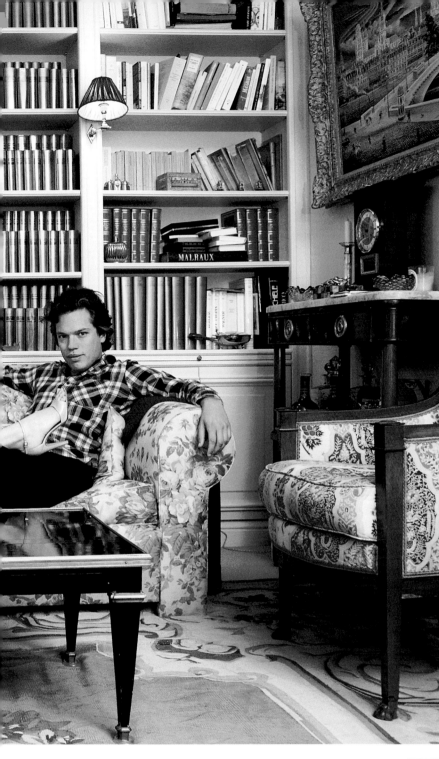

thibault de montaigu

sofía achával

The wallpaper in the bathroom is from Le Manach. The writer Louise de Vilmorin had decorated her house in Verrières with this wallpaper. ⟶

This is an Aubusson tapestry.

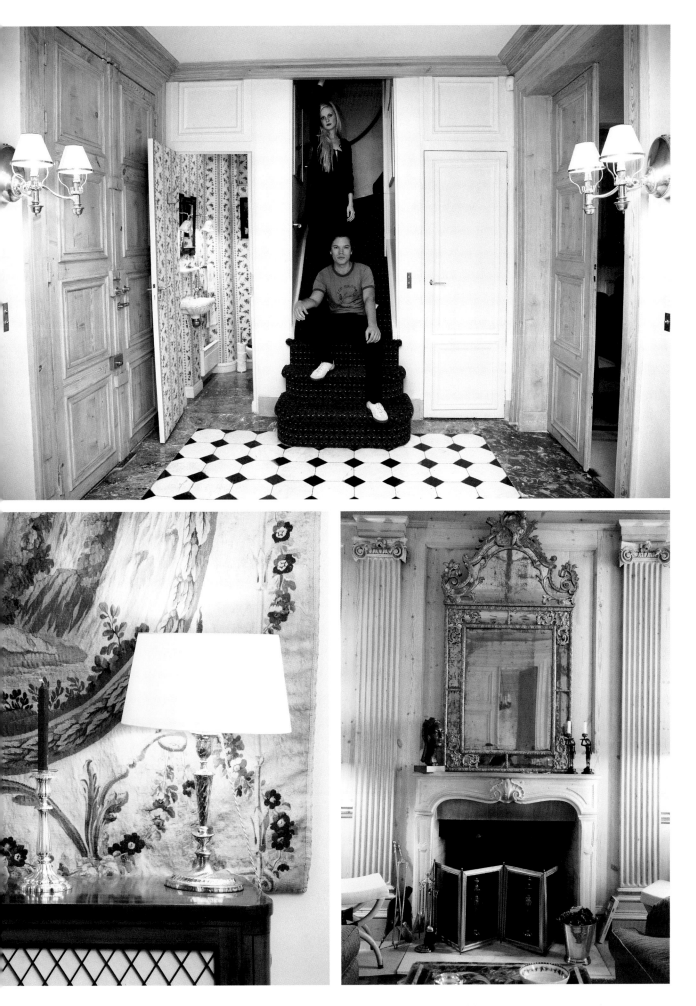

Hi Thibault and Sofia! Thibault could you tell me what it was like writing your first book?

It was going to the shrink on acid, only you don't pay.

Thibault what is the plot of the first story you can remember writing?

I think it was about a guitar who could talk and was begging its owner to play jazz.

Sofia tell me about working with Sebastian Faena?

He is my childhood friend, so it feels like home.

Thibault what is your next book going to be about?
The 50's in France : Bardot, Vadim, "les filles de Madame Claude", the arrival of heroin ...

Sofia what designers inspire you?
I love Karl Lagerfeld for Chanel and Yves Saint Laurent.
Thibault what authors inspire you?
Fitzgerald, Hemingway, Drieu la Rochelle

Sofia draw Thibault's face Thibault draw Sofia's face ↓

Sofia describe where you were born →
In Buenos Aires a big and sunny city.

Thibault what does the future hold?
Time will tell, but I might tell it before

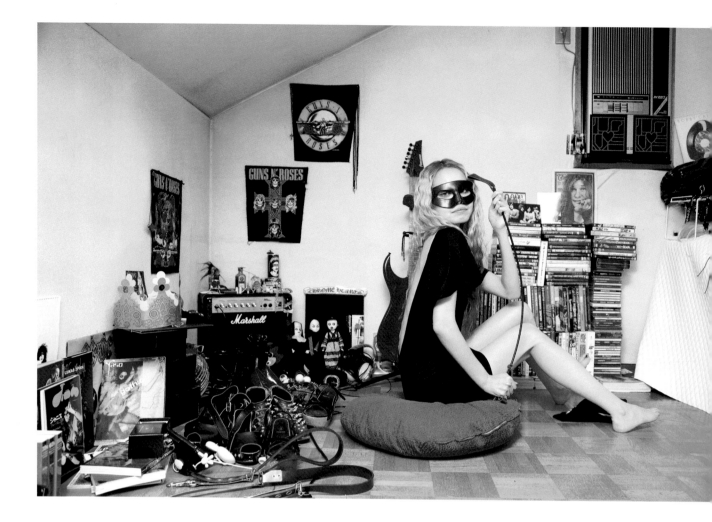

nakao

NAKAO WAS THE FIRST person I ever photographed in Japan.
She is super laid-back, loves listening to Janis Joplin, and playing
her guitar. She used to be one of the most out-there, wildly
amazing party girls in Tokyo. Until recently, she was known to go
to parties covered in fake blood wearing only pasties and medical
scrubs. Her favorite drink is pink champagne.

Nakao has four different colors of pasties to choose from.

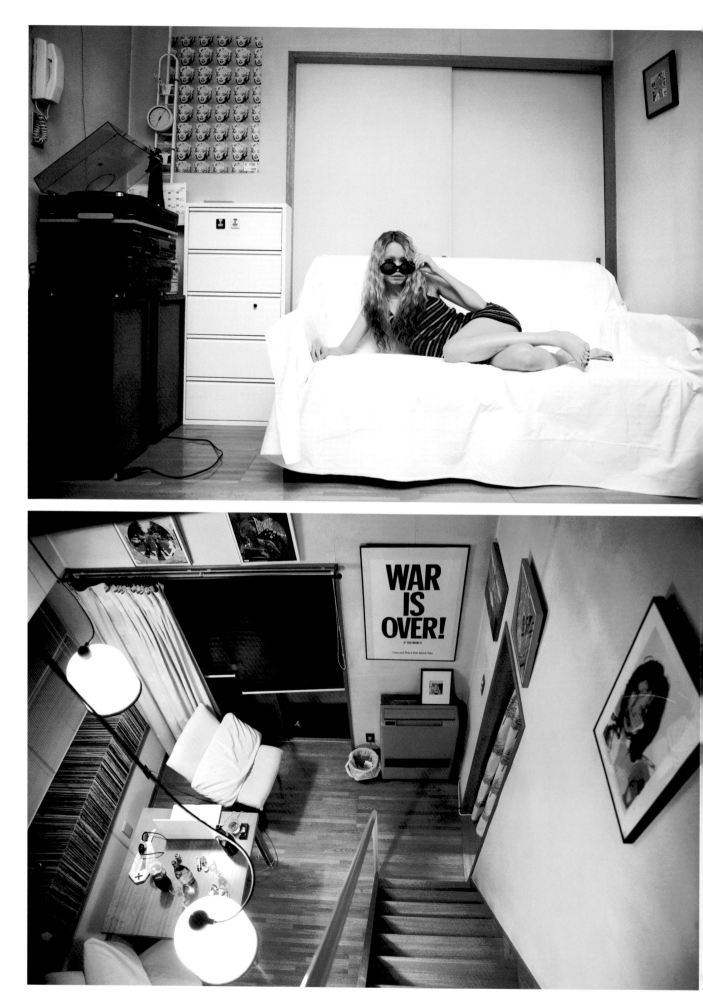

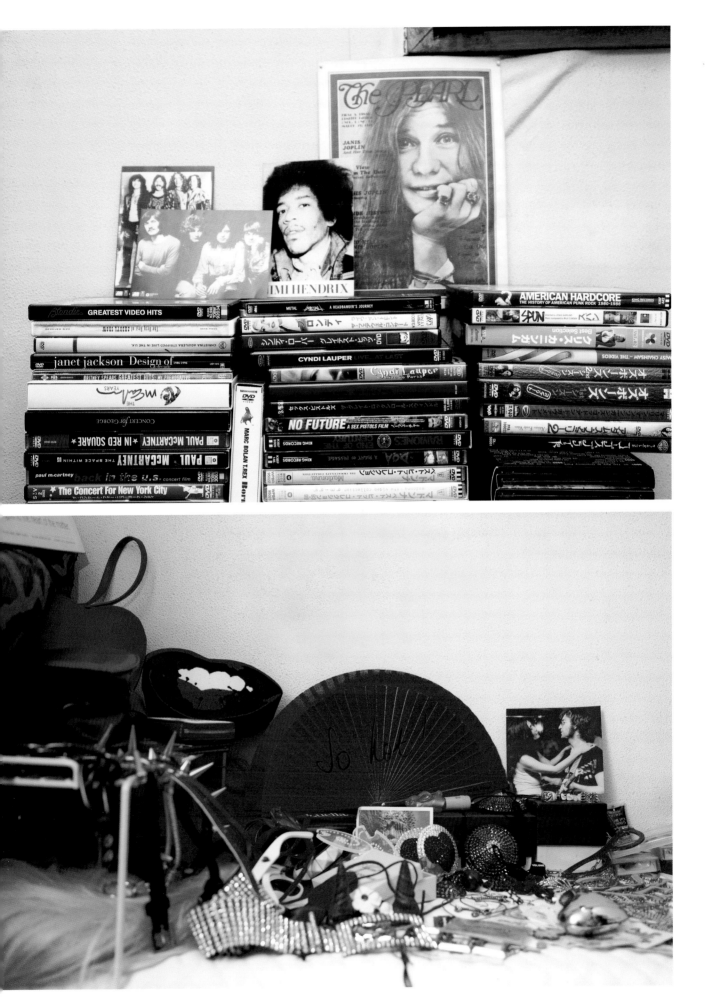

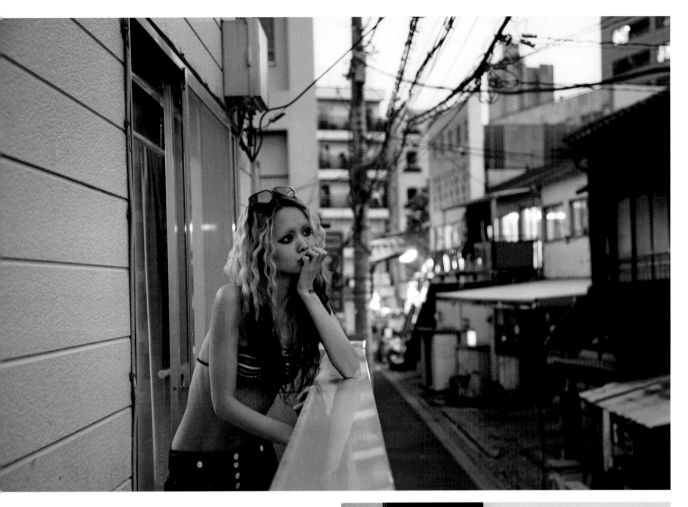

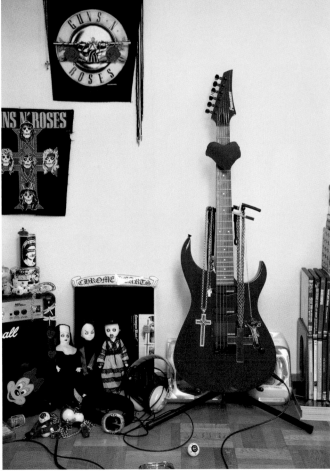

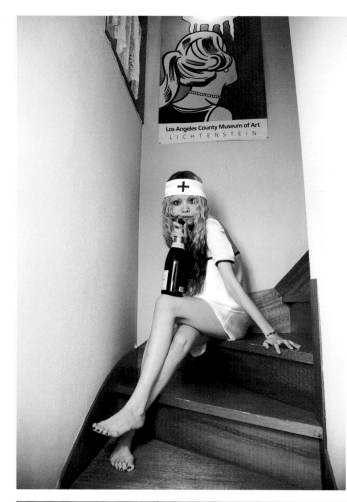

Nakao wearing her silk naughty nurse nightie, drinking pink champagne

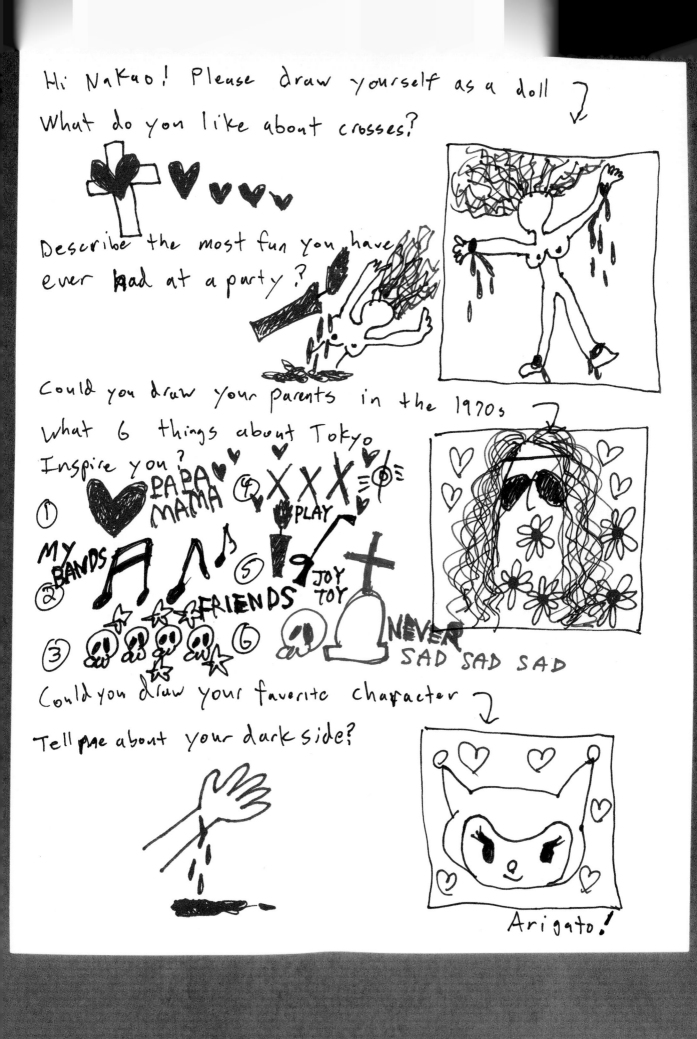

Hi Nakao! Please draw yourself as a doll

What do you like about crosses?

Describe the most fun you have ever had at a party?

Could you draw your parents in the 1970s

What 6 things about Tokyo Inspire you?

① ♥ PAPA MAMA
② MY BANDS
③
④ XXX PLAY
⑤ JOY TOY
⑥ NEVER SAD SAD SAD

FRIENDS

Could you draw your favorite character

Tell me about your dark side?

Arigato!

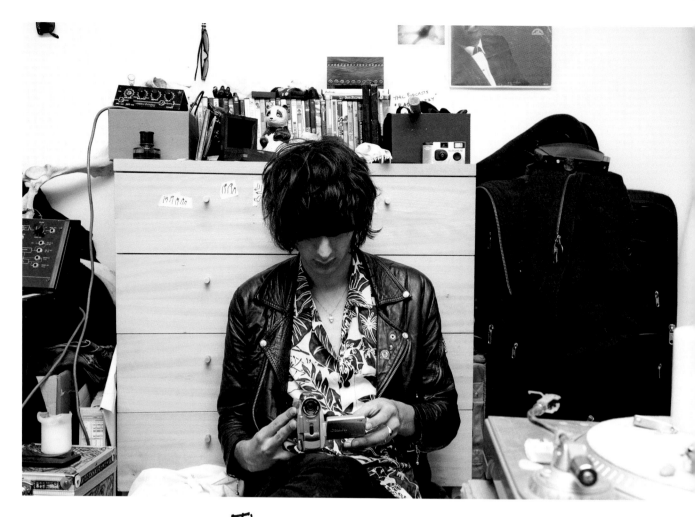

The gas mask is from World War II and belongs to Faris's flatmate. When he's out, Faris puts it on the windowsill and pretends it belongs to him.

faris badwan

FARIS IS THE SHYEST person I have ever photographed; he literally hid in the closet while I was trying to take his picture. This is especially surprising because he is the lead singer of a popular band, The Horrors. His bedroom seems chaotic but it is actually painstakingly organized in ways that I still cannot figure out. He is really into date stamps, photos of photos, creepy bones, old teeth, anagrams, analog equipment, and old records.

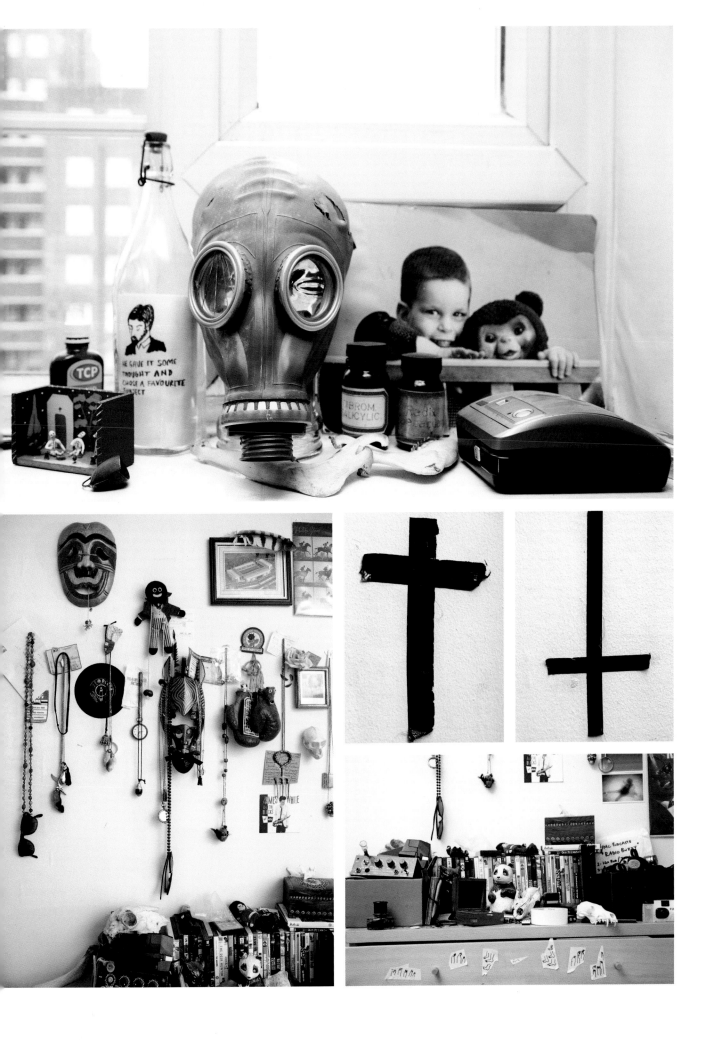

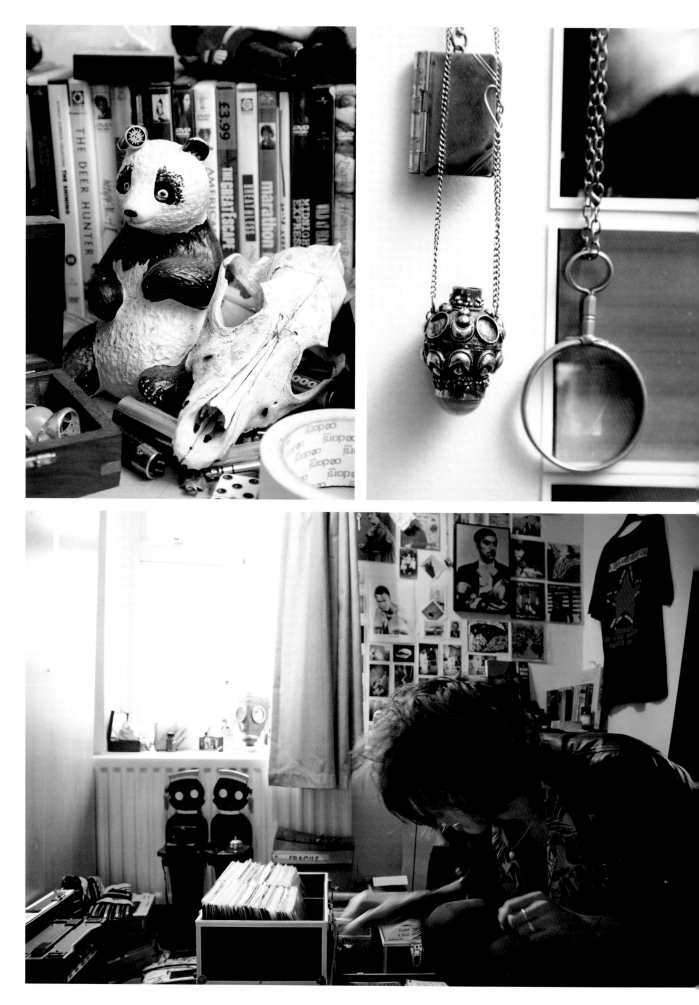

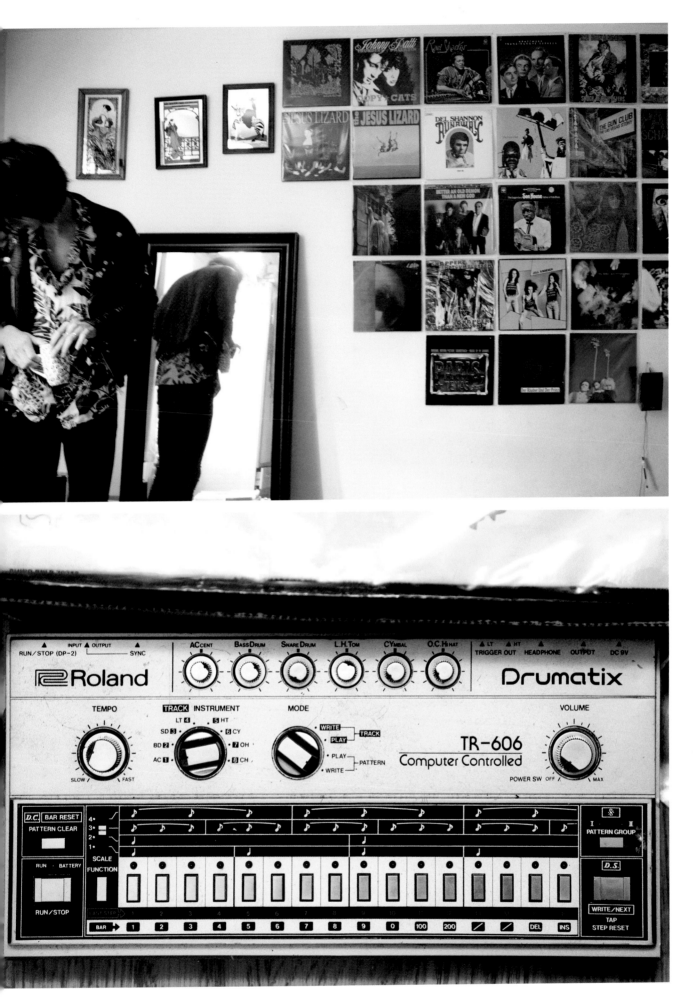

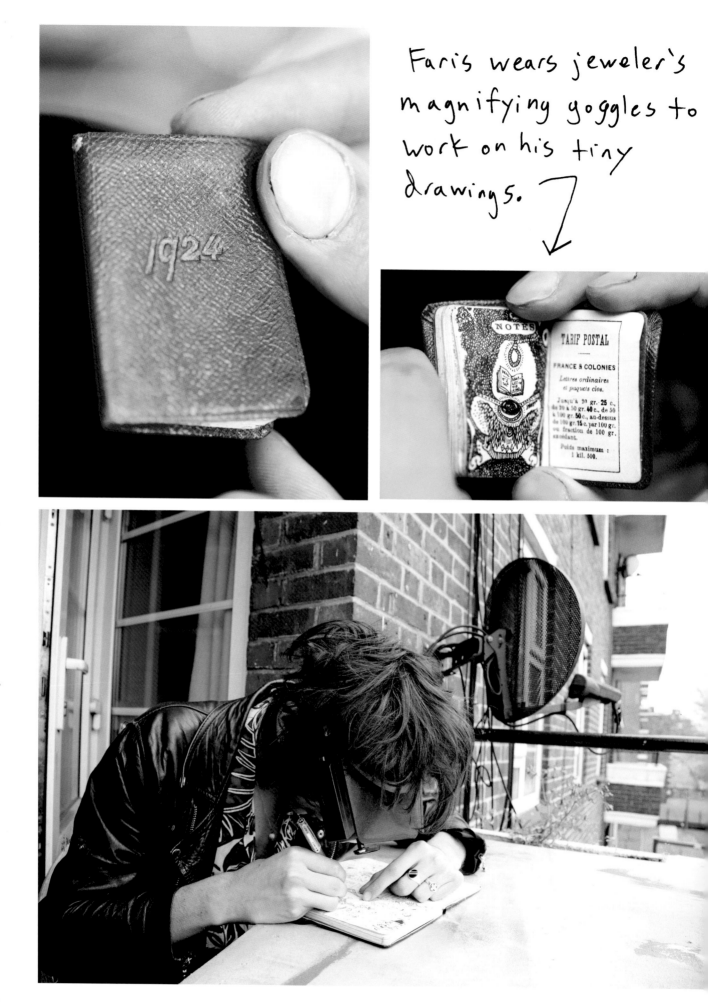

Faris wears jeweler's magnifying goggles to work on his tiny drawings.

Hi Faris! What do you like about taking photos? (see miami sleeve) (also

When you kneel down and take photos of people in front of the sky trying to recreate the lighting from my favourite
70s detective film lighting and deer in the headlights, album covers.

Could you draw your favorite teeth in your collection?

What don't you love about your room?

~~I don't love it, I find it very hard to~~

I don't like the lamp shade but haven't
found a solution. Also the curtain needs
changing. ~~The~~ Nails go into the walls easily though.

If you could only keep one thing in your room

What would it be?

Probably my hammer and nails
or my date stamp ~~although~~ although I know these Date stamp
are ~~~~ ~~The picture of Luis Aguilar~~

Could you draw a self-portrait here →

What would you like to hide?

Err this is a tough question myself? I'm not trying
to be clever I

I don't know
what I
meant
to do
and now
I have run
out
of
space

MIAMI
THE SUN CLUB

I just don't
understand

← I know
you like
watercolours
so here are
some
except I did
use water I us
the tea ~~to~~ I ma
you that
you did't
drink

Could you draw your favorite album cover →

Why did you start playing music? superb

Boredom although ~~also too much except~~ of all the idiots in bands when I was
Actually I think I only wanted to do it because of at school who ~~this~~ thought they were ~~as a result~~
going to get ~~equally ~~

Could you tell me about the best vintage/flea market find you
have ever made?

Definitely the things I like finding the most are the photos from the 20s that look uncanily
like my younger brothers.

What did you learn in your travels in america?

biker
The venue we played in philadelphia has a trap door behind the stage. We were being pelted
with bottles and I knelt down and accidentally fell through it and rolled onto the street
Dick Dale played there the week previous although I doubt he got pelted or fell through the
trap door,
What 6 things does london have that ~~no one~~else has.
everywhere

① _____ ③ _____ ⑤ _____
 ④ _____ ⑥ _____ I amended
② _____ this
 question
lampshade but have found
Could you draw me a map of your room it no
Luis aguilar easier
 1 1 APR 2009 to answ,
stereo
sound
 Thanks!
keyboard

MELIA IS HEAD CHEF at the Smile, a cool downtown restaurant. She has a huge art collection that she displays on chairs around her house. Her husband, Frank, aka Kid America, is a downtown New York fixture. He makes movies and has his own line of action figures that are sold in Japan. My earliest memory of Frank is of him DJing at a party with some old 45s and yelling over them at the top of his lungs.

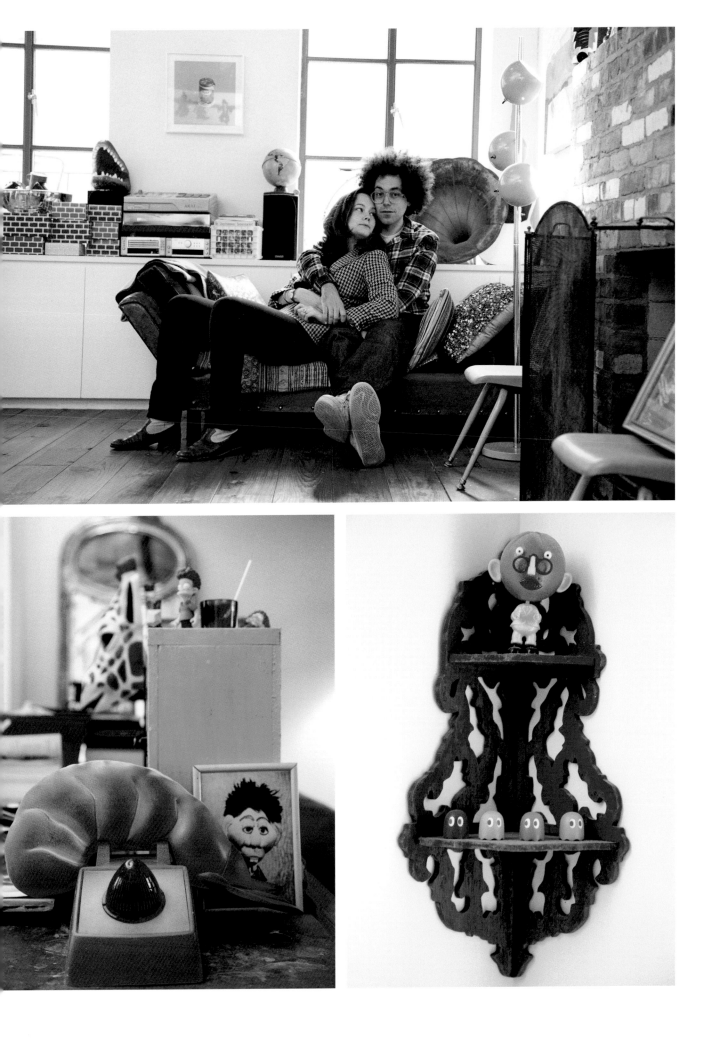

Frank's Kid America action figure. →

The neon TV was a wedding present from friends.

This is from a fake prom held at an abandoned public school.

Hi Melia + Frank! Melia could you tell me the concept behind your catering company? An eclectic mix of food that doesn't feel "catered" but you might not make yourself.

Frank could you describe the plot line of your most recent Lil Hipsters episode? In "THROWIN' CRAZE", RUSSEL TEACHES KRISPY HOW TO BUG OUT BUT IT LANDS THEM BOTH IN THE LOONY BIN... RUBBISH JAMES, THE RAT, TO THE RESCUE!!

Frank draw Melia as a mascot ➤

Melia draw Frank as a giraffe ↗

Frank tell me about your first date with Melia → WE WENT TO GET ICE CREAM. MELIA HAD ME WAITING ON MY STOOP FOR A HALF HOUR, SHE WAS SO NERVOUS.

Melia what are your top 6 favorite things to cook right now?
1 Meatballs
2 Pickled Radishes
3 Steak
4 Harissa honey turkey
5 Roasted fennel
6 Molasses Ice cream

Melia draw Frank (Frank as a baby)

Frank draw a new state flag for NY ↴

Yoon

dj verbal

DJ VERBAL GREW UP in Tokyo totally obsessed with hip-hop—life was all about gangster rap tapes and *Word Up!* magazine. His wife, Yoon, grew up in Seattle listening to grunge and wearing flannel shirts. Verbal is a member of the rap group Teriyaki Boyz. Together they design a clothing and a jewelry line. They met at church and are both total sweethearts. These photographs were taken in their office and recording studio, which houses Verbal's museum-worthy collection of vintage hip-hop and cartoon artifacts.

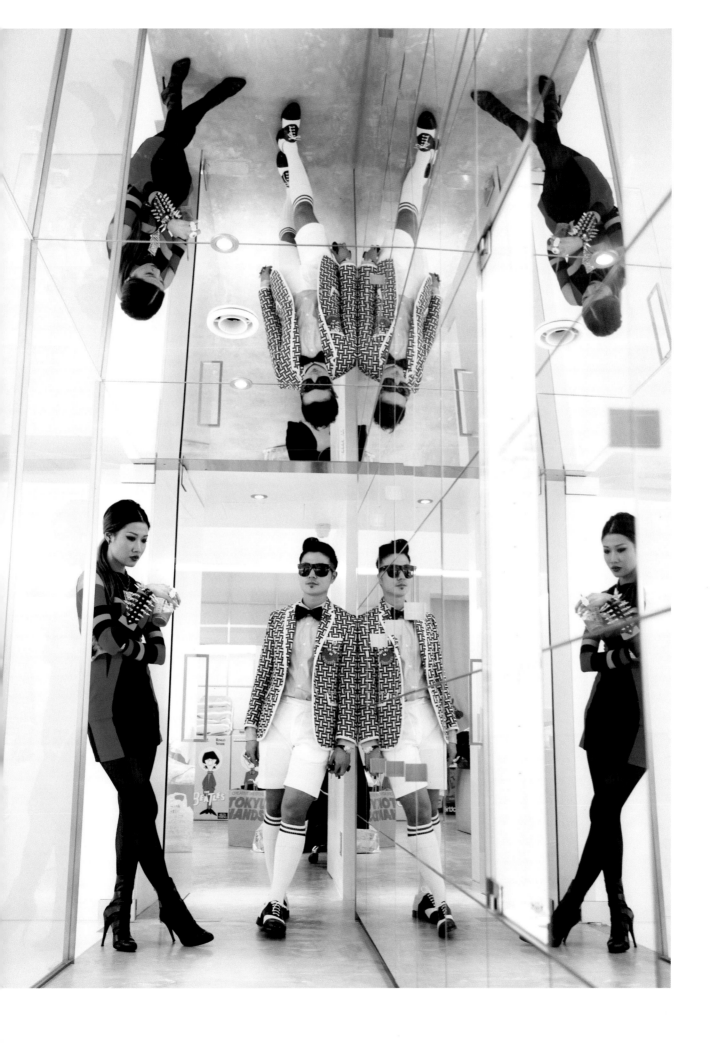

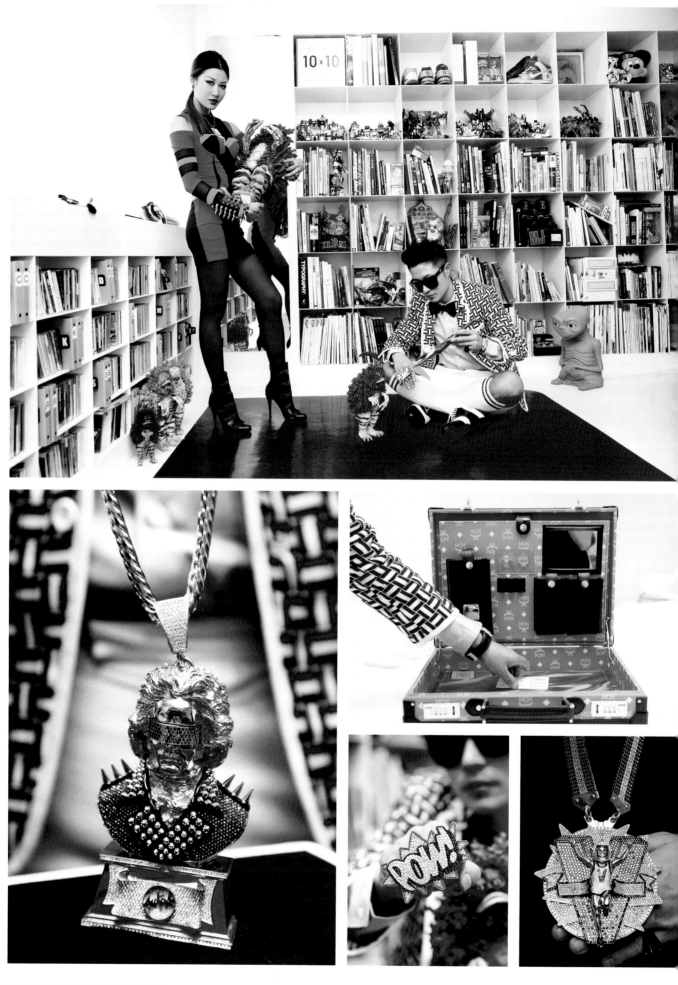

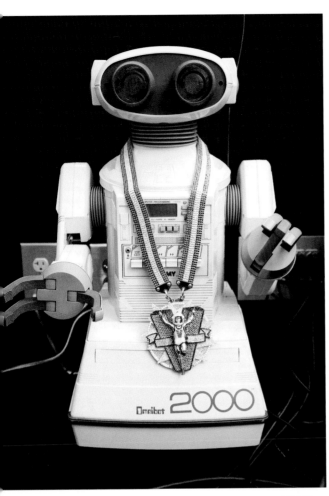

The robot is from the 80s, when 2000 sounded super futuristic. It is wearing Verbal's gold-colored, 200-carat diamond, sapphire, and ruby necklace. ←

Hi Yoon + Verbal! Verbal can you draw one of your favorite outfits when you were in 8th grade?

Yoon can you draw yourself as a high school girl in seattle?

Verbal what do you like about Beethoven?
GENIUS! "ANTI" in his own time... a revolutionary!

Yoon could you draw a cover of a magazine with Verbal on it?

Raiders

PUBLIC ENEMY

STOP WATCH

LEATHER MEDALLION

FILA FILA

Yoon who is your favorite garbage pail kid?
"BARFIN' BART"

Verbal who is your favorite transformer and why?
BumbleBee... he's loyal!

Yoon what are the 6 most inspirational stores in the world?

① EBAY

② Salvation Army

③ Toys 'R' us or KIDDY LAND

④ Home Depot

⑤ Walmart

⑥ Tokyu Hands & DONKI (in Japan) "DON QUIXOTE"

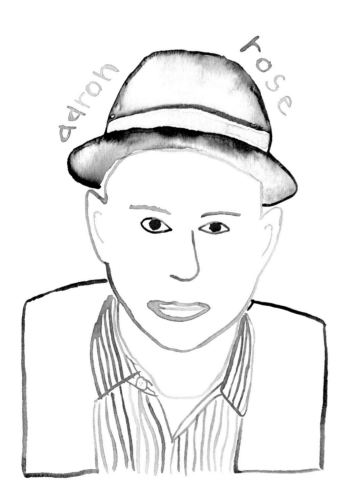

adroh rose

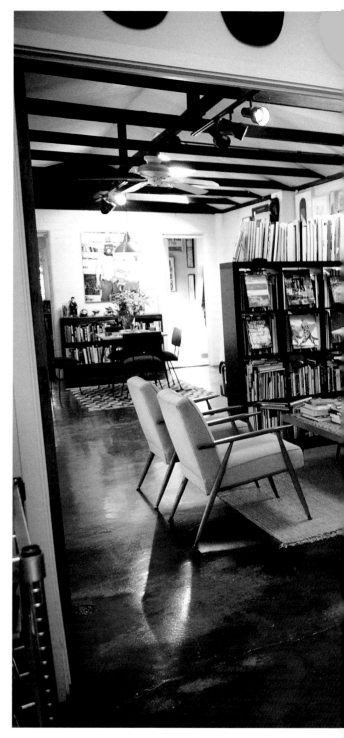

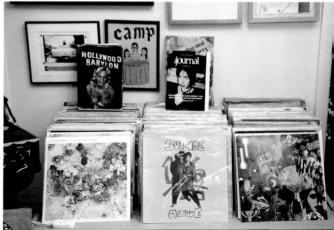

ARON ROSE RAN THE Alleged Gallery in New York in the early
0s, and it was about ten years ahead of its time. He also directed
eautiful Losers, is in a conceptual rock band called The Sads, and
dits one of my favorite magazines, *ANP Quarterly*. He keeps it
real, I think of him as the Ian MacKaye of the art world. His
ouse is better than any art gallery I have ever been in; he should
harge admission when you enter.

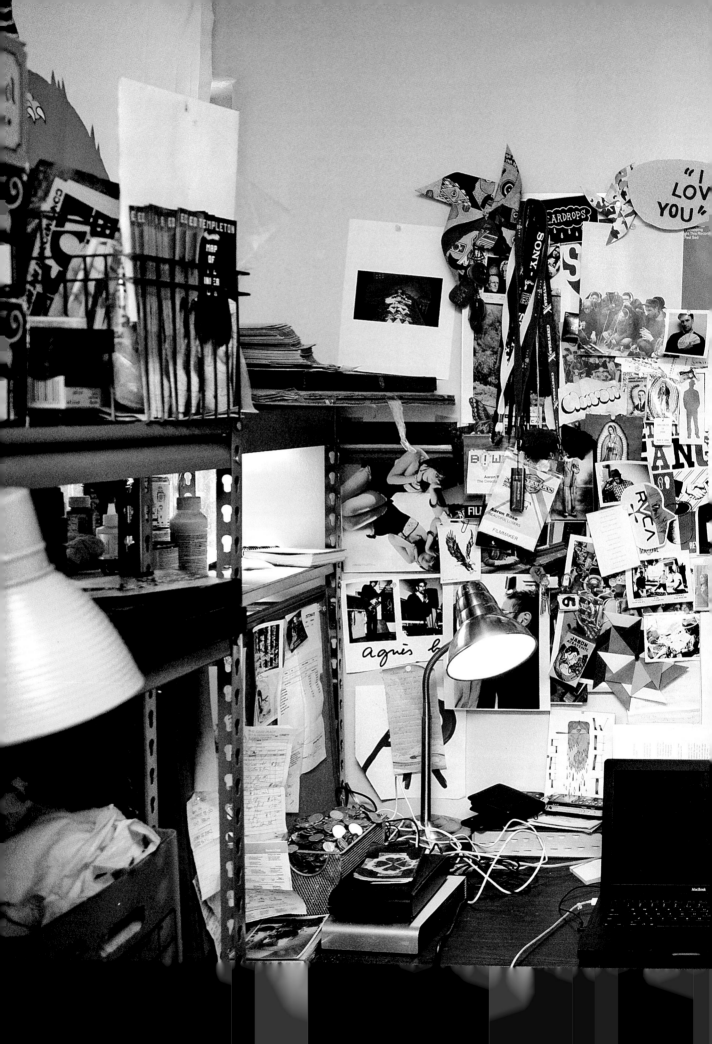

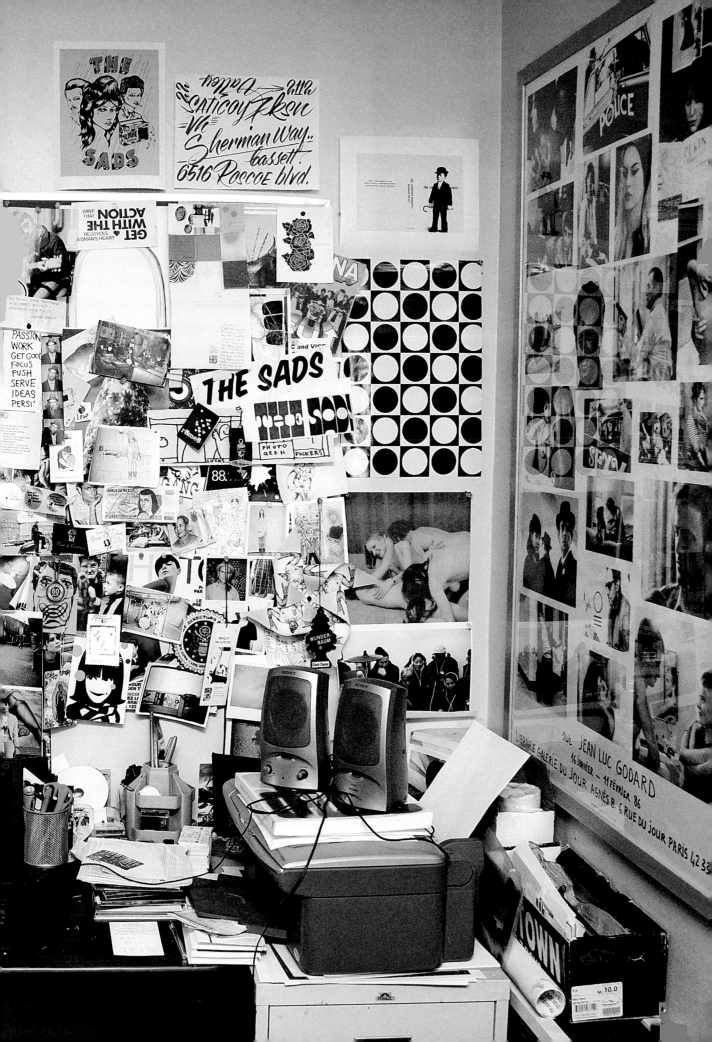

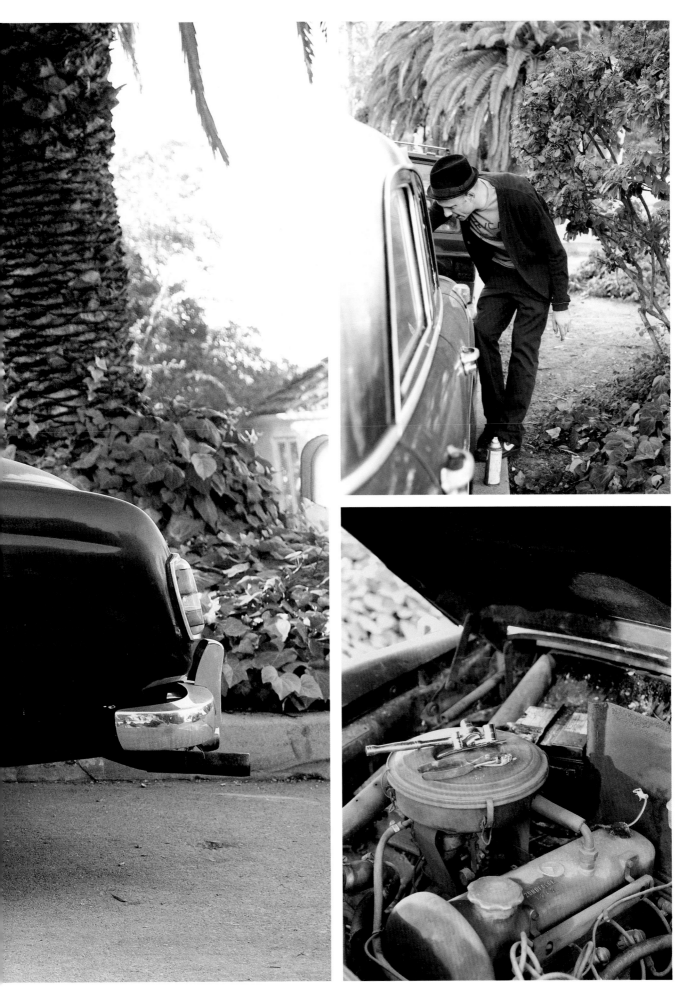

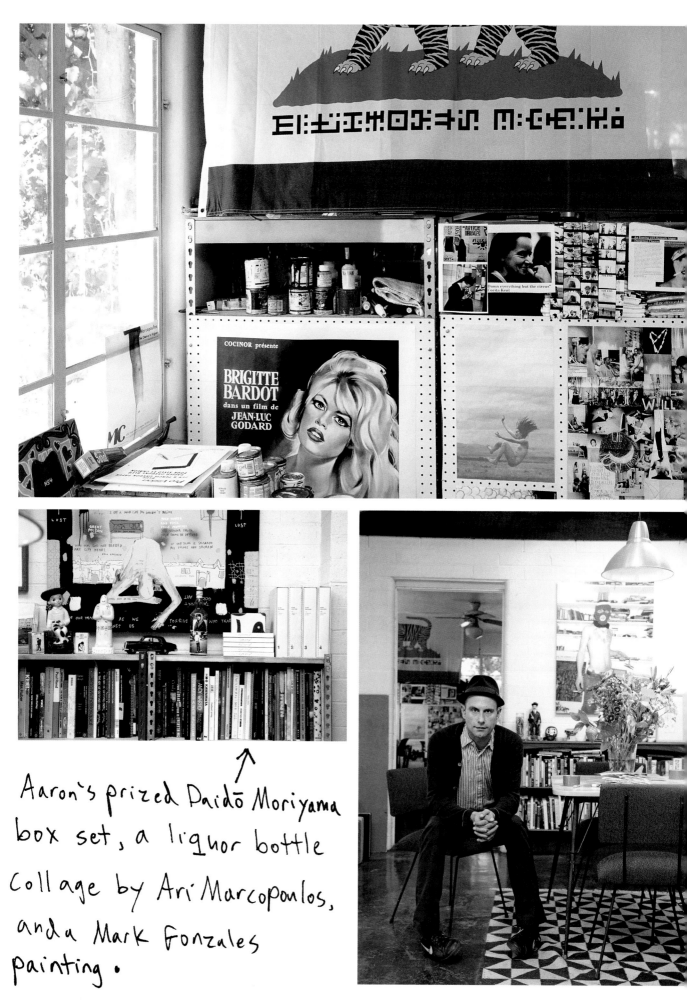

Aaron's prized Daidō Moriyama box set, a liquor bottle collage by Ari Marcopoulos, and a Mark Gonzales painting.

Hi aaron! Tell me why collaboration is better than competition? BEING FRIENDS WITH PEOPLE IS JUST WAY BETTER THAN NOT. IN THE GRAND SCHEME OF THINGS ART JUST MEANS NOTHING AND PEOPLE WHO TAKE IT SERIOUSLY HAVE REALLY LOST THE PLOT. MORE FUN TO JUST MAKE THINGS.

Who are the beautiful losers?

 NO COMMENT.

Could you design a new California State Flag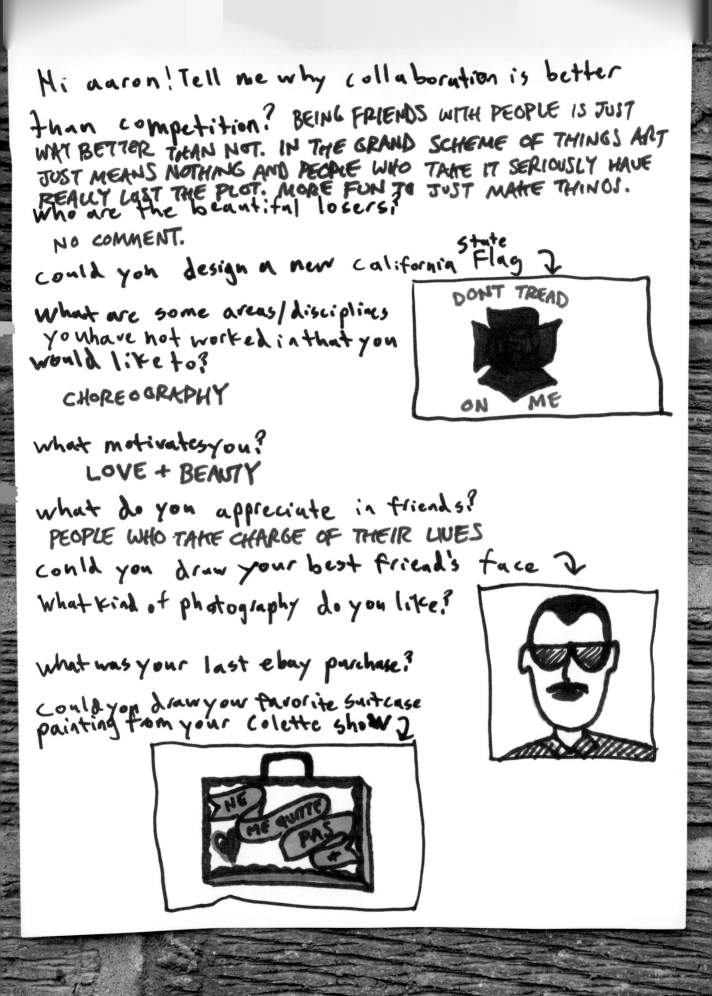

What are some areas/disciplines you have not worked in that you would like to?

 CHOREOGRAPHY

What motivates you?
 LOVE + BEAUTY

What do you appreciate in friends?
 PEOPLE WHO TAKE CHARGE OF THEIR LIVES

Could you draw your best friend's face

What kind of photography do you like?

What was your last ebay purchase?

Could you draw your favorite suitcase painting from your Colette show

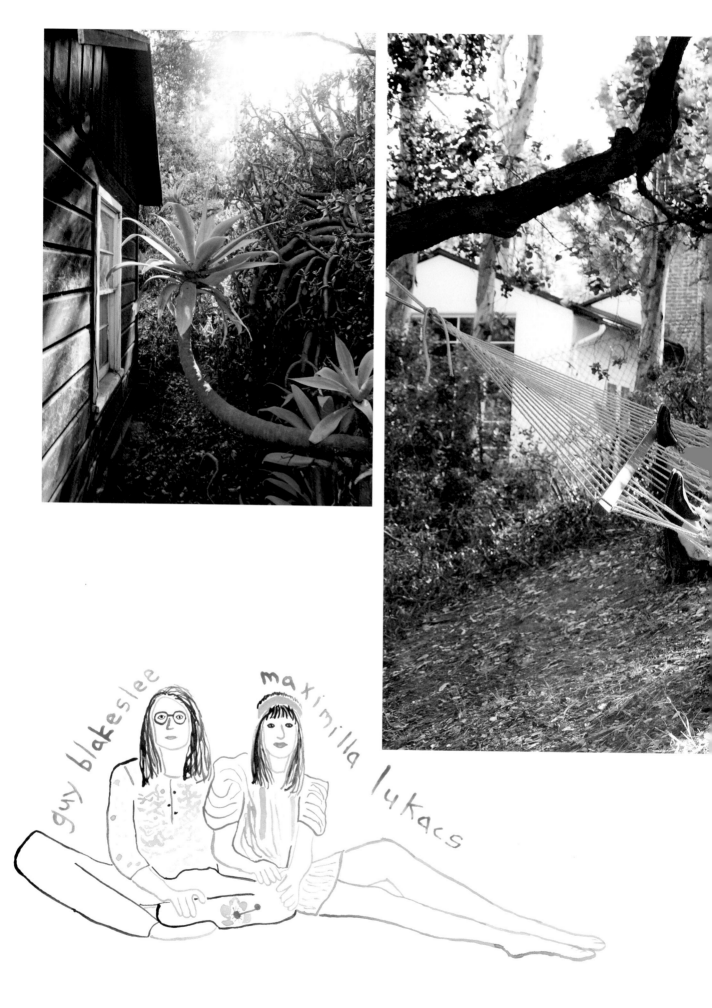

guy blakeslee maximilla lukacs

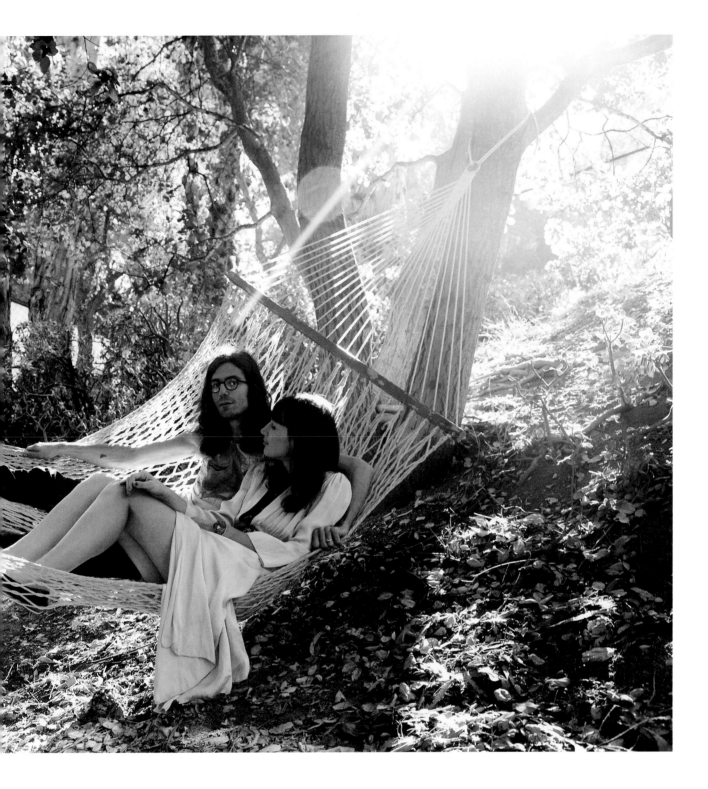

GUY IS A MUSICIAN WHO plays in the Entrance Band and Maximilla is a film director and artist. Their home in Laurel Canyon is tucked up in a forest and is a beautiful mix of big glass windows and dark wood. The jukebox in the living room is filled with vinyl 45s; the selection was curated by their friend who lives in the small cottage behind their house. Guy and Maximilla do lots of psychedelic collages, make paintings, and like to jam out in the living room. They are the embodiment of the Laurel Canyon lifestyle.

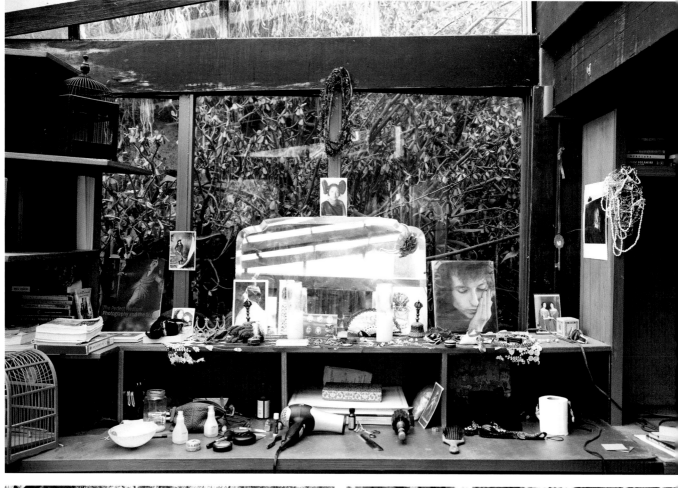

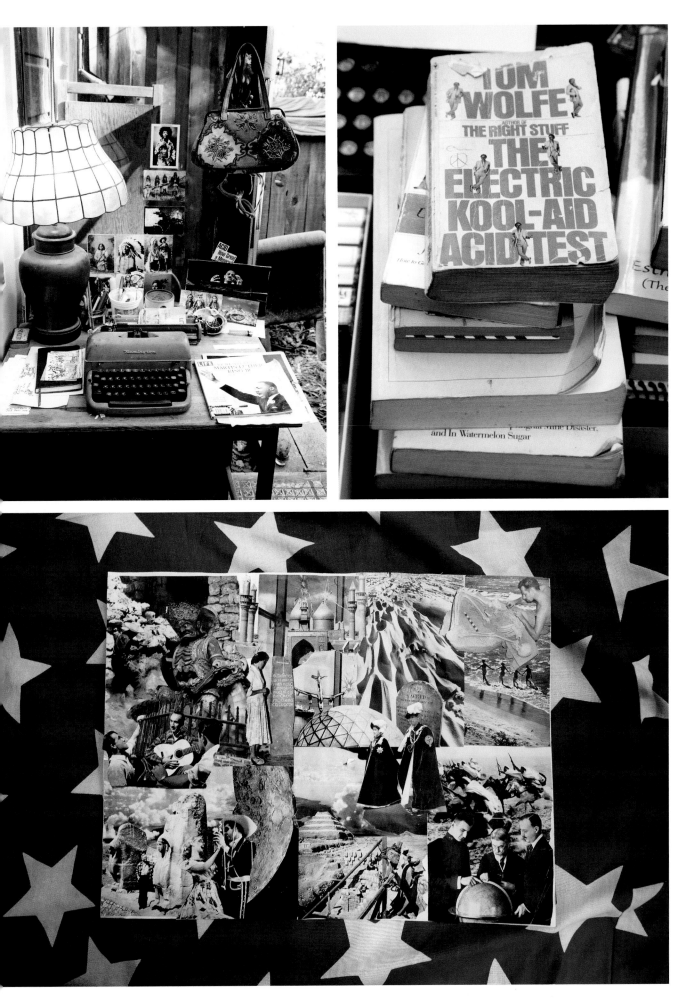

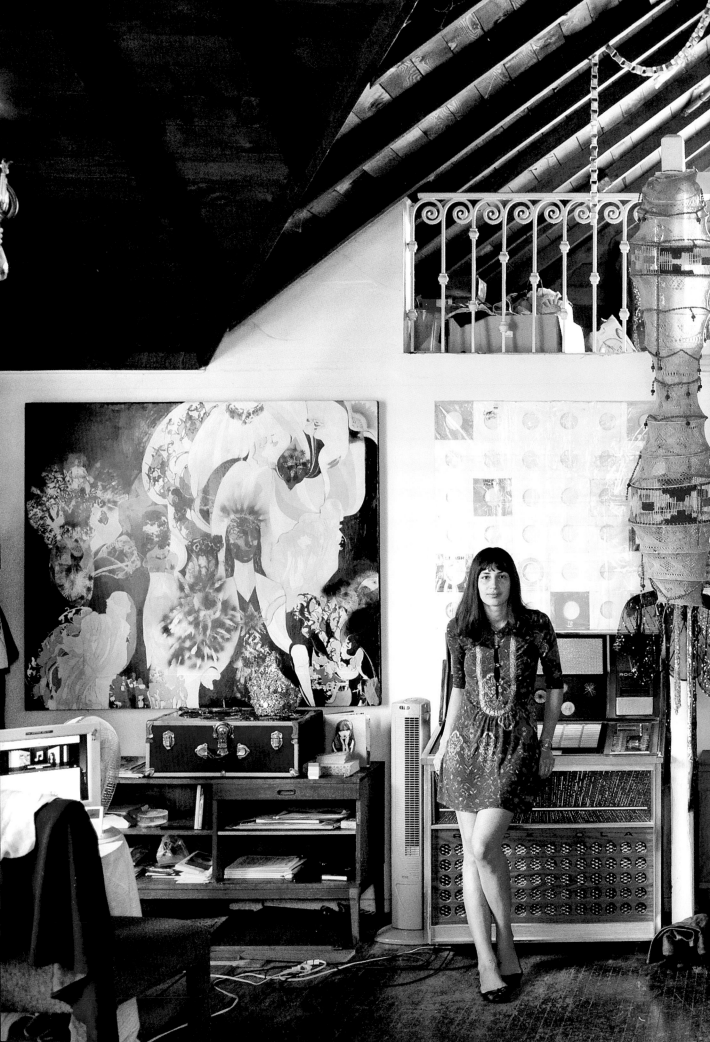

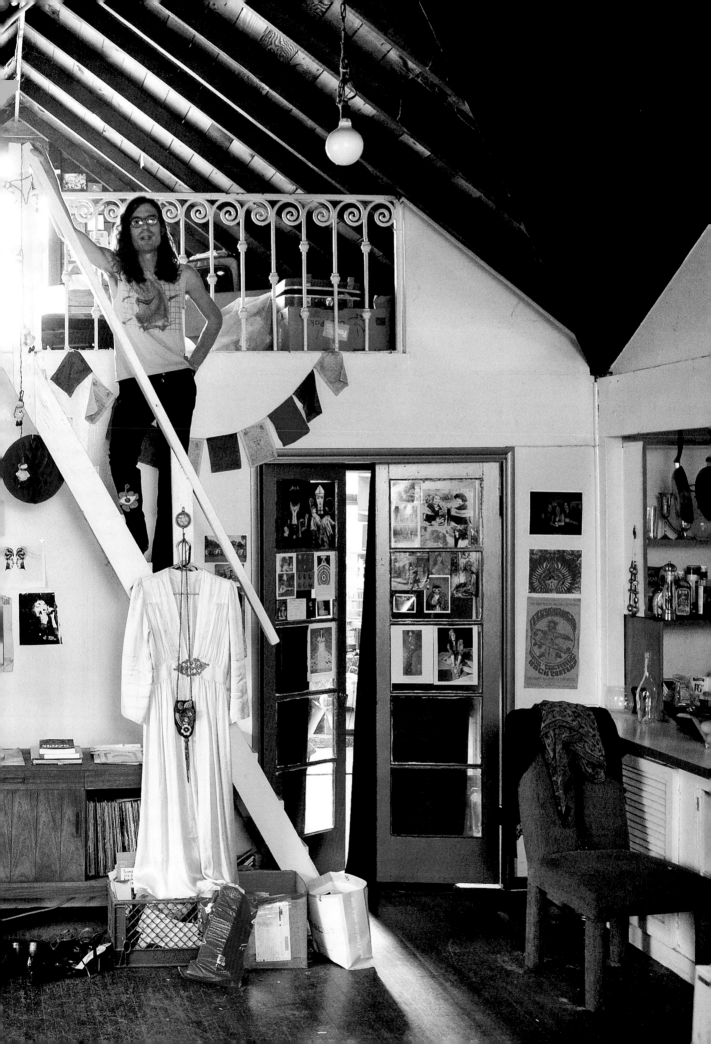

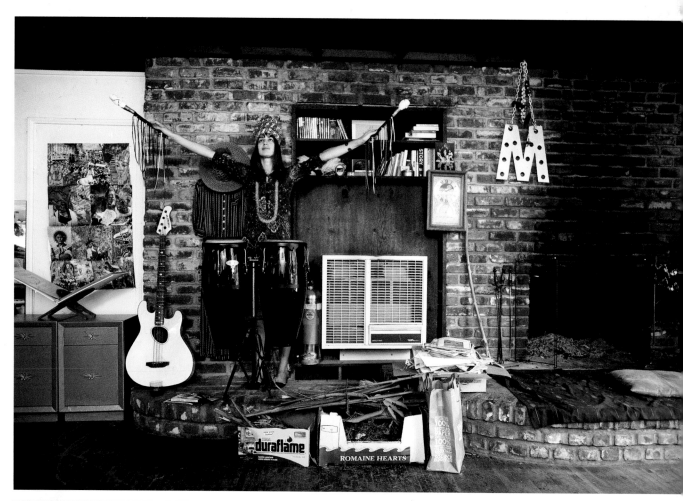

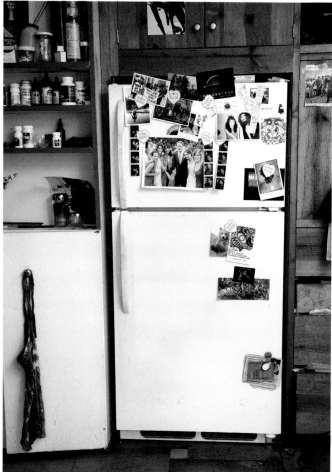

Many nights have been spent playing music and hanging out with friends around the fireplace.

Hi Maximilla + Guy! How did you guys meet?
G- FATE

Guy draw Maximilla? Maximilla draw Guy?

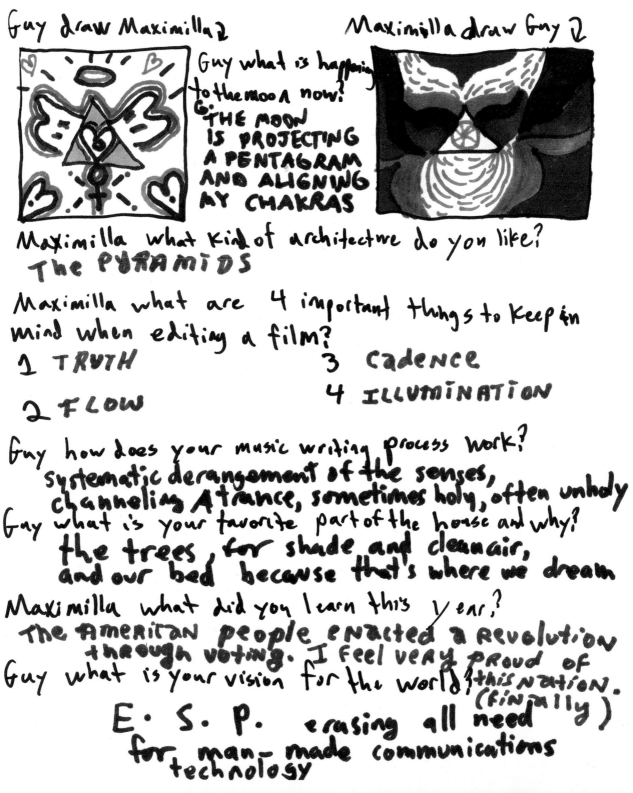

Guy what is happening
to the moon now?
G- THE MOON
IS PROJECTING
A PENTAGRAM
AND ALIGNING
MY CHAKRAS

Maximilla what kind of architecture do you like?
The PYRAMIDS

Maximilla what are 4 important things to keep in
mind when editing a film?
1 TRUTH 3 CADENCE
2 FLOW 4 ILLUMINATION

Guy how does your music writing process work?
Systematic derangement of the senses,
channeling A trance, sometimes holy, often unholy
Guy what is your favorite part of the house and why?
the trees, for shade and clean air,
and our bed because that's where we dream
Maximilla what did you learn this year?
the American people enacted a Revolution
through voting. I feel very proud of
Guy what is your vision for the world? this nation.
(finally)
E. S. P. erasing all need
for man-made communications
technology

Acknowledgments

DEBORAH AARONSON, Editor

JULES THOMSON, Production Manager

MATTHIAS ERNSTBERGER, Designer

THOMAS POROSTOCKY, Designer

THANK YOU TO EVERYONE in this book and all of the other people who invited me into their homes and collaborated with me on The Selby.

And thank you to Danielle Sherman, for all of her creativity and support. Rikki, Richard, and Scott Selby, Mitch Goldstone, Carl Berman, Mark Goldstone, Olga Vargas, and Christopher Vargas, and the rest of my family. Deborah Aaronson, who supported my vision 100 percent of the time and has been the best editor I could have ever hoped for. Matthias Ernstberger, Thomas Porostocky, and Alex Merto of Timko&Klick. You guys did an amazing job designing this book. Natacha Polaert at Nouvelle Garde, for curating Paris. Chris Searl at *Monster Children* magazine, for curating Sydney. Junsuke Yamasaki, for curating Tokyo. Sylvia Farago, for curating London. Mark Hunter the Cobrasnake, for your advice and ideas. Sarah, Sarah's mom, and the whole colette team, for their support. Lesley Arfin, for writing a wonderful introduction and for asking me to photograph her in a bikini. My agent, Erin Hosier, at Dunow, Carlson & Lerner Literary Agency.

A special thank you to Carol Alda, Howard Bernstein, Francesca Bonato, Fanny Bostrom, Peter Cushing, Stephanie Derham, Sierra Domaille, William Eadon, Anthony Elia, Ehrin Feeley, Barry Friedman, Sakiko Fukuhara, Bill Gentle, Caroline Geraud, Joshua Goldfarb, Lucy Goodwin, Heather Hanrahan, Asch Harwood, Kim Hastreiter, Steve Hoskins Jr., Lee Jennings, Emi Kameoka, Aya Kanai, Theresa Kang, Masako Kaufman, Matt Kliegman, Paola Kudacki, Steve Kurutz, Colette Lacoste, Brian Lamotte, Karen Langley, Caroline Lebar, Subway Lung, Nicolas Malleville, Derrick Miller, Jennifer Vaughn Miller, Mariko Munro, James Penfold, Jaime Perlman, Rachel Picard, Carlos Quirarte, Carine Roitfeld, Leslie Rubisch, Carole Sabas, Guillaume Salmon, Ingrid Sophie Schram, Rhonda Sherman, Sally Singer, Jeremy Sirota, Philip Smiley, Abigail Smiley-Smith, Akiko Stehrenberger, Dave Steiner, Jules Thomson, Stefano Tonchi, Laurie Trott, Danika Underhill, and Maya Lilley Wild.

Library of Congress Cataloging-in-Publication Data

Selby, Todd.
The Selby is in your place/Todd Selby.
p. cm.
ISBN 978-0-8109-8486-8 (hardcover)
1. Portrait photography. 2. Celebrities—Portraits. 3. Celebrities—Homes and haunts—Pictorial works. I. Title.
TR681.F3S424 2010
779'.2092—dc22
2009032344

© 2010 Todd Selby

Published in 2010 by Abrams, an imprint of ABRAMS. All rights reserved. No portion of this book may be reproduced, stored in a retrieval system, or transmitted in any form or by any means, mechanical, electronic, photocopying, recording, or otherwise, without written permission from the publisher.

Printed and bound in China
10 9 8 7 6 5 4

Abrams books are available at special discounts when purchased in quantity for premiums and promotions as well as fundraising or educational use. Special editions can also be created to specification. For details, contact specialmarkets@abramsbooks.com or the address below.

THE ART OF BOOKS SINCE 1949

115 West 18th Street
New York, NY 10011
www.abramsbooks.com